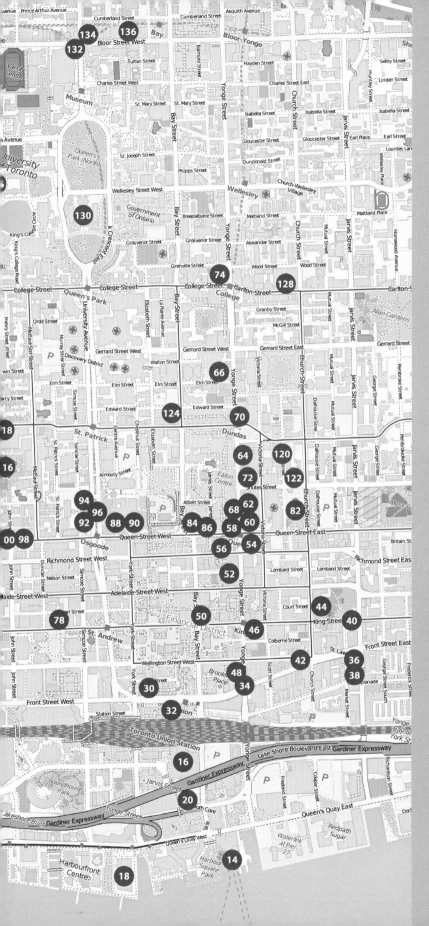

D0845044

TORONTO THEN AND NOW

You can find most of the sites featured in the book or

Numbers in red circles refer to the pages where sites appear
in the book.

* The map and site location circles are intended to give
readers a broad view of where the sites are located. Please
consult a tourist map for greater detail.

TORONTO

THEN AND NOW®

First published in the United Kingdom in 2016 by
PAVILION BOOKS
an imprint of Pavilion Books Company Ltd.
1 Gower Street, London WC1E 6HD, UK

"Then and Now" is a registered trademark of Salamander Books Limited,
a division of Pavilion Books Group.

© 2016 Salamander Books Limited, a division of Pavilion Books Group.

Copyright under International, Pan American, and Universal Copyright Conventions.
All rights reserved. No part of this book may be reproduced or transmitted in any form
or by any means, electronic or mechanical, including photocopying, recording, or by any
information storage-and-retrieval system, without written permission from the copyright holder.
Brief passages (not to exceed 1,000 words) may be quoted for reviews.

All notations of errors or omissions should be addressed to Salamander Books,
1 Gower Street, London WC1E 6HD, UK.

Pavilion Books is committed to respecting the intellectual property rights of others. We have
therefore taken all reasonable efforts to ensure that the reproduction of all content on these
pages is done with the full consent of copyright owners. If you are aware of any unintentional
omissions, please contact the company directly so that any necessary corrections may be made
for future editions.

ISBN-13: 978-1-91090-407-7

Printed in China

10 9 8 7 6 5 4 3 2 1

Endpaper map is courtesy of OpenStreetMap contributors—www.OpenStreetMap.org

AUTHOR'S ACKNOWLEDGEMENTS

The author would like to acknowledge the assistance of Barry Long of Oakville Ontario, who
read the manuscript and offered suggestions. The book was greatly improved by his efforts.
I would also like to express my appreciation for the expertise and generous assistance of the
staff of the City of Toronto Archives. Almost all the archival photographs in this publication
are from their superb collection. I am also grateful to Frank Hopkinson of Pavilion Books, who
guided me through the various stages when writing the book. As well, I would like to recognize
the endeavours of David Salmo, who edited the text, offered suggestions, and creatively
designed the pages with their numerous photographs.

PICTURE CREDITS

"Then" photographs
Courtesy of City of Toronto Archives: pages 8 top (Fonds 1257, Item 134); 10 top (Fl.1548, Item
1737); 12 top (Fonds 1266, Item 18723); 14 top (S0071, Item 10962); 18 (Fonds 1257, Item 1018); 20
(Fonds 1244, Item 0743); 22 (S0071, Item 11537); 24 bottom (Fonds 1231, Item 0541); 26 (Series 71,
Item 7108); 28 (Fonds 1231, Item 87); 30 (S.0372 SS 0100, It. 109); 32 top (Fonds 1548, Item 14352);
34 (F1526, fl100047, Item 3); 38 (Fonds 1568, Item 363); 42 left (F0124, fl0002, id0065); 44 (File 1568,
Item 0278); 46 left (Fonds 1231, Item 1129); 48 (Fonds 1568, Item 224); 50 (Fonds 1257, Item 14); 52
(Fonds 1568, Item 311); 54 left (Series 372, SS 0058, Item 0082); 56 (S0372, SS0001, Item 1410); 58
top (Fonds 1244, item 712); 60 (Fonds 1231, Item 2036); 62 (Series 1278, File 100); 64 (Series 71, Item
11708); 66 left (Fonds 1231, Item 5915); 68 (Fonds 124, Item 123); 70 (Series 574, fl0013, id49321); 72
left (Fonds 1231, Item 337); 74 (Fonds 124, file0003, id 0062); 76 (Fonds 1231, Item 755); 80 (Fonds
1568, Item 282); 82 (Fonds 1568, Item 464); 84 left (Fonds 1231, Item 311); 86 (S0071, it.4293); 88
(Fonds 1498, Item 9); 90 left (S 0071, It.49428); 92 (F0124 fl 10001, Id.0071); 94 left (Fonds 1244,
Item 3172); 96 left (Fonds 1257, Item 191); 98 (Fl.1231, Item 761); 100 (Fonds 124, F0124, Fl0002, id
0131); 102 (Fonds 1244, Item 1162); 104 (Series 0372, SS0058, Item 113); 106 (Fonds 1567, Item 5);
108 (Fonds 1244, Item 2366); 110 (Fonds 1231, Item 2010); 112 (Series 0376, File 10002, Item 49);
114 (f1266, it.26172); 116 (Series 1244, Item 304); 118 (Series 372, SS.0041, Item 314); 120 left (Fonds
1257, id.0741); 122 left (Fonds 1231, Item 88); 124 (Series 71, Item 9041); 128 (Fonds 1526, Item 6); 130
top (Fonds 1266, Item 976); 132 (Fonds 1244, Item 1140); 134 (Fonds 1231, Item 349); 136 top (F0124,
FL0003, id.0100); 138 left (Fonds 1231, Item 305); 140 (Fonds 1548, Item 15540); 142 (Fonds 1231,
Item 577).

Courtesy of Toronto Public Library: pages 24 top; 36; 46 right; 66 right; 78; 84 right; 90 right;
138 right.

Courtesy of Library of Congress: pages 8 bottom; 32 bottom; 126; 130 bottom.

Courtesy of Ontario Archives: page 40.

Courtesy of David Milne, Ontario Archives Collection: page 16.

"Now" photographs
All photos were taken by Karl Mondon, except for the following pages, which are courtesy of the
author: 25 bottom; 37; 39; 71 bottom; 89 bottom; 105; 119; 135; 141; 143.

TORONTO
THEN AND NOW®

DOUG TAYLOR

PAVILION

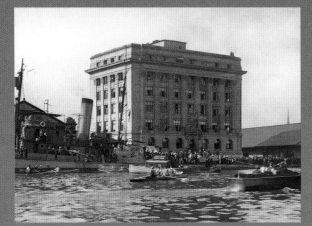
Harbour Commission Building, 1927 p. 20

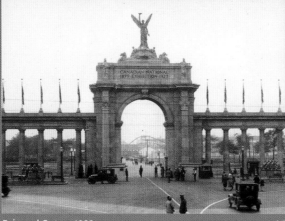
Princes' Gates, 1929 p. 26

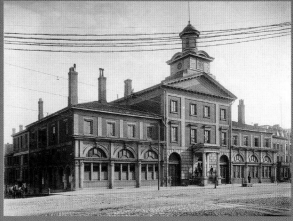
Toronto's First City Hall / St. Lawrence Market, 1895 p. 36

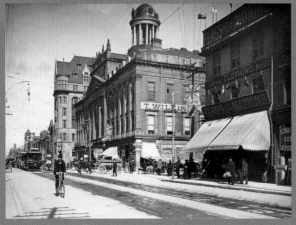
St. Lawrence Hall, c. 1910 p. 40

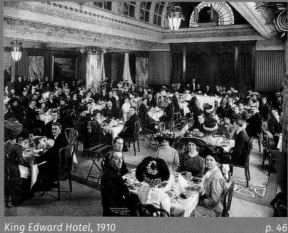
King Edward Hotel, 1910 p. 46

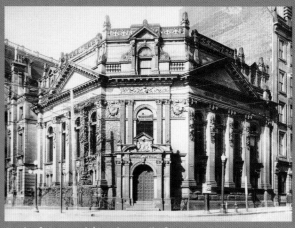
Bank of Montreal / Hockey Hall of Fame, c. 1900 p. 48

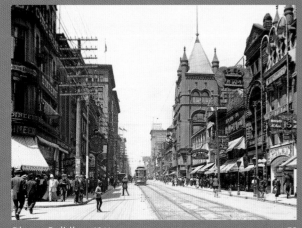
Dineen Building, 1911 p. 52

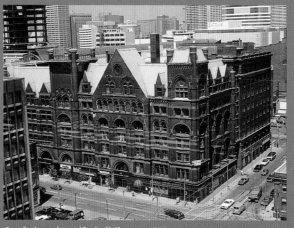
Confederation Life Building, c. 1977 p. 54

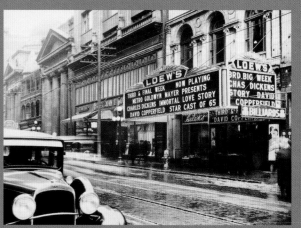
Loew's Theatre / Elgin Theatre, 1935 p. 62

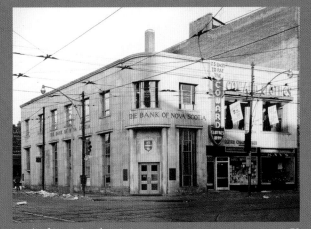

Bank of Nova Scotia, 1950 p. 70

Royal Alexandra Theatre, 1955 p. 78

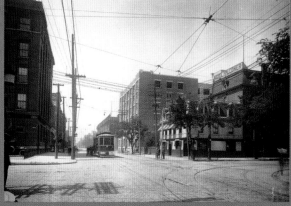

Richardson House, 1914 p. 80

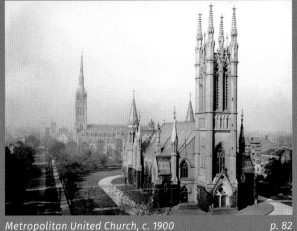

Metropolitan United Church, c. 1900 p. 82

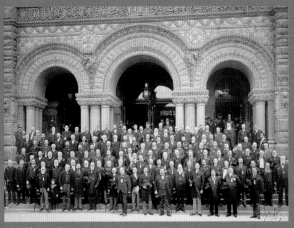

Old City Hall, 1899 p. 84

Victory Theatre, c. 1968 p. 106

Knox College, 1899 p. 112

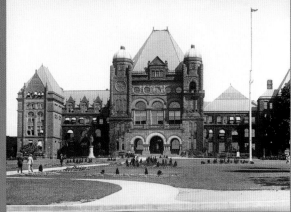

Ontario Legislative Building, 1923 p. 130

University Theatre, 1983 p. 136

TORONTO

THEN AND NOW INTRODUCTION

On an autumn day in September 1787, on a narrow isthmus between the mainland and Lake Ontario's Bay of Quinte, British officials gathered with three Mississauga chiefs. For £1,700 in cash and trade goods, they purchased the rights to an enormous tract of land on the north shore of Lake Ontario. The treaty included the land surrounding the mouth of the Humber River, the primary intent of the negotiations. The transaction became known as the "Toronto Purchase." The Humber River was important, as it was a trade route that led to the Upper Great Lakes. Unknown to those who participated in the transaction, where the river emptied into the lake was to be the future site of the city of Toronto.

Four years later, the British government appointed John Graves Simcoe the lieutenant governor of Upper Canada. On July 25, 1791, he arrived at the provincial capital, Newark (Niagara-on-the-Lake) and discovered that the town was within sight of the American guns at Fort Niagara. Realizing that a safer location was necessary, he chose to relocate to Toronto, as it was further from the border and possessed an excellent harbour rimmed by majestic oak trees.

In late July 1793, Simcoe and his family sailed from Newark to Toronto. They disembarked and encamped near the east bank of the Humber River, close to the foot of the city's present-day Bathurst Street. Simcoe erected what was technically the first "Government House" in Toronto, a term applied to the official residences of the king's representative in the colonies. However, in this instance, it was merely three second-hand canvas tents—a rather humble beginning.

In the ensuing weeks, Simcoe explored Toronto, discovering that the site possessed two large river valleys—the

Humber and the Don—geographic barriers that would greatly influence the development of the town. However, the waterways also provided transportation routes and, eventually, power for grist and lumber mills.

In 1793, Simcoe accepted Surveyor Alexander Aitkin's plan of 1788 of the harbour and requested that a town site be included at its eastern end. Simcoe also ordered the construction of a garrison, later named Fort York, on the west bank of Garrison Creek, at the far western end of the harbour.

On August 26, 1793, to the thunderous roar of cannons, Simcoe officially changed the name of the town from Toronto to York, in honour of the youngest son of King George III, the Duke of York. By September, Simcoe ordered surveyor Augustus Jones to plan a military road from York to Holland Landing. Ignoring the contours of the land, it was built in a straight line. He named it Yonge Street after George Yonge, Secretary of State and War in the British Cabinet. Simcoe was unaware that this roadway would become Toronto's main street.

In 1794, Simcoe officially declared that the capital of the province would be York, but only temporarily since he preferred London (Ontario) for this distinction. However, a dispatch dated March 16, 1794 confirmed that the town was henceforth to be the permanent capital of Upper Canada (Ontario). When Simcoe departed the province in 1796, he left behind a settlement that was firmly established.

York continued to prosper and in 1834 it was incorporated as a city and its name changed to Toronto. During the decades ahead, the city overcame the impediments of its geography. Bridges spanned the two great river valleys that

had prevented its expansion. The malarial swamps near the Don River were drained, allowing the town to spread eastward. There was also a barrier to northward expansion, caused by the ancient Lake Iroquois after it receded to form the Great Lakes. Its shoreline created an escarpment, which today is on the north side of Davenport Road. However, roadways eventually pushed up over the severe incline and communities were established above the hill.

More roads were built that extended northward from the harbour—Bay, Jarvis, Spadina, and York Streets as well as University Avenue. Major east–west avenues constructed were Queen, King, Adelaide, Richmond, Bloor, and eventually St. Clair.

Economic activity expanded In the 1850s after the railroads arrived. Following Confederation in 1867, since Toronto was Ontario's capital, government services created further growth. In 1869, Timothy Eaton opened a business that in the decades ahead would become the most important retail company in Canada and one of the largest in the world.

The demand for cultural and sports activities intensified. Toronto's first legitimate theatre, the Royal Lyceum, was established on King Street. In 1860, the Queen's Plate commenced and today is the longest continuously run thoroughbred horse race in North America. The 1,750-seat Grand Opera House opened in 1874 and in 1886 Sunlight Park became the city's first baseball stadium.

As the 20th century dawned, immigrants continued to arrive in increasing numbers, and during the next two decades the city's population almost doubled. In the financial district, buildings soared to new heights. The 1920s witnessed further expansion in the arts, science and

architecture. In 1920, members of "The Group of Seven," who later became icons of Canadian art, held their first exhibit at the Art Gallery of Toronto (AGO). In 1923, Frederick Banting discovered insulin to treat diabetes and the world's supply of the medicine was manufactured in Toronto. The city's new Union Station was officially opened in 1927, one of the most complex transit stations in the world. In 1931, the 34-storey Bank of Commerce was completed, in that decade the tallest building in the British Commonwealth. When World War II ended in 1945, there was another influx of immigrants, greatly increasing the city's ethnic diversity. The opening of the St. Lawrence Seaway in 1959 further stimulated Toronto's economy.

The growth continued into the 21st century. Today, Toronto is a multicultural city that is home to many international companies. It is the nation's banking and financial centre. Its theatre scene is the third largest in the English speaking world, and it has excellent opera and ballet companies, as well as a world-famous symphony orchestra. Major research facilities are headquartered in the city, along with three universities and four daily newspapers. The city's annual film festival (TIFF) is one of the most important in the world and the city's restaurants are among the finest on the continent.

Beginning with a few tents beside Lake Ontario in the 18th century, Toronto is today Canada's most populous urban centre and the fourth largest city in North America.

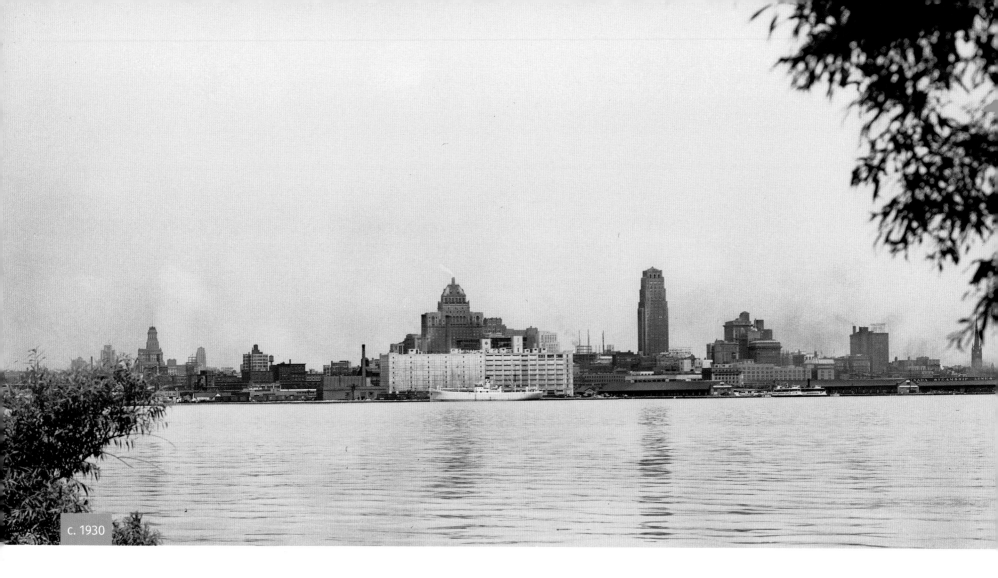

c. 1930

TORONTO HARBOUR

Now a dramatic setting for Toronto's soaring skyscrapers

ABOVE: The view gazes northward from Centre Island at the Toronto skyline in this photo. Though a modest skyline compared with the modern era, by the third decade of the 20th century, tall buildings were already reaching skyward, hinting at the dazzling towers of glass and steel that were to appear in the years ahead. The harbour was one of the reasons for choosing the site for the city, and the port remained an active part of its commercial life for many years. In the centre of the photo, the large white structure is the Terminal Building (today the Queen's Quay Terminal). The western portion of this building was demolished when it was restored. Behind it is the imposing Fairmont Royal York Hotel. To the right of it is the Bank of Commerce (CIBC), at the time the tallest building in the British Commonwealth. On the western (far left-hand) side of the skyline is the tower of the Canada Life Building. The photo on the right is looking toward Yonge Street Wharf.

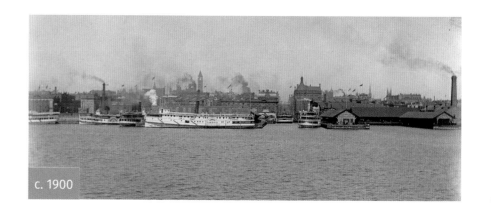

c. 1900

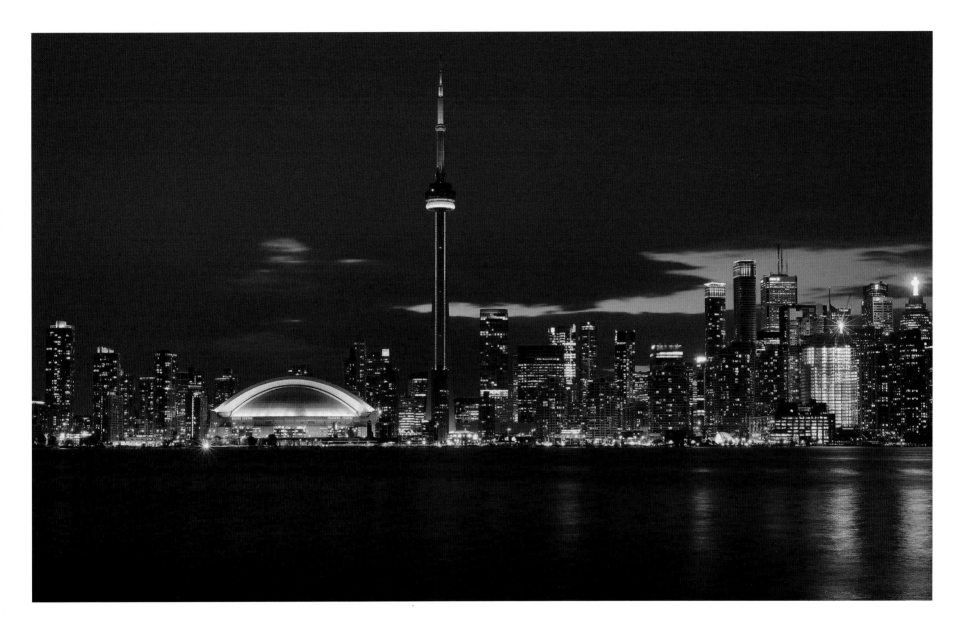

ABOVE: Today, in North America, only New York City possesses more skyscrapers than Toronto. The CN Tower soars above the tallest towers, to a height of 553 metres (1,814 feet). Left of the CN Tower is the illuminated dome of the Rogers Centre stadium. The harbour is now a favourite site for the construction of condominiums, their impressive height adding to the skyline. It is perhaps best appreciated when viewed from the deck of a Toronto Island ferry, when the lights of the buildings sparkle magically in the darkened sky beside the same waters that Toronto's founder John Graves Simcoe must have viewed when he arrived in the summer of 1793. Thus, it is fitting to commence exploring Toronto, then and now, with the harbour area, because with the dawn of the 21st century, the city has rediscovered its importance. Toronto is now reclaiming the land usurped by the railroads and numerous industries to create public parkland, recreational areas, and commercial facilities. More development is occurring near the harbour than in any other part of the city.

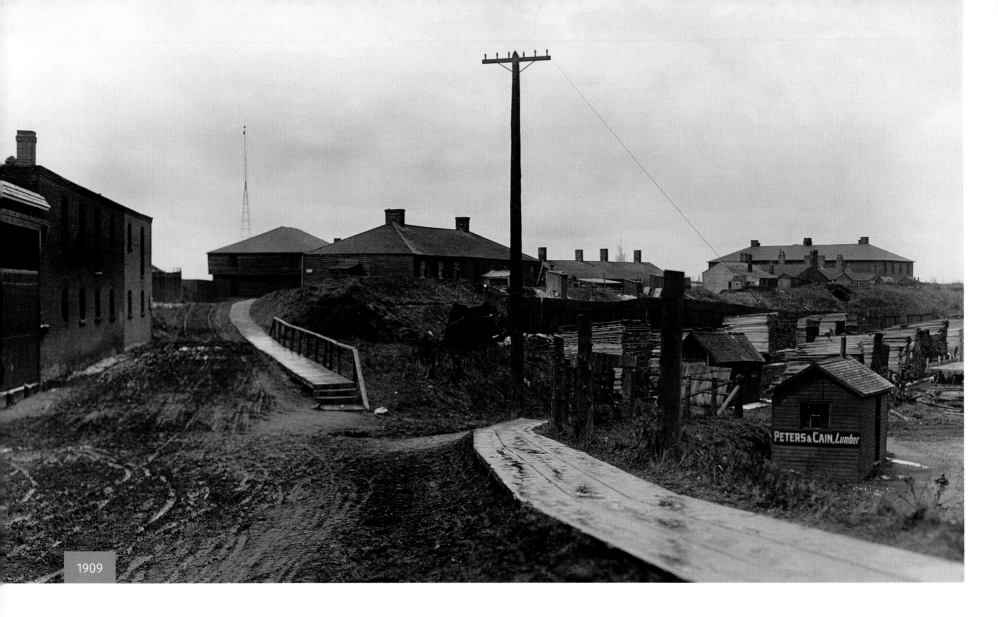

1909

FORT YORK

Condominium towers now surround this 18th-century fort

ABOVE: When Fort York was built, the waves of Lake Ontario lapped beside its walls. The view in this photo gazes west toward the east gate of the fort, on April 10, 1909. Its construction began on July 21, 1793, when soldiers of the Queen's Rangers erected log buildings and a palisade surrounding them to defend the town against an American invasion. The fort was destroyed during the Battle of York in April 1813, but in the weeks following the attack, the British commenced rebuilding. The site remained active until 1841, when troops were relocated to the Stanley Barracks, a short distance to the southwest. In 1909, ownership of Fort York was ceded to the City of Toronto, but it continued to be employed for training Canadian troops until the 1930s. In 1934, it was restored for Toronto's centennial. Structures not built during the years 1813–15 were demolished and the restored fort reopened on May 24, 1934. Blockhouse #2 is shown in the photo on the right.

1925

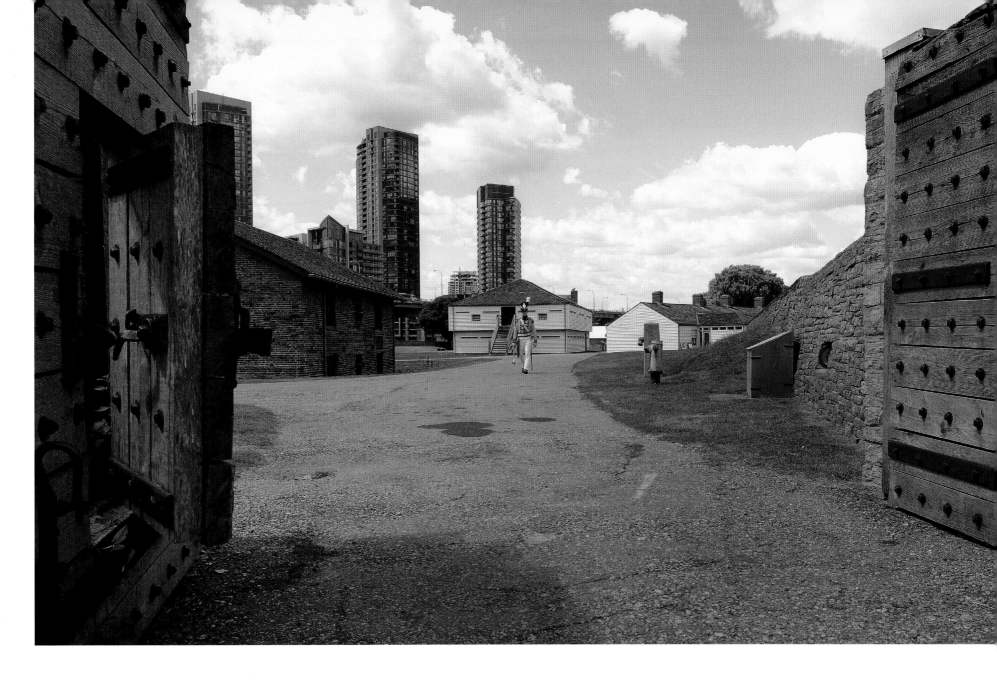

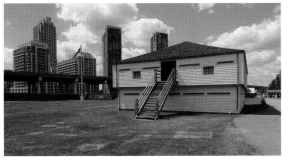

ABOVE: Today, Fort York is increasingly being surrounded by condominium towers. The red-brick building visible inside the gates, on the left, was constructed in 1814 and served as the magazine for storing gunpowder. In 1824, it was converted into a storehouse. Blockhouse #2, from 1813, is visible behind the man in military uniform marching toward the gate. The blockhouse (also shown left) served the needs of 160 soldiers, its thick timbered walls protecting its occupants from bullets and exploding shells. Until the 1820s, the only way to enter the structure was by a door on the second floor. The stairs to the door were raised if the blockhouse were under attack. The building to the right of the blockhouse is the Officers' Blue Barracks. Built in 1814, it provided living quarters for junior officers. The present-day building is a reconstruction, but includes materials from the original structure.

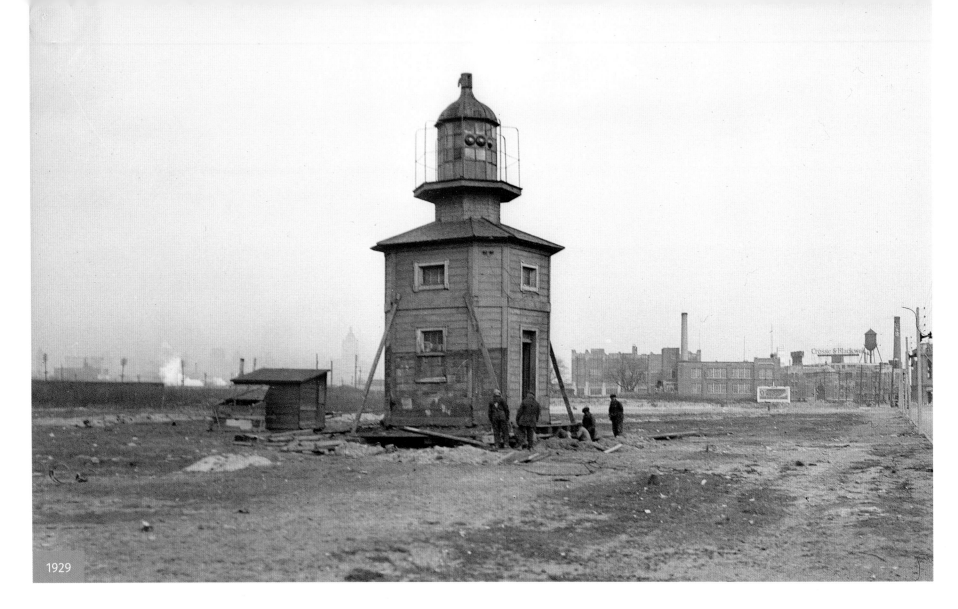

1929

QUEEN'S QUAY LIGHTHOUSE
The lighthouse remained in service until 1911

ABOVE: This photo from November 26, 1929 looks east along Lakeshore Boulevard, after the Queen's Quay Lighthouse was relocated from its original location at Queen's Quay Wharf. In 1837, the British Parliament in London granted funds to construct a wharf near the foot of Bathurst Street. Queen Victoria ascended the throne the year the wharf was completed, resulting in its being named "The Queen's Wharf." In 1838, a lighthouse was built on it to guide ships into port, since the entrance was shallow and treacherous. Because shipping continued to increase, in 1851 an additional 21 metres (70 feet) were added to the wharf, extending it to the west, rather than further out into the lake. In 1861, they replaced the lighthouse with a taller one designed by Kivas Tully, and also built a smaller one near it. The larger lighthouse was painted white, and the smaller red. The red lighthouse is shown above, while the photo on the right shows both lighthouses in their original Queen's Quay Wharf location.

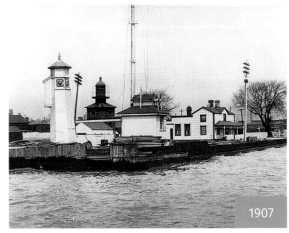

1907

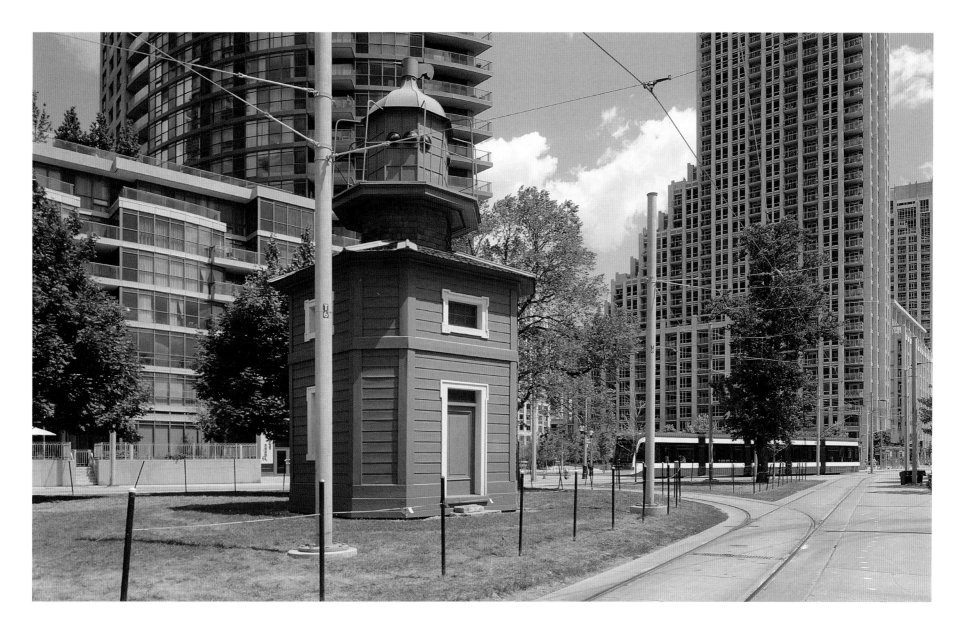

ABOVE: The two historic lighthouses built in 1861 remained in service until 1911, when the harbour entrance was relocated 395 metres (1,300 feet) to the south. The lighthouses were then high, dry, and obsolete. The white lighthouse was demolished, but in 1929 the red lighthouse was donated to the Harbour Commission. They relocated it to its present-day site near the foot of Bathurst Street by employing wooden rollers and horses. At the time, the area was undeveloped and almost devoid of buildings. The lighthouse is now in a small grassy park, hemmed in by the busy lanes of traffic on Fleet Street and the Lakeshore Boulevard. The lighthouse is square-shaped, with flattened corners that simulate an octagon. At the top of the structure was an enclosed metal lantern that contained curved lenses to concentrate the light into a powerful beam. The historic structure is today maintained by Heritage Toronto.

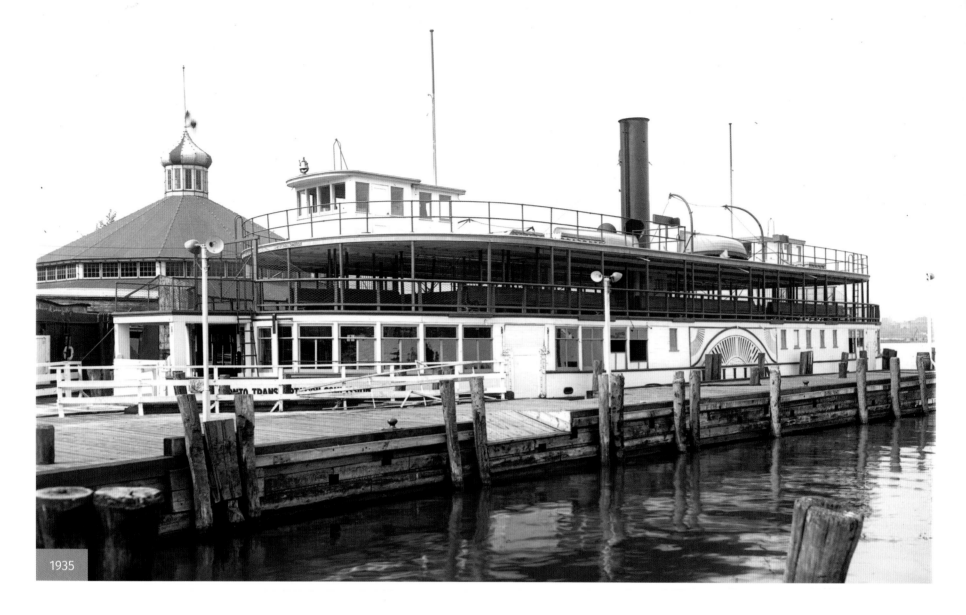

1935

TORONTO ISLAND FERRIES—THE *TRILLIUM*
The passenger ferry is now used for private functions and tours

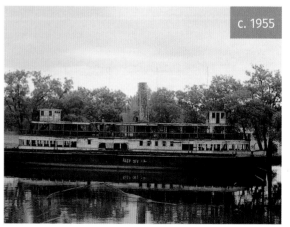

c. 1955

ABOVE: This photo shows the *Trillium* at dockside on July 4, 1935. Transporting passengers across the harbour by ferry commenced in 1833, the boats propelled by two horses on a circular treadmill. In the 1850s, steam-powered boats were introduced. Due to the fact that many competing entrepreneurs were offering transportation across the harbour, and safety was often ignored, the city formed the Toronto Ferry Company in 1890. The *Trillium* was launched in 1910, built by Polson Iron Works, located at the foot of Sherbourne Street. It was a side-paddled, steam-powered boat. Other ferries in the fleet during those years were the *Mayflower*, *Blue Bell*, and *Primrose*. They carried passengers to Centre Island, Ward's Island, and Hanlan's Point, the latter destination where the city's main baseball stadium and an amusement park were located. In 1926, the ferries to the islands became the responsibility of the Toronto Transportation Commission, and passengers were able to cross the harbour for the price of a TTC ticket.

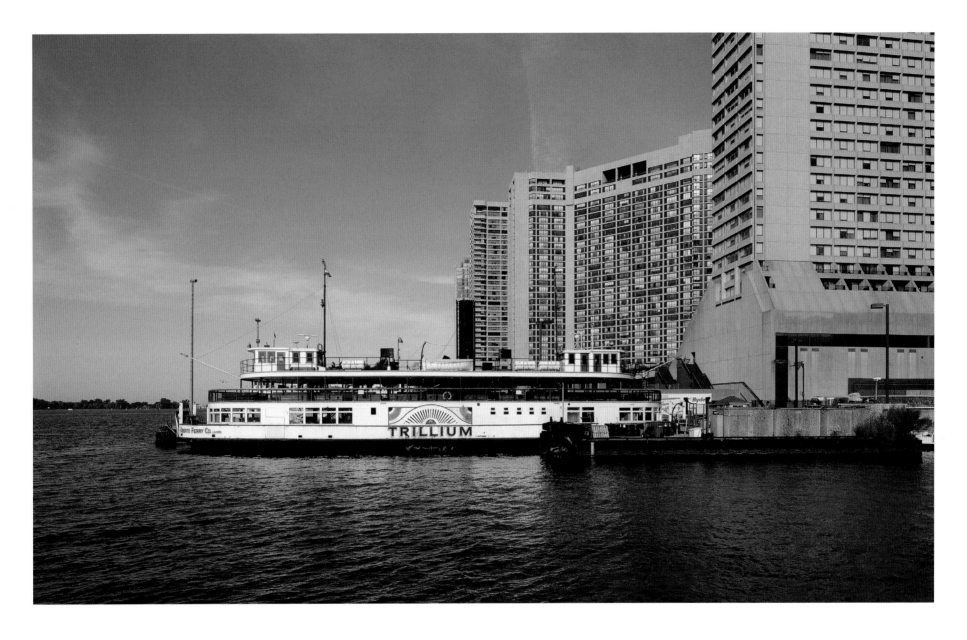

ABOVE: The old steam-powered ferries were eventually scrapped, but the *Trillium* was towed to a quiet lagoon at Centre Island (shown in the c. 1955 photo) and abandoned to rot. Fortunately, in 1973, the city decided to restore the old ferry and, following two years of reconstruction, it was launched again on May 19, 1976. Today it is docked in the harbour near the foot of Yonge Street, but is only used for private functions and tours. The ferries of the same vintage as the *Trillium* were replaced by the Toronto Transportation Commission with those that were diesel-powered. The *William Inglis* was launched in 1935, named after the owner of the Polson Iron Works, the company that built the ferry. In 1939, the *Sam McBride*, named after a Toronto mayor, joined the fleet. The *Thomas Rennie*, named after a prominent Toronto businessman, was the third ferry to be launched, appearing on the scene in 1950. In 1963 the *Ongiara* was added to transport passengers to Hanlan's Point.

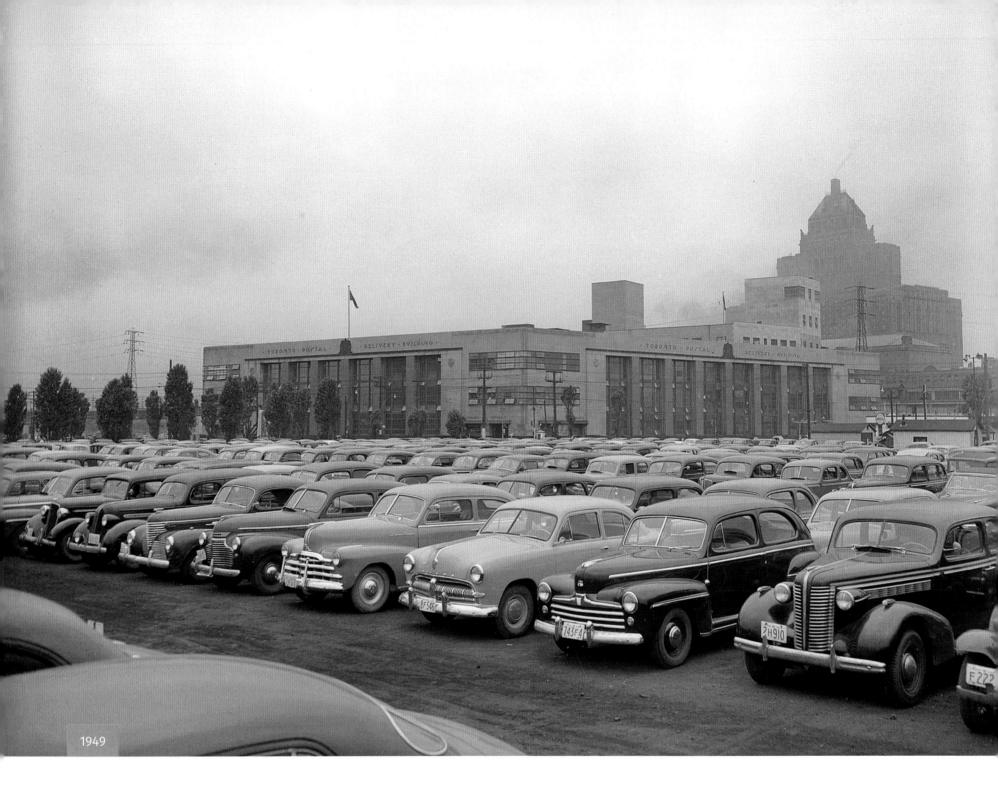

1949

TORONTO POSTAL DELIVERY BUILDING / AIR CANADA CENTRE
The city's main postal delivery terminal until the early 1990s

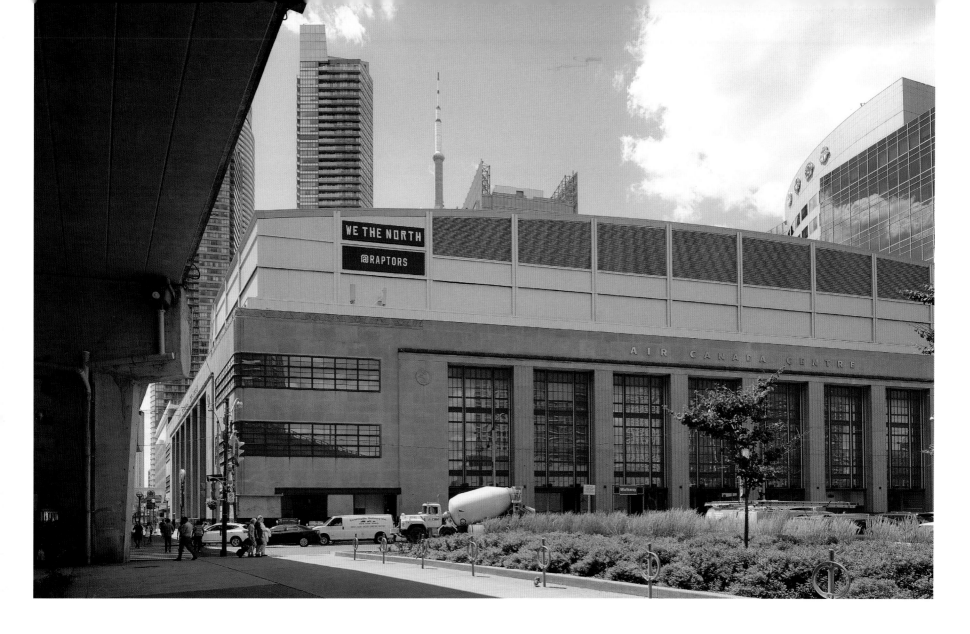

LEFT: In this photo, taken on June 30, 1949, the low-rise building in the background is Toronto's Postal Delivery Building, located at 40 Bay Street. The view is to the west, toward the east and south facades of the building; in the distance is the Fairmont Royal York Hotel. In the late 1930s, the Federal Government realized that a new postal terminal was required and Charles B. Dolphin was hired to design the structure. Construction began in 1939, employing concrete and steel. Completed in 1941, it was located at the foot of Bay Street, its south facade facing Lakeshore Boulevard. A tunnel connected it to Union Station, permitting mail arriving by train to be transferred directly into the postal terminal. During World War II, control of the building was transferred to the Department of National Defense, but it was returned to the postal system in 1946, and remained the city's major delivery terminal until the early 1990s.

ABOVE: Today, the surroundings of the Postal Delivery Building have greatly changed. The view in this photo shows the underside of the Gardiner Expressway on the left-hand (south) side of the building. In 1994, the building was purchased to create a home for the Toronto Raptors Basketball Club and the Maple Leaf Hockey Club. Its interior was mostly demolished, but the facades of the original structure were retained. They reflect a combination of styles—Art Deco and Art Moderne—containing smooth horizontal lines with rounded corners. At the base of the building is a series of carved limestone panels, created by stone-carver Louis Temporale Sr., which depict the history of communication and transportation in Canada. The building's cladding is of Queenston limestone and its base is composed of black granite. Above the original facades is an enormous dome that allows space for the enormous arena within. When the renovations were completed, the building opened as the Air Canada Centre (the ACC), and is today the city's main sports complex.

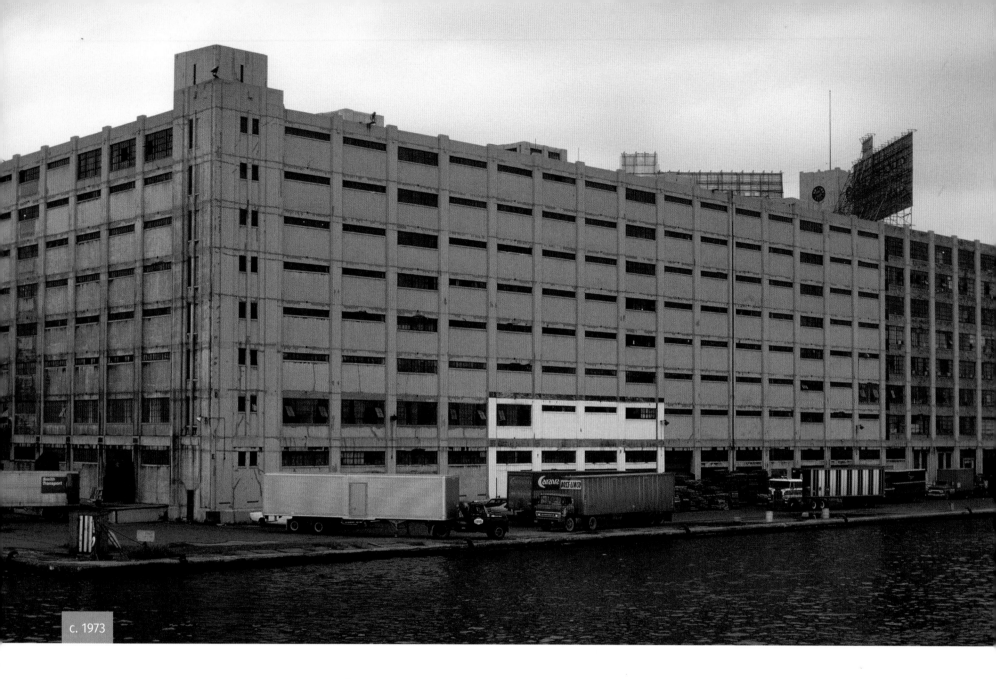

c. 1973

TERMINAL WAREHOUSE / QUEEN'S QUAY TERMINAL
The first poured-concrete building in Canada

ABOVE: This photo of the Terminal Warehouse at Queen's Quay was taken from the lake, looking north toward the building's west and south facades. Only the extreme right-hand portion of the complex still exists. Its architects were Moores and Dunford of New York City. When it was constructed in 1927, ten thousand wooden piles were driven down to the bedrock to support the massive structure. It was the first poured-concrete building in Canada and one of the largest in the Art Deco style ever erected in Toronto. At a cost of $3 million, it contained over a million square feet of storage facilities. Two railway lines entered its first floor for unloading. Its freezer plant produced many tons of ice daily, which was placed in railcars for shipping perishable products. Its sheltered loading bays handled a hundred trucks at a time, an amazing feat for its decade.

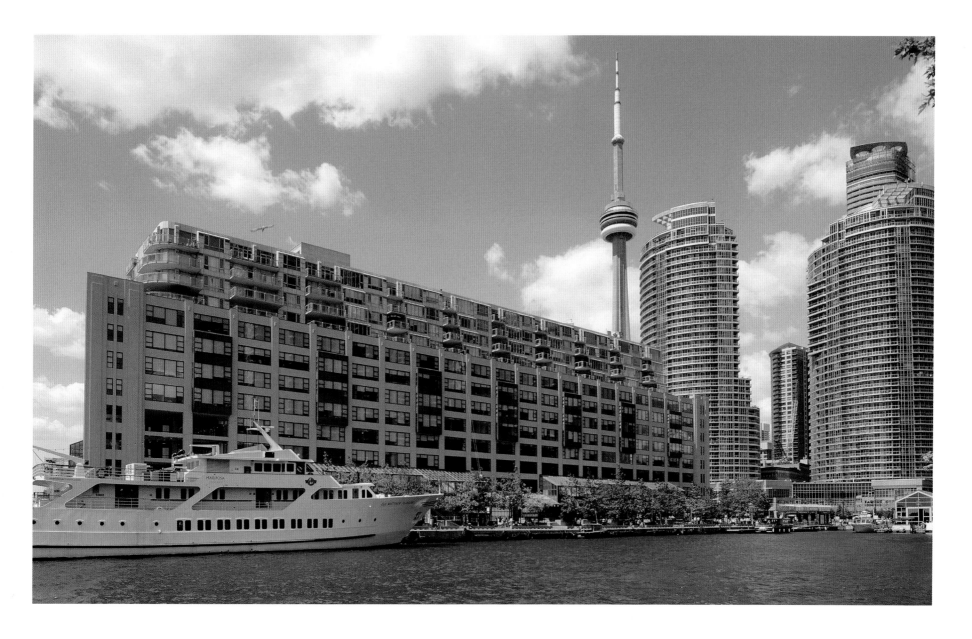

ABOVE: This view is of the east facade of the former eight-storey Terminal Warehouse at 207 Queen's Quay. The warehouse was purchased by the Canadian Government in 1975 as part of a plan to develop the city's waterfront. In 1983, the structure was renovated and restored by Zeidler Roberts Partnership, at a cost of $60 million. The unattractive southwest section was demolished, and four floors of condominiums were added to the top of the portion that remained. The ground-floor level was divided into spaces for boutiques, gift shops, restaurants, and a grocery store, with the floors above containing mainly offices. An intimate theatre for the performing arts was also included. The name of the building was changed to Queen's Quay Terminal after the renovations. Outside, on the east and south sides, there are cafés and restaurants with patios that provide diners with an excellent view of the harbour. Boats that offer harbour excursions and tours are docked nearby. It is one of Harbourfront's most popular destinations.

HARBOUR COMMISSION BUILDING
Landfill has transformed the building's harbourside location

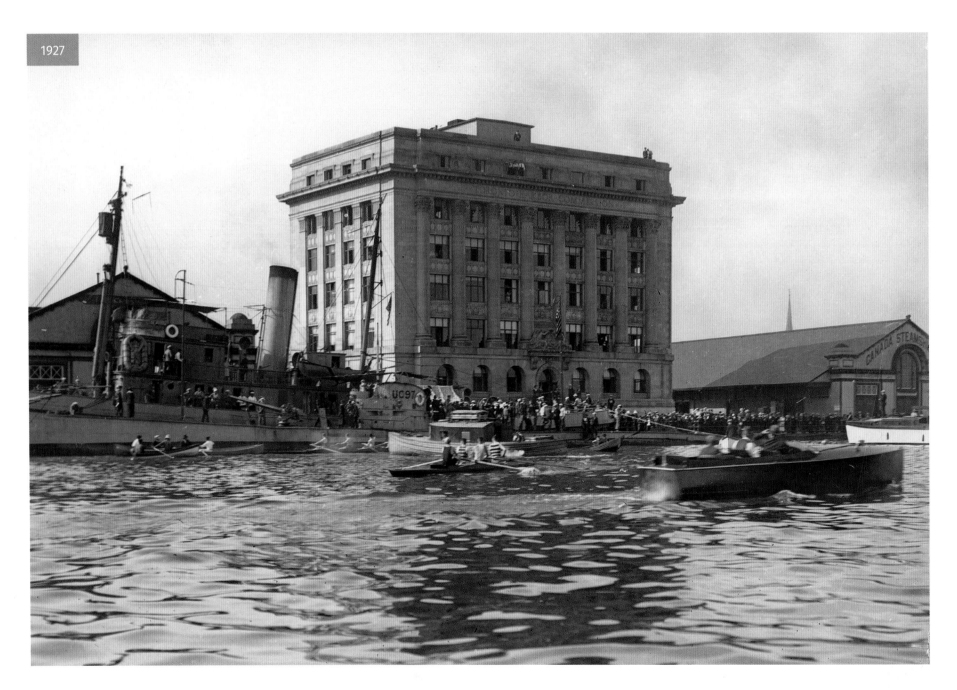

1927

LEFT: This view, from June 1927, shows the Harbour Commission Building when it was located beside the water. Following a city referendum in 1911, authority over the harbour's activities and the land surrounding it was granted to the Harbour Commission. Construction for an office building for the Commission commenced in 1917, erected on reclaimed land at the water's edge. Located at 60 Harbour Street, it was designed by Alfred Chapman, a partner in the firm of Chapman and Oxley. Born in Toronto, Chapman later assisted in designing the Princes' Gates, Sunnyside Bathing Pavilion, and the Palais Royale. He chose the Beaux-Arts style for the Harbour Commission Building. Its facades were faced with Indiana limestone, the architectural detailing a mixture of classical, Renaissance, and Baroque designs. The commissioner's room was panelled with solid walnut and it contained an impressive fireplace. When the building opened in 1918, it boasted an elevator and a telephone switchboard reception, both features highly prized in that decade.

BELOW: The Harbour Commission Building is today somewhat lost amid the downtown office towers and soaring condominiums, as well as the ramps of the Gardiner Expressway. Its postal address remains 60 Harbour Street, but, as is evident in the photo, it is no longer situated beside the water as landfill has pushed the water's edge further south. On the symmetrical facade facing Harbour Street, three-sided pilasters rise vertically from above the first floor, reaching as high as the lower cornice, which contains classical detailing. The pilasters create the impression of depth, without the expense of erecting true columns. Part of the structure now houses the offices of the Toronto Port Authority (TPA), and the remainder of the space is rented to other corporate enterprises. In 2012 the Port Authority announced that it would maintain and preserve the building, now known as the 30 Bay/60 Harbour Project. It presently has a restaurant on the ground-floor level.

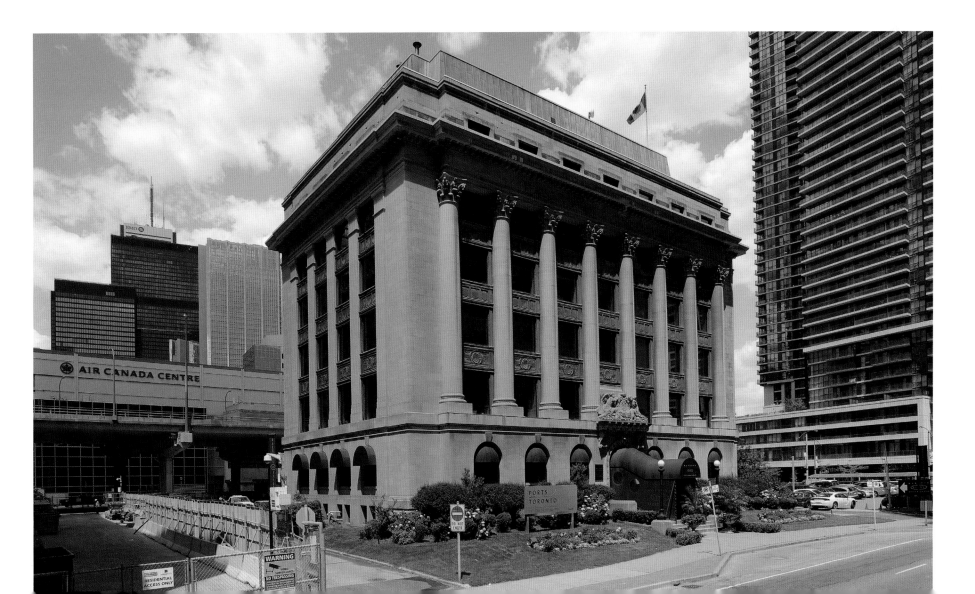

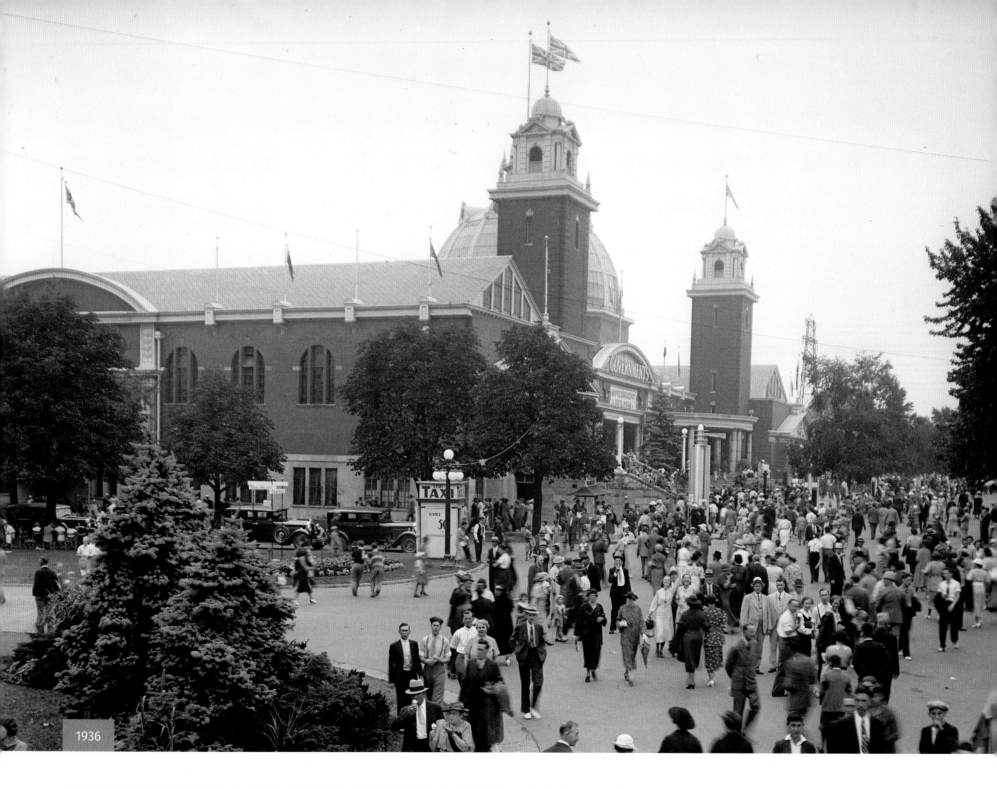

1936

GOVERNMENT BUILDING AT THE CANADIAN NATIONAL EXHIBITION

The exhibition's fairground was the first in the world to be electrified

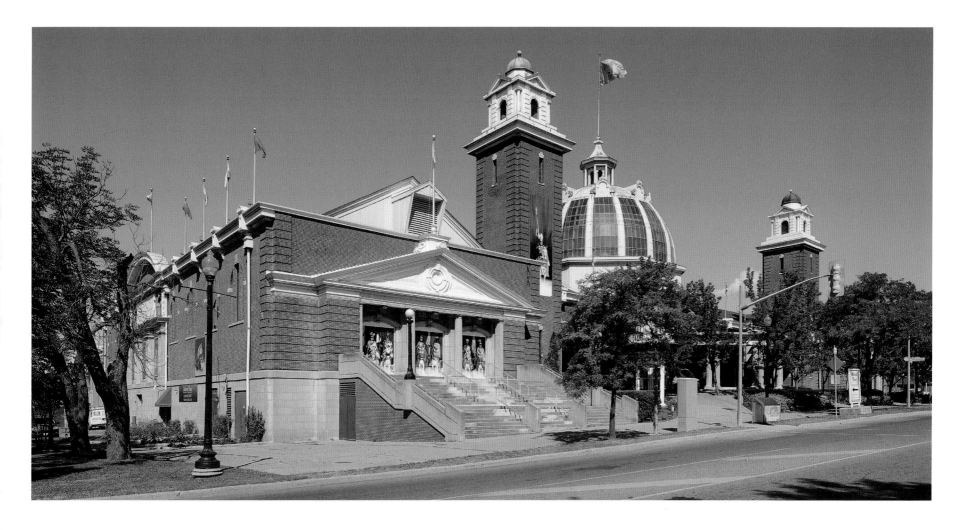

LEFT: This photo depicts the Government Building (later the Arts, Crafts and Hobbies Building) at the Canadian National Exhibition (CNE) on September 7, 1936. It was built in 1912 to display exhibits sponsored by local and foreign governments. Its architect was George W. Gouinlock, who designed four other buildings on the CNE grounds. The late-summer fair first opened in 1879, and in that year it was named The Industrial Exhibition. For an entrance fee of 25 cents, visitors were able to tour 23 buildings. The fair was advertised as the "Show Window of the Nation"—the world's largest permanent exhibition. In 1882, the exhibition became the first fairground in the world to be electrified, allowing it to remain open until 10 p.m. each evening. Two years later, an electric railway was introduced, which at first only operated within the grounds. The system of employing overhead wires and a trolley pole to power vehicles was pioneered at the exhibition.

ABOVE: Today, the Government Building is no longer a part of the annual fair, as the western section of the grounds is closed to visitors when the CNE is open. Though none of the original buildings from 1879 survives, each year toward the end of summer their counterparts continue to attract over a million visitors. Until 1993, the Government Building was one of them. Its enormous dome is similar to the one on the Horticultural Building, also designed by George W. Gouinlock. When the Government Building was the Arts and Crafts Building, during the 1970s and 1980s, the CNE held an annual art competition for school children. They displayed the winners' works in the building, along with those of another popular contest—quilting. During those years, the booths that featured hobbies, including stamps and coins, filled the enormous space within. Since 1993, Medieval Times has rented the building, where guests can now enjoy a Middle Ages-style banquet while watching knights on horseback joust in mock tournaments.

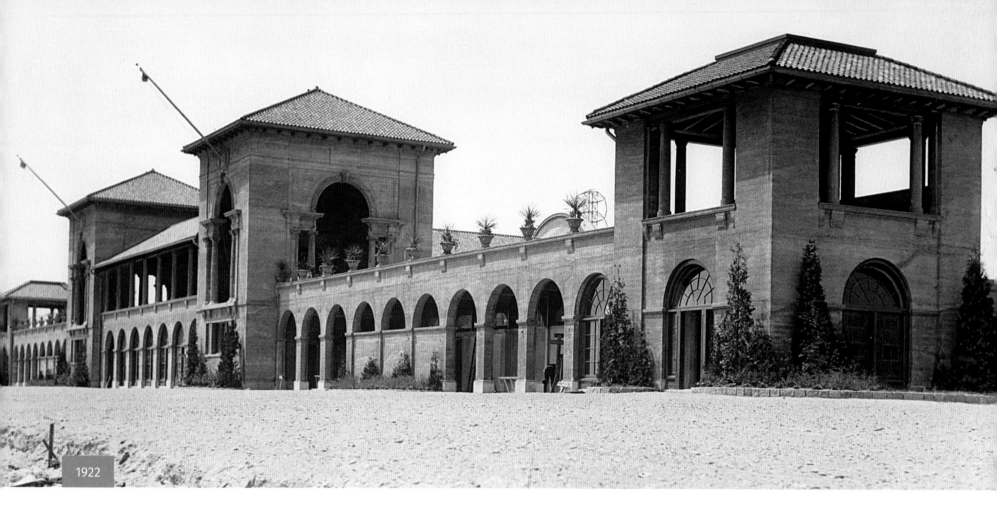

1922

SUNNYSIDE BATHING PAVILION

A rare survivor from "The Poor Man's Riviera"

ABOVE: This photo shows the bathing pavilion at Sunnyside Beach beside Lake Ontario in June 1922, just a few weeks before it opened to the public. The land surrounding the pavilion (shown right) had few trees as it was constructed on landfill. Plans for the public beach and amusement park were approved by the City of Toronto in 1910, and construction commenced in 1913. However, the outbreak of World War I interrupted its progress. It continued again in 1918, dredging sand from the harbour and Humber Bay to use as landfill to create the beach. When Mayor McGuire opened Sunnyside on June 28, 1922, there were seven amusement rides as well as the bathing pavilion and the swimming pool beside it. The bathing pavilion, which cost $300,000, accommodated 7,700 bathers, with a locker for each patron. On its rooftop was a garden that possessed the space for 400 guests. The pavilion's architect was Alfred Chapman. Sunnyside Beach became very popular and was known as "The Poor Man's Riviera."

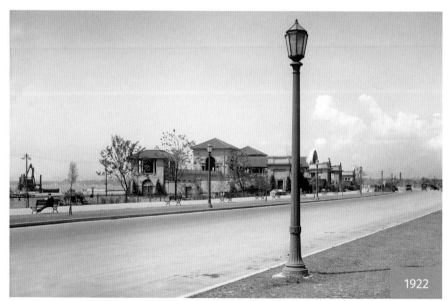

1922

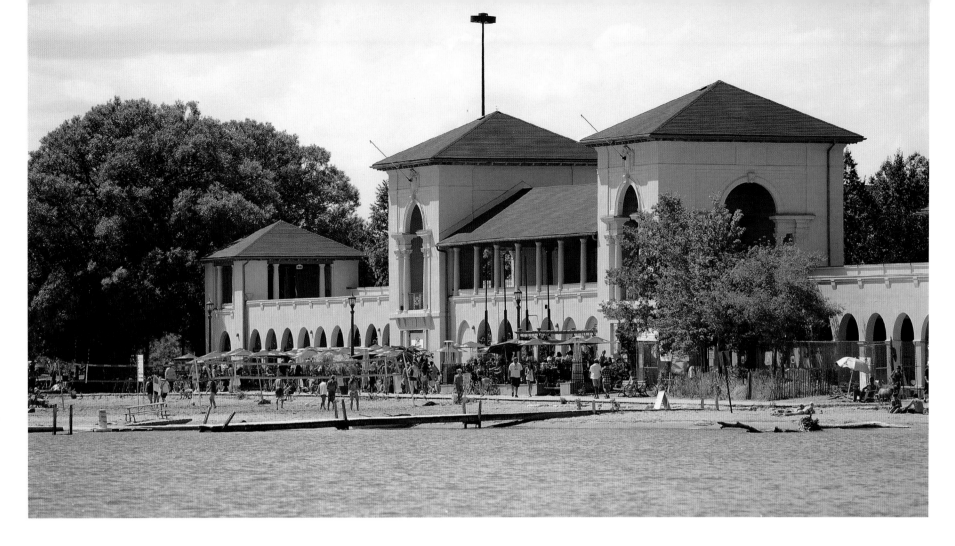

ABOVE: In the 1950s, most of the attractions at Sunnyside were demolished to accommodate the Gardiner Expressway. The bandshell, drug store, food stands, and other buildings, along with the famous rollercoaster nicknamed "The Flyer," disappeared forever. However, the pavilion survived. Its rooftop garden no longer exists, but the Sunnyside Pavilion Café, on its south side, continues to serve food and refreshments beside the lake. A 5.4-kilometre (3.4-mile) breakwall, built a short distance offshore, protects swimmers from the rough waters of Lake Ontario and creates a safe area for canoeing and sailing. In 1975, the Sunnyside pavilion was officially designated a Heritage Site. In the late 1970s, the Olympic-size heated swimming pool, on the east side of the pavilion, was renovated and renamed the Gus Ryder Pool, in honour of Marilyn Bell's swimming coach. In 1954, Marilyn Bell became the first person to swim across Lake Ontario. The swimming pool at Sunnyside reopened in June 1980. Today, the area surrounding the pavilion, which was once landfill, contains many mature trees.

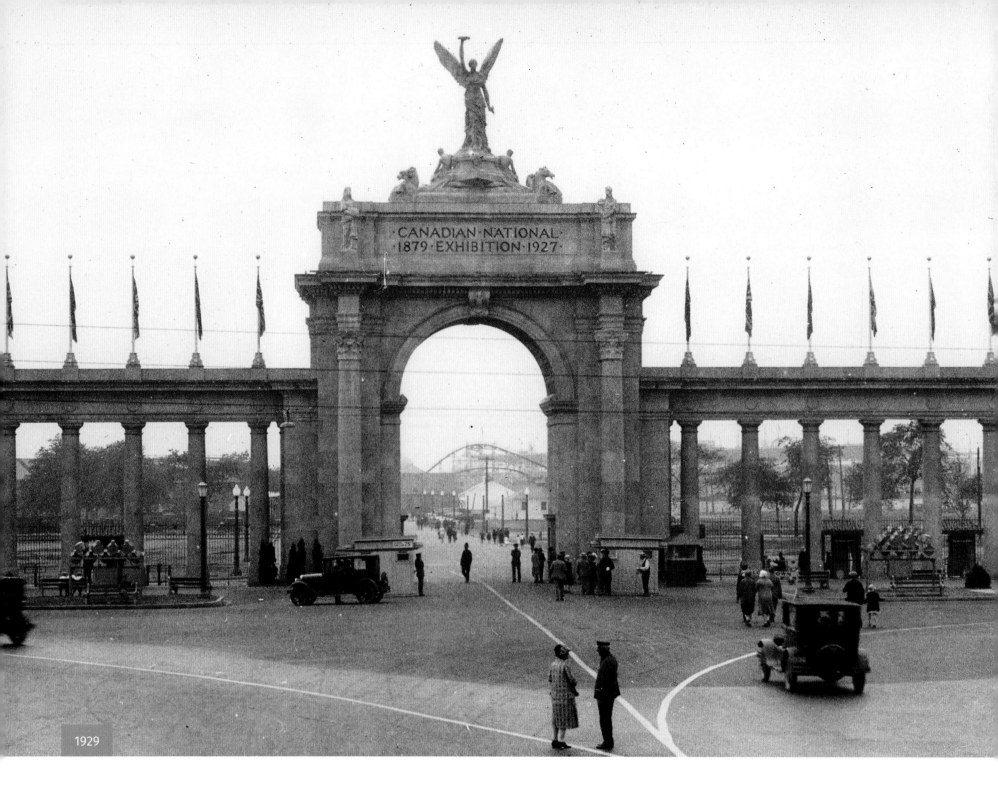

1929

PRINCES' GATES AT THE CANADIAN NATIONAL EXHIBITION
Built to commemorate the Diamond Jubilee of Confederation and the visit of Prince Edward and Prince George

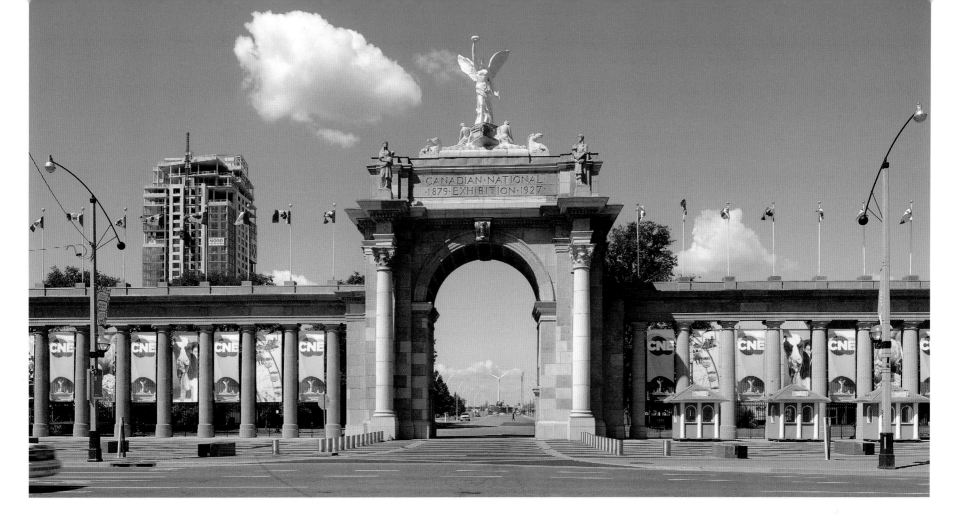

LEFT: This photo depicts the Princes' Gates at the eastern end of the Canadian National Exhibition grounds on August 29, 1929. The concept of building enormous arches, to commemorate milestone events, important personages, or places, originated in ancient Rome. One of the most famous is the Arch of Septimius Severus, constructed in AD 203 to pay homage to the conquests of the Emperor Severus. Rome's triumphal arches provided the inspiration for the Arc de Triomphe in Paris in 1806, Marble Arch in London in 1827, and the Washington Square Arch erected in New York City in 1895. Toronto's arch, containing the Princes' Gates, was built in 1927 to commemorate the Diamond Jubilee of Confederation and the visit of the Prince of Wales, who later became King Edward VIII. His brother, Prince George, Duke of York, who accompanied Edward to Toronto in 1927, was eventually crowned King George VI in 1937, following his brother's abdication.

ABOVE: The eastern entrance to the CNE grounds is today through the Princes' Gates. Originally named the Diamond Jubilee of Confederation Gates, the name was later changed to the Princes' Gates to honour the two young royals who officiated at the opening. The gates were designed by the architectural firm of Chapman and Oxley. Constructed of sculpted stone (cement), the various statues atop the gates were modelled by Charles D. McKenzie. Above the central arch of the gate is the imposing goddess of "Winged Victory," the figure's right hand holding high a hero's crown (shown right), although originally it held a lamp. The left hand grasps a single maple leaf, symbolic of the Canadian nation. At the feet of the figure, on each side, are sea horses amid ocean waves. Rows of pillars, nine on either side of the great archway, represent the nine provinces that were members of Confederation the year the gates opened. Newfoundland, the tenth province, did not join Canada until 1949.

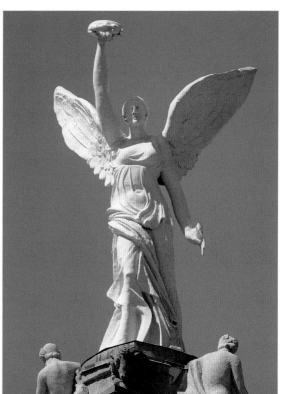

1912

COLBORNE LODGE IN HIGH PARK
The first home in Toronto to have an indoor washroom and bathtub

ABOVE: Much of the land where High Park exists today was owned by John G. Howard, a successful surveyor and engineer. In 1836, he purchased 165 acres to the west of the city and erected a house at the south end of the property. He named it Colborne Lodge after Sir John Colborne (1778–1863), Lieutenant-Governor of Upper Canada (Ontario), who was Howard's benefactor. Colborne Lodge, designed by Howard himself, was to the east of Grenadier Pond, on a hill with a commanding view of Lake Ontario.

The cottage was designed in the Regency style. In their simplest version, Regency-style homes resembled cottages, with large verandas sweeping around their exteriors. In their grandest form, the homes appeared similar to the great mansions of the aristocracy in colonial lands such as India and are often referred to as Romantic Classicism.

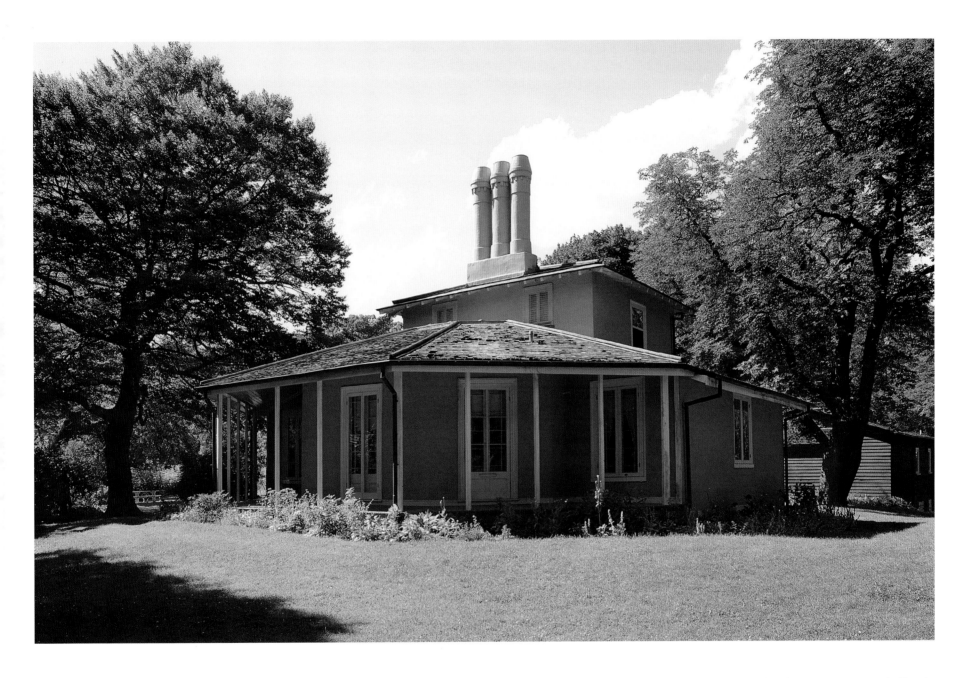

ABOVE: Colborne Lodge is now a museum and is open to the public. Today, it appears cozy and quaint, but in the 19th century, living in the home presented many difficulties, despite its possessing an indoor washroom and bathtub, the first ever installed in Toronto. Since it was a lengthy trip to the markets in the city, the Howards attempted to be self-sufficient, harvesting their own vegetables and fruit trees. They also maintained an herb garden, flower garden, and beehives. In 1873, Howard offered the property to the City of Toronto to create a public park, in exchange for a pension and on condition that he and his wife would be allowed to live in the home for the remainder of their lives. On Howard's death in 1890, ownership of the land and the house reverted to the city. He was buried in the park beside his wife, Jemima.

FAIRMONT ROYAL YORK HOTEL
Once the largest hotel in the British Commonwealth

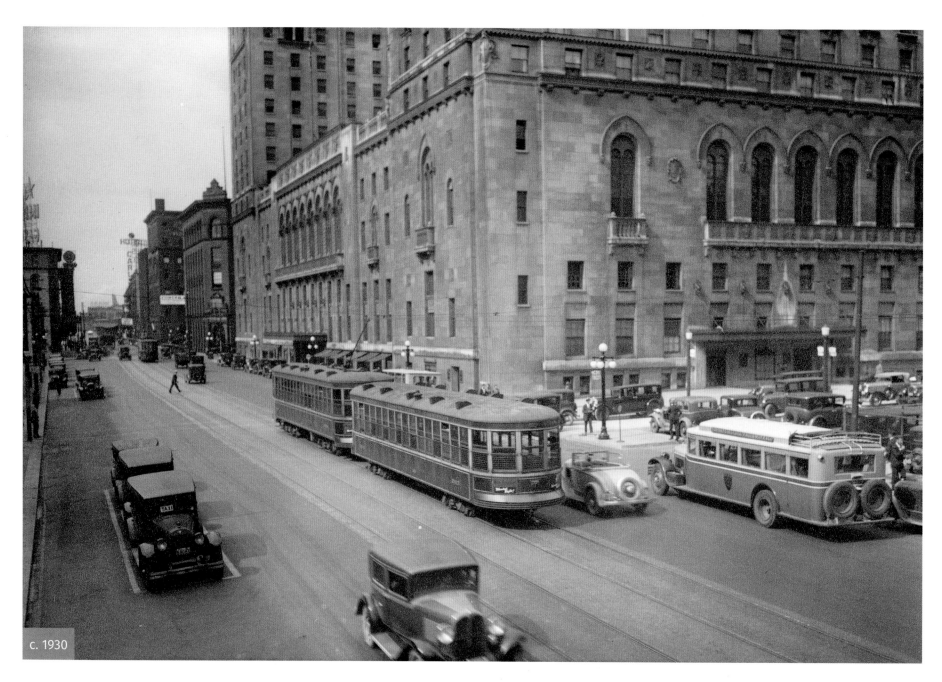

c. 1930

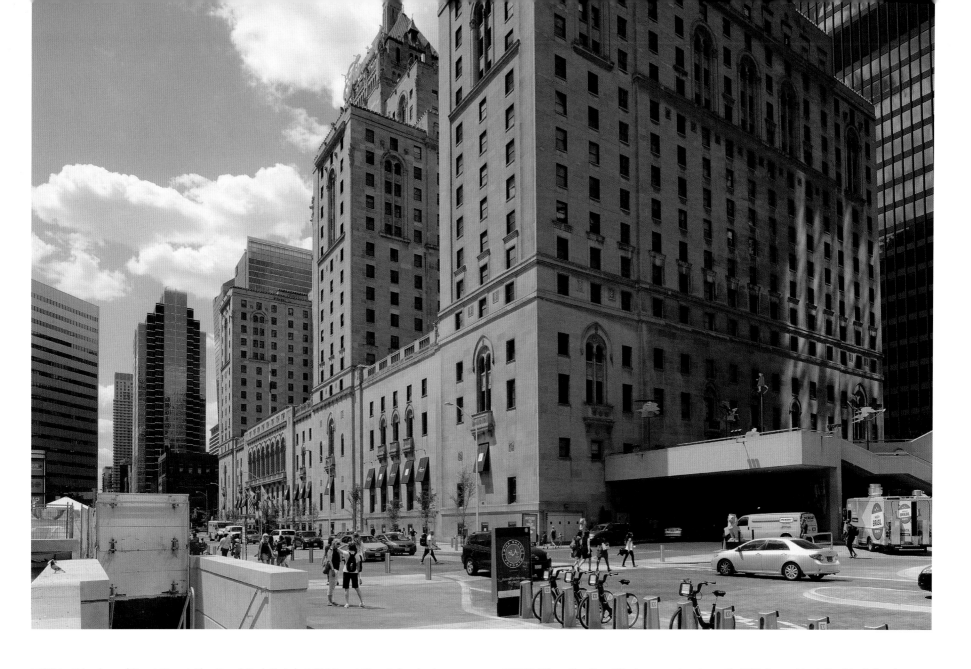

LEFT: In this view of Front Street, the Royal York Hotel at 100 Front Street dominates the scene. The first buildings on the site appeared in 1838, when Captain Dick, a wealthy steamboat captain, constructed four brick townhouses. In 1856, Mr. Sword bought the houses and converted them into a hotel. In 1859, Captain Dick reappeared on the scene, bought the hotel, and renamed it the Queen's. It became the city's most elite hostelry and dining establishment. The future King George V, when he was the Prince of Wales, stayed at the Queen's, as did several American presidents. The closing of the Queen's in 1927 was the end of an era and the beginning of a new one. The Royal York Hotel was built on the site by Canadian Pacific Hotels, a division of the Canadian Pacific Railways. When completed, it was the largest hotel in the British Commonwealth.

ABOVE: When the Royal York opened on June 11, 1929, it was the tallest building in the city. The hotel's architects were Ross and Macdonald, with the firm of Sproat and Rolph. They chose the "Chateau Style," reflecting the latest Art Deco trends of the 1920s. The Royal York possesses a copper roof and touches of the Romanesque in the many arched windows in its podium. The 28-storey building originally had 1,048 rooms, but when an east wing was added in 1958, the number of rooms increased to 1,600. It is situated on one of the most advantageous locations in the city for a hotel, since it is directly across from Union Station and is connected to PATH, an underground maze of pedestrian tunnels, shops and food courts. Canadian Pacific Hotels joined with Fairmont Hotels in 1959, and today the hotel is known as the Fairmont Royal York Hotel. It is a favourite of celebrities and royals when they visit Toronto.

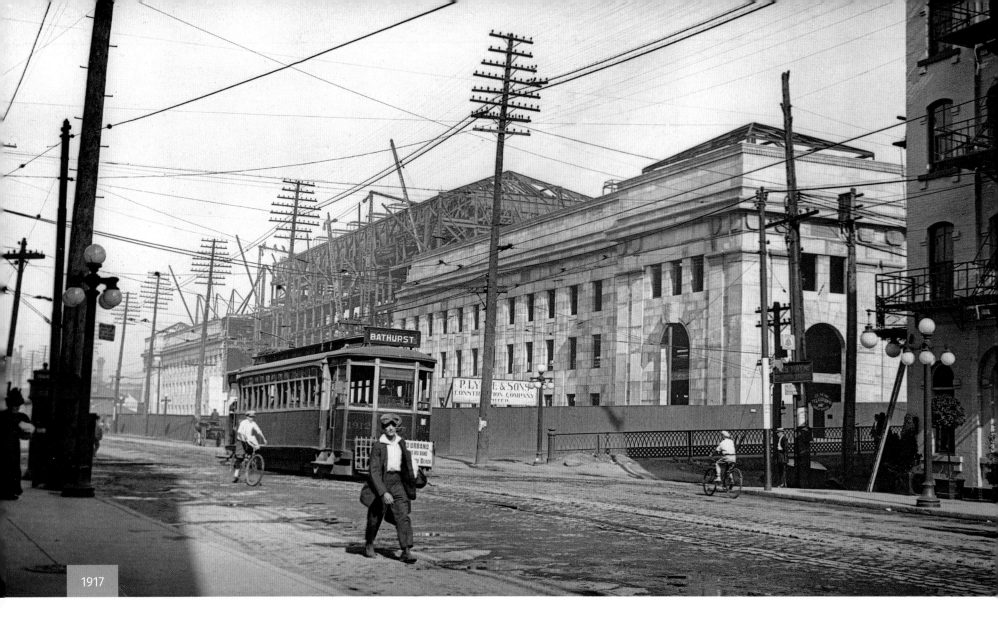

1917

UNION STATION

The Beaux-Arts style station is a City of Toronto National Historic Site

ABOVE: This view shows Front Street in 1917, when construction on Union Station had not been completed. In the early decades of the 20th century, almost everyone entered or departed Toronto by train. As a result, Union Station was considered the main gateway to the city. Toronto's first train station was a mere shed on Front Street. The second station was east of the shed, between Simcoe and York Streets, and the first to be named Union Station. The third was constructed in 1873, on land that was also between York and Simcoe, but a short distance further west. The Union Station of today was officially opened on August 6, 1927, by the Prince of Wales, who later became King Edward VIII. However, the station was not fully operational until January 1930. During World War II, many Canadian soldiers departed for overseas and returned home through Union Station. The photo on the right shows the previous Union Station.

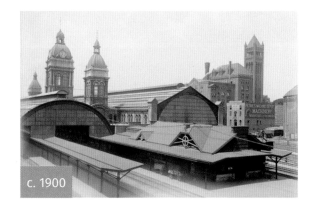

c. 1900

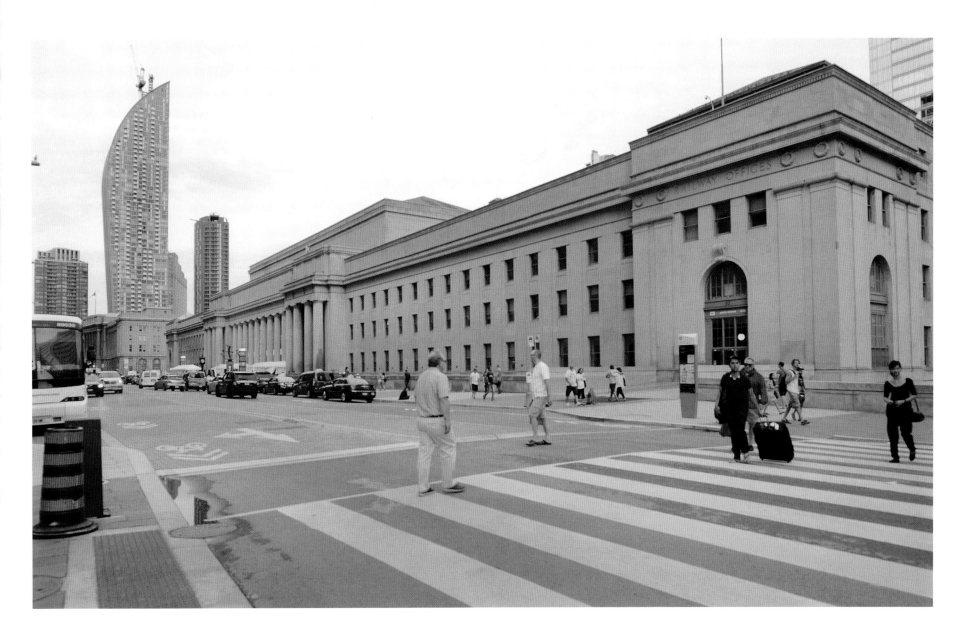

ABOVE: Toronto's present-day Union Station was designed in the Beaux-Arts style by the architects H. G. Jones and J. M. Lyle. Its monumental facade on Front Street contains 22 enormous pillars, 12 metres (40 feet) in height, weighing 75 tons each. The ceiling of the Great Hall soars 27 metres (88 feet) and is faced with glass-like Guastavino tiles whose colours match the walls. The floor of the Great Hall and the stairways leading to the exits and entrances are of Tennessee marble. Though originally built as a rail terminal to serve those who travelled between cities throughout Canada and the United States, it is now used by VIA Rail for its commuting passengers, and is the central hub of the ever-expanding GO Transit system. In 2010, massive renovations commenced to improve the services that the station offers, at a cost of half a billion dollars. It was completed July 2015 in time for the Pan Am Games. It is a designated National Historic Site, owned by the City of Toronto. The tall building on the left is the L Tower, a condominium by the world-famous architect Daniel Libeskind.

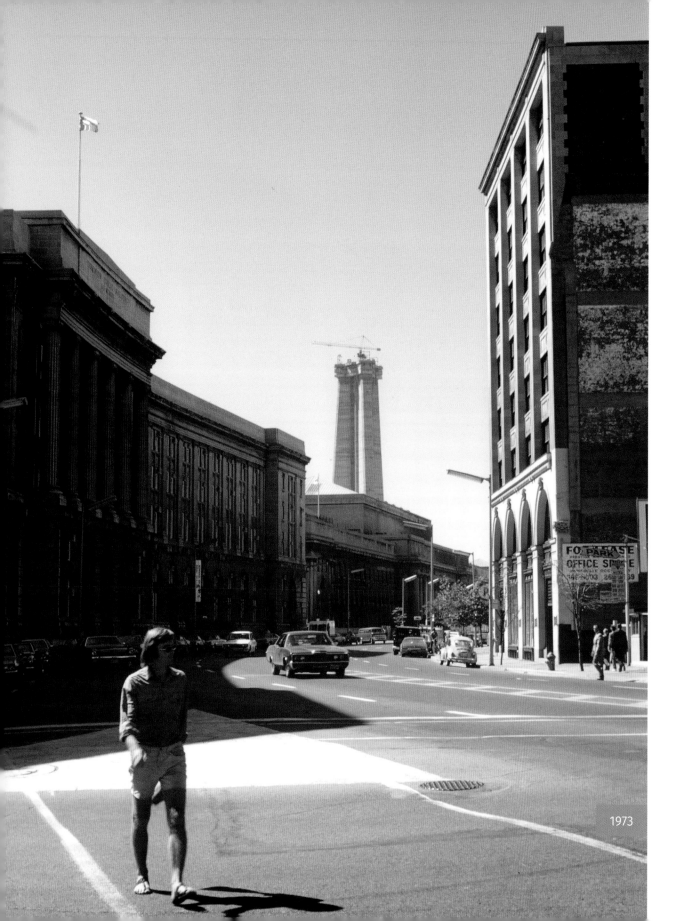

1973

CN TOWER

One of the Seven Wonders of the Modern World

LEFT: In the background of this photo is the incomplete CN Tower. The view looks west on Front Street from near Yonge Street. The tower is included among the sites on Yonge Street as it is so prominently visible from this location. It was in the 1970s that it became apparent that a tower of great height was needed as the city's skyscrapers were interfering with communication signals. Built by CN Railways, its construction began on February 6, 1973. The final sections of the antenna were lifted into place by a Sikorsky helicopter. The tower was finally completed on April 2, 1975, but the structure was not opened to the public until June 26, 1976. Its height is 553 metres (1,815 feet), the equivalent of a 147-storey skyscraper. The shaft is 335 metres (1,100 feet), topped by a seven-storey pod with a revolving restaurant capable of accommodating 400 guests and an observation deck that provides a magnificent 360-degree view.

RIGHT: For 31 years, the CN Tower was the tallest free-standing structure in the world, until the Burj Khalifa Tower in Dubai, at 829 metres (2,720 feet), surpassed it. In 1986, the world's first flight simulator-ride experience opened at the base of the tower, and in 1997 its 9,000-bottle wine cellar, serving the tower's 360 Restaurant, became the highest wine cellar in the world. LED lights were installed in June 2007 to illuminate the tower at night, with colours reflecting the seasons, special events or holidays. On Canada Day, it is bathed in red and white, at Christmas in green, Halloween in orange, and the rainbow colours the week of gay pride. In 2011, Edgewalk was built, a 1.5-metre (5-foot) ledge that encircled the exterior of the pod, allowing intrepid visitors to experience the 360-degree view from outside the structure, while in 2014 a Ripley's Aquarium opened at the base of the tower. The tower was declared one of the Seven Wonders of the Modern World in 1995. The dramatic view in the photo below is not an unusual sight. Due to its height and antenna, lightning usually strikes the tower 70 to 80 times a year.

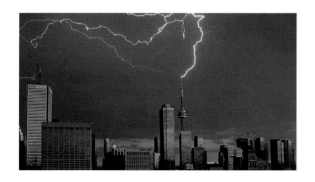

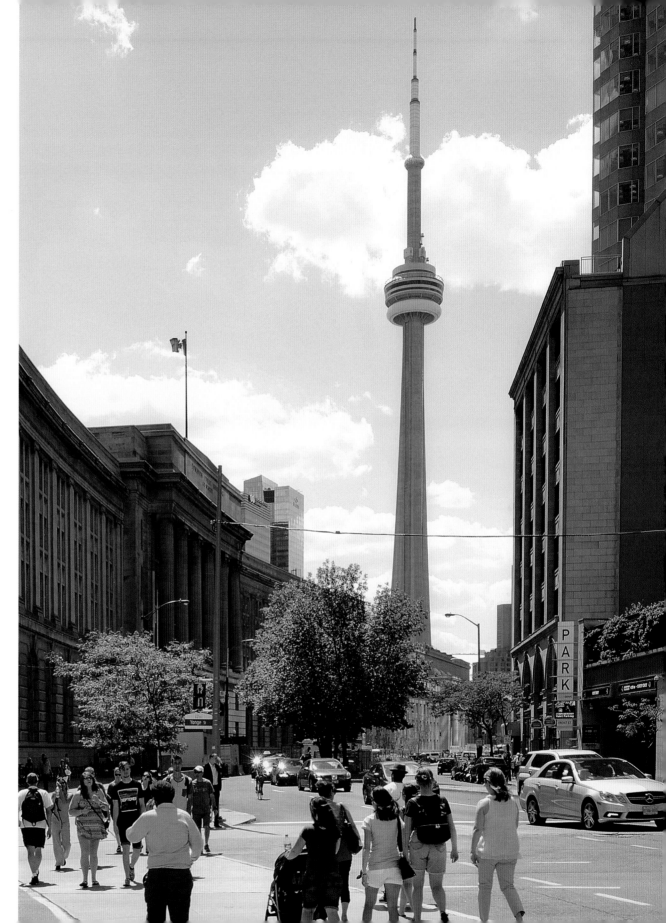

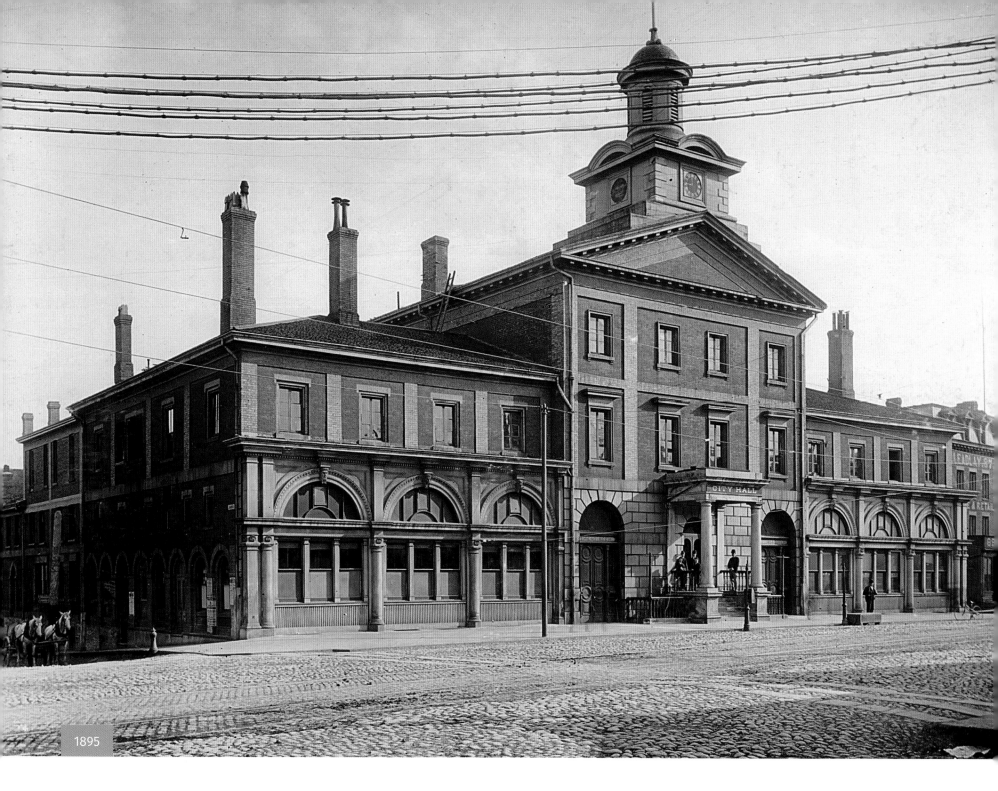

1895

TORONTO'S FIRST CITY HALL / ST. LAWRENCE MARKET

Part of the former structure was incorporated into its replacement

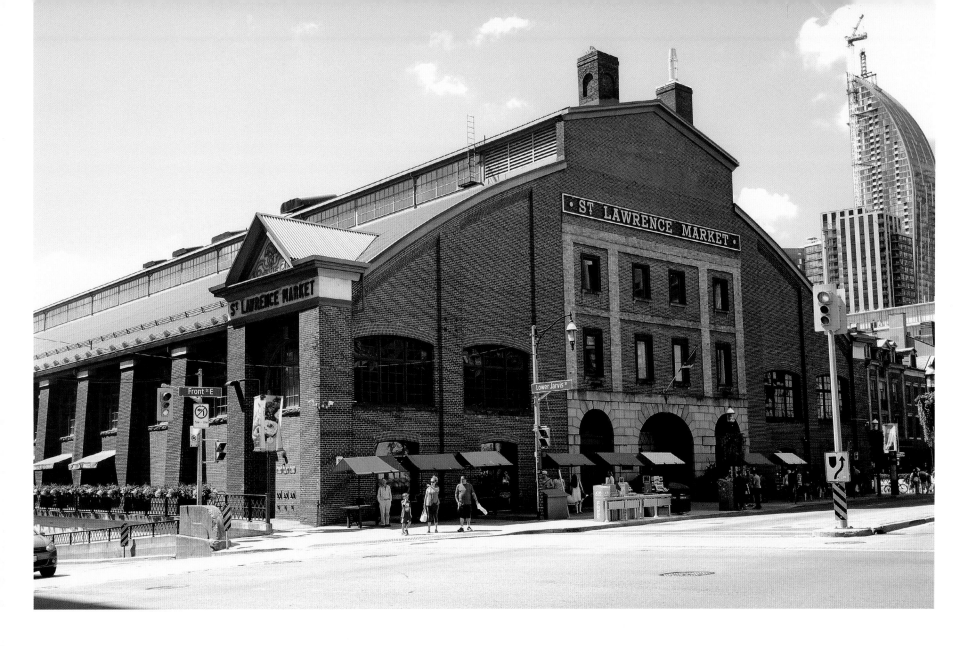

LEFT: This photo is of Toronto's first official City Hall, built in 1845 at Front and Jarvis Streets. In 1834, the town of York was incorporated as a city and renamed Toronto. Because there was no official City Hall, for a decade after its incorporation elected officials met in a red-brick structure on King Street East, at the north end of the original St. Lawrence Market. In 1834, the year the city was incorporated, the population of the city was 9,000, but by 1844 it had increased to 24,000 residents and a permanent City Hall was deemed essential. It was erected on land reclaimed from the lake, south of the Market Square. Designed by Henry Bower Lane, its Georgian brick facade was trimmed with white stone. The building extensions on either side of the centre section contained offices and shops. Above the top floor of the centre block there was an ornate cupola.

ABOVE: The first City Hall was vacated in 1899 when larger premises were constructed at Bay and Queen Streets (today's Old City Hall). In 1901, rather than demolish the first City Hall, the centre portion was incorporated into the new market building, but the portico, cupola, pediment, and the wings on either side of the first City Hall's centre block were demolished. The new structure became known as the South Market of the St. Lawrence Market complex. Shoppers entering the South Market today pass through the white stone arches that were the entrances to Toronto's first City Hall. From inside the market, the south facade of the former structure is visible, although busy shoppers likely do not notice the historic structure as they wander among the crowded aisles. The old council chamber of the first City Hall remains on the second floor, but it now contains the Market Gallery, which opened in March 1979 to display the city's art collection and feature special exhibitions.

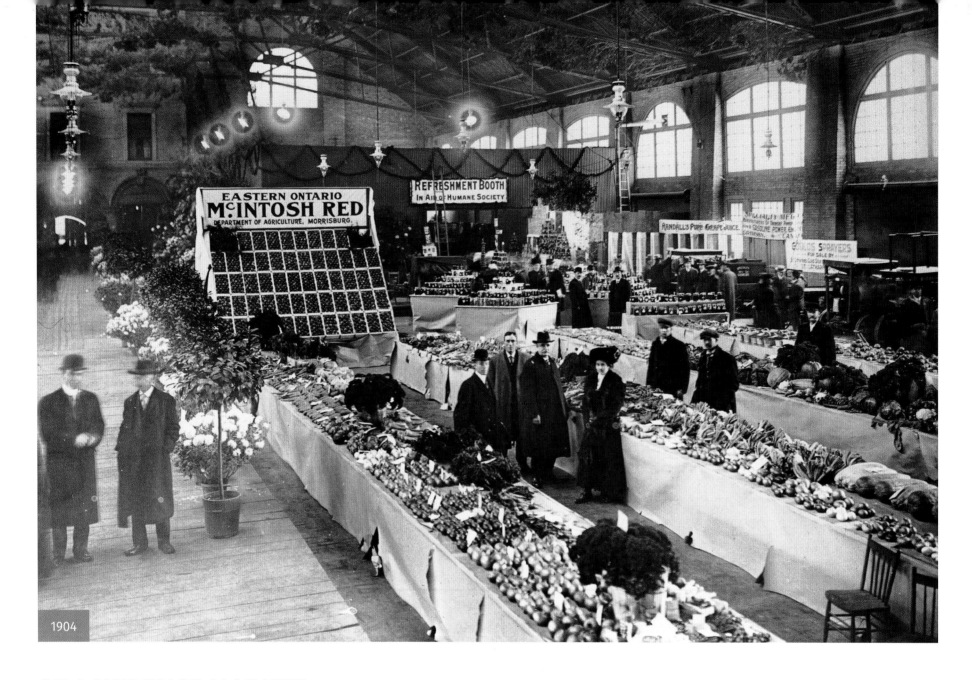

1904

ST. LAWRENCE MARKET

One of the best food markets in the world

ABOVE: This view of a produce display faces the east and north walls of the South Market end of St. Lawrence Market. In 1803, Governor Peter Hunter instructed that a farmers' market be created in the town of York and named the St. Lawrence Market, in honour of the patron saint of Canada. At first, the market square was simply a spacious field with a water pump, where local farmers sold their produce and livestock. On Saturdays, farmers arrived from the neighbouring townships, having departed their farms long before daybreak, travelling by horse and cart along the muddy roads that led to the town of York. About the year 1814, they erected a small wooden shelter at the north end of the square, adjacent to King Street East. In 1820, the sides of the structure were enclosed and in 1831 an impressive quadrangular market complex was constructed, stretching from King Street on the north to Front Street on the south.

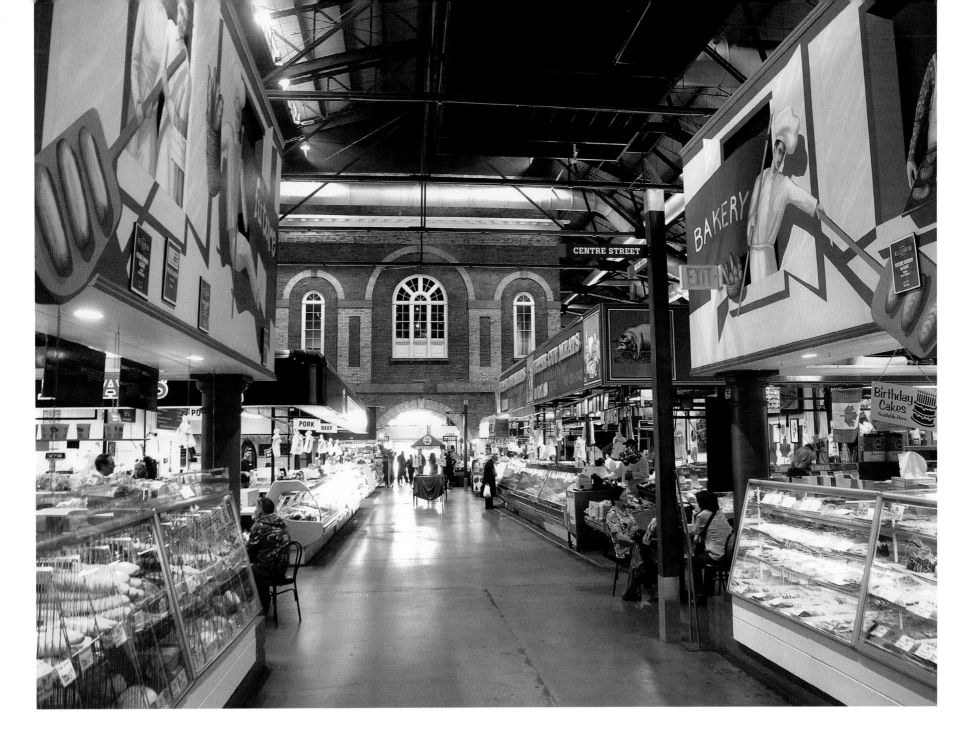

ABOVE: Use of the present-day location of the St. Lawrence Market commenced in 1844, when the market expanded from the north side of Front Street to the south side by employing landfill to push the lake further south. In 1845, Toronto's first permanent City Hall was built on the reclaimed land. After the first City Hall was vacated in 1899, officials commissioned John W. Siddal to design a new market complex, in which he included the centre portion of Toronto's first official City Hall. Completed in 1904, the new building contained an enormous steel truss roof that soared high above the floor below, where the vendors' stalls were located. The large arched windows of the old council chamber remained visible from inside the building and are evident in the background of this photograph. The April 2004 edition of *Food and Wine* magazine rated the St. Lawrence Market among the 25 best markets in the world and in 2012 *National Geographic* named it the best food market in the world.

ST. LAWRENCE HALL

The centre of Toronto's cultural entertainment scene for over 75 years

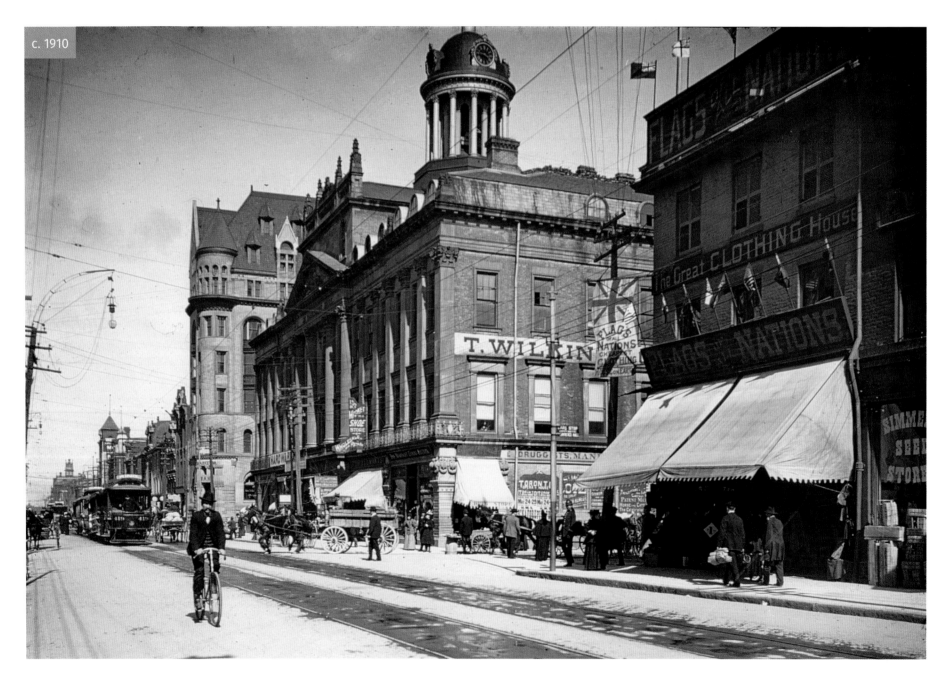

c. 1910

LEFT: This view is of King Street East, from west of St. Lawrence Hall. The magnificent hall was built following a disastrous fire that swept along King Street in 1849, destroying almost 15 acres of stores, offices, and homes. It decimated much of the northern section of the St. Lawrence Market complex, built in 1831. The city voted to rebuild the red-brick building on the market's King Street side. However, they eventually reconsidered and decided to rebuild the entire square. The new plans included a grand concert hall at its north end. William Thomas was hired to design the hall. He was also the architect of St. Michael's Cathedral, the Bishop's Palace, and the Brock Monument at Queenston Heights. However, many consider St. Lawrence Hall, influenced by the Italian Renaissance style, his greatest achievement, as it is one of the finest examples of Victorian classicism in Canada.

BELOW: St. Lawrence Hall on King Street East, which officially opened in 1851, is majestically crowned by a cupola resembling a Roman temple and possessing clocks that face the four points of the compass. The second floor has offices, and the third storey contains a hall with sufficient capacity for 1,000 people. Above the fourth floor is a French Mansard roof, designed to withstand the weight of the heavy snows of a Canadian winter. For over 75 years, St. Lawrence Hall was the centre of Toronto's cultural entertainment scene. It hosted some of the most important personages of the 19th century, including Sir John A. Macdonald and George Brown, the founder of the newspaper that became *The Globe and Mail*. As the population of the city increased and the city's boundaries expanded, the district surrounding St. Lawrence Hall became less desirable. In 1894, when Massey Hall opened on Shuter Street, the cultural activities of the city gravitated to the newer and larger venue.

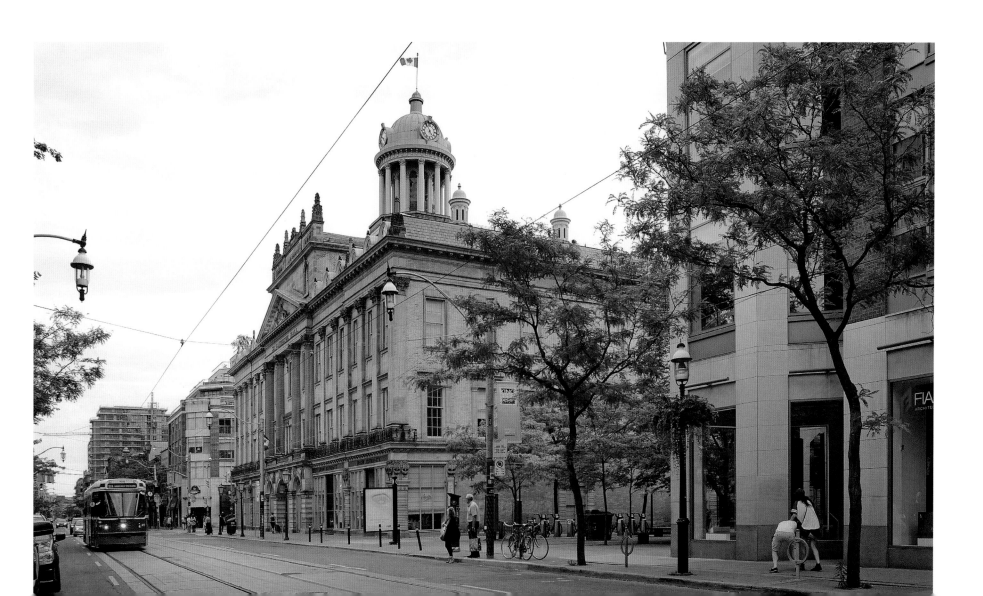

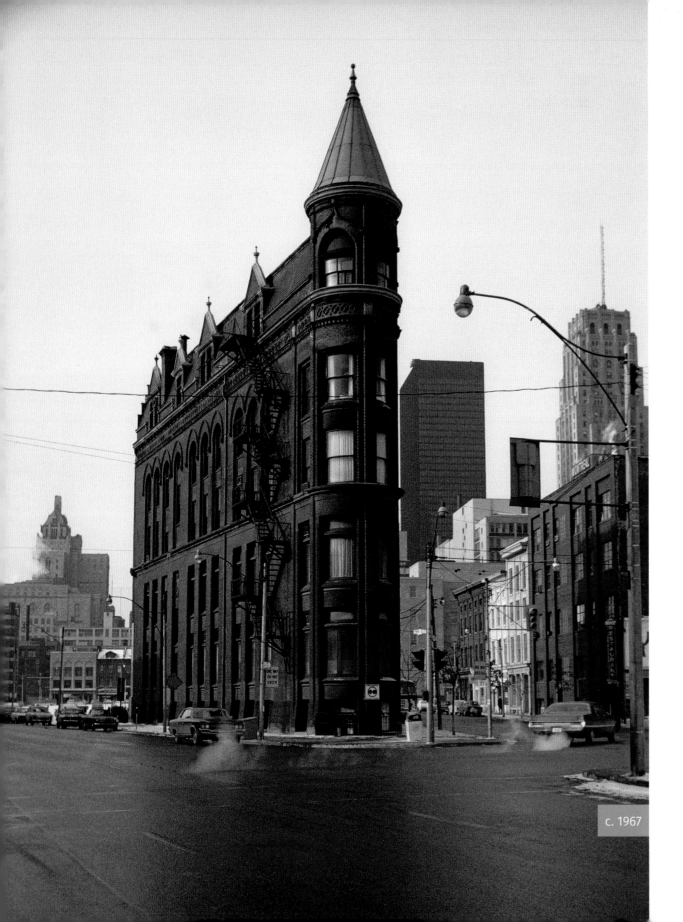

c. 1967

THE GOODERHAM BUILDING

The inspiration for New York City's famous Flatiron Building

LEFT: The original three-storey building (shown below) on this odd-shaped piece of land at Front and Wellington Streets was erected in 1845 as an appendix of the Wellington Hotel, located on nearby Church Street. In the early 1890s, George Gooderham, the eldest son of William Gooderham, purchased the property, ordered the demolition of the building, and hired David Roberts Junior (1845–90) as his architect to design a new headquarters for his company—the Gooderham and Worts Distillery. Costing $18,000, the five-storey building was completed in 1892. In the basement, the windows were partially above ground, creating an extra level. The design of the structure was the inspiration for the famous Flatiron Building in New York City, built in 1902.

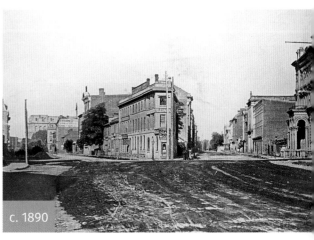

c. 1890

RIGHT: The red-brick Gooderham Building at 49 Wellington Street East is located at the confluence of Wellington Street East, Front Street East, and Church Street, in the St. Lawrence neighbourhood. The surroundings of the Gooderham Building have changed since the 1960s. However, the building still attracts attention because of its unusual shape. It was built on the narrow triangular piece of land that in the past was referred to as the Coffin Block, as its outline resembled a 19th-century coffin. The structure itself was known as the Flatiron Building. Its unusual shape occurred because the streets of the early-day town of York (Toronto) were laid-out on a grid pattern, the straight lines slanted to accommodate the curve of the shoreline of Lake Ontario. The Gooderham Building is Romanesque in design, with traces of Gothic. It was the headquarters of Gooderham and Worts Distillery from 1892 until 1952. In 1975, the building was officially declared a heritage site. It was restored in the 1990s, and is highly coveted as office space. Its rooms, with 3.7-metre (12-foot) ceilings, are ideal for companies that wish to rent space in a historic property. The 53-storey TD Canada Trust Tower, behind and to the left, was completed in 1990.

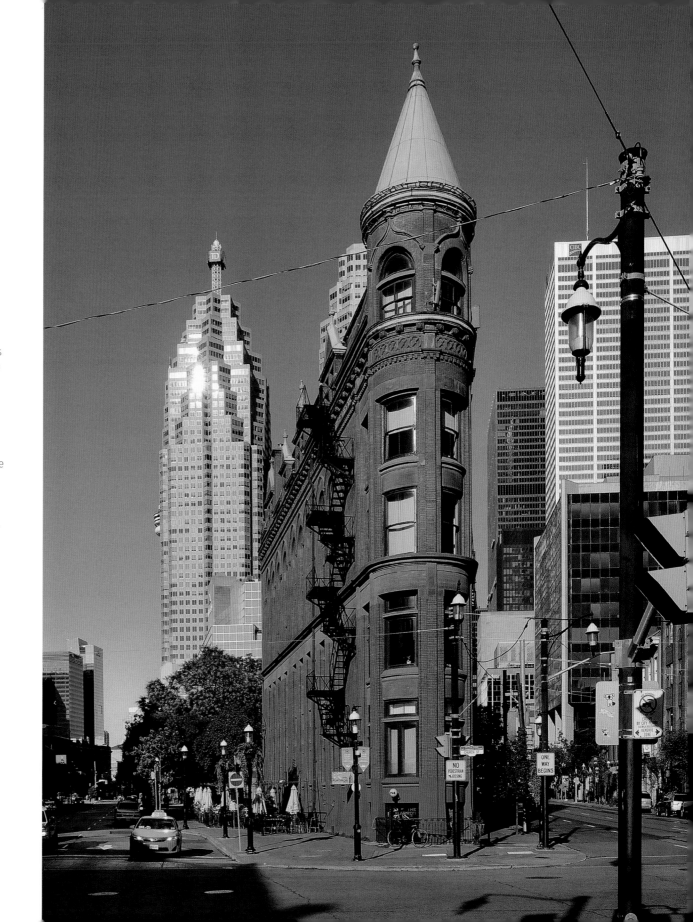

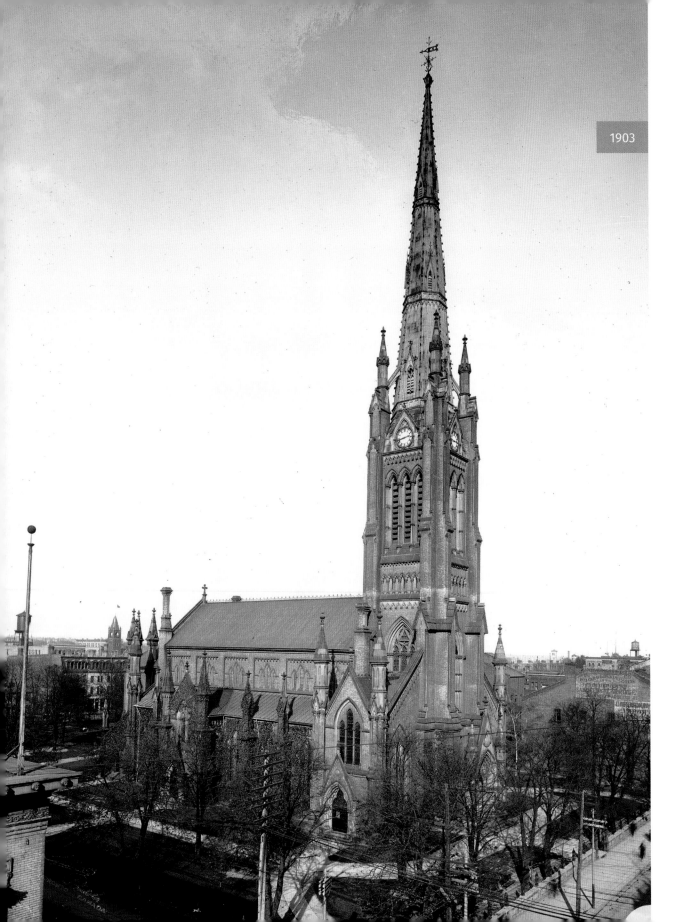

1903

ST. JAMES CATHEDRAL
Home of the oldest congregation in Toronto

LEFT: This photo of St. James Cathedral on the northeast corner of Church and King Streets was taken in 1903, a short distance to the west of St. Lawrence Hall. The previous structure on the site was destroyed by the Great Fire that swept King Street in April 1849. The new church broke with tradition, as it was aligned on a north–south axis. Built in the Gothic Revival style, its architects were William Cumberland and Thomas Ridout. The facades were faced with yellow bricks from the local brickyards and it was trimmed with Ohio stone, quarried near Queenston, Ontario. The interior columns of red granite were from the Bay of Fundy area. Services of consecration were on June 19, 1853. Between the years 1873 and 1874, the spire on the tower and the transepts, designed by Henry Langley, were added. The clock was placed in the tower the following year, a gift from the citizens of Toronto.

RIGHT: The City of Toronto continues to maintain the clock in the tall Gothic tower. To enter the cathedral today is akin to reliving a part of Toronto's early-day history. Dr. John Strachan, Toronto's first Anglican bishop, appointed in 1839, was buried under the chancel in 1867 with a brass plaque placed over his resting place. When the churchyard beside the church was closed in 1844, the bodies were reinterred at the St. James Cemetery on Parliament Street. However, gravestones from the old cemetery were cemented into the walls of the church's entranceway. Included is the stone of John Ridout, who died in the last pistol duel fought in the town of York, on July 12, 1817. In the interior of St. James are many commemorative brass plaques, including one to Sir Casimir Gzowski (1818–98), aide-de-camp to Queen Victoria. It is on the east wall of the nave, and was donated by officers of the Toronto Garrison. In the St. George's Chapel, there are beautifully crafted stained-glass windows. The window shown below was added in 1935 to celebrate the Silver Jubilee of King George V.

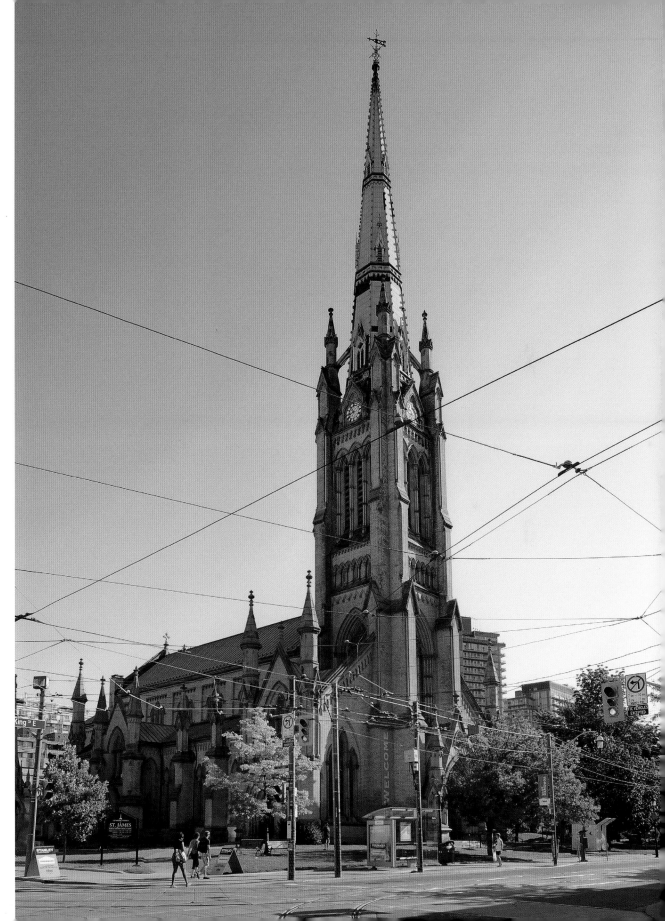

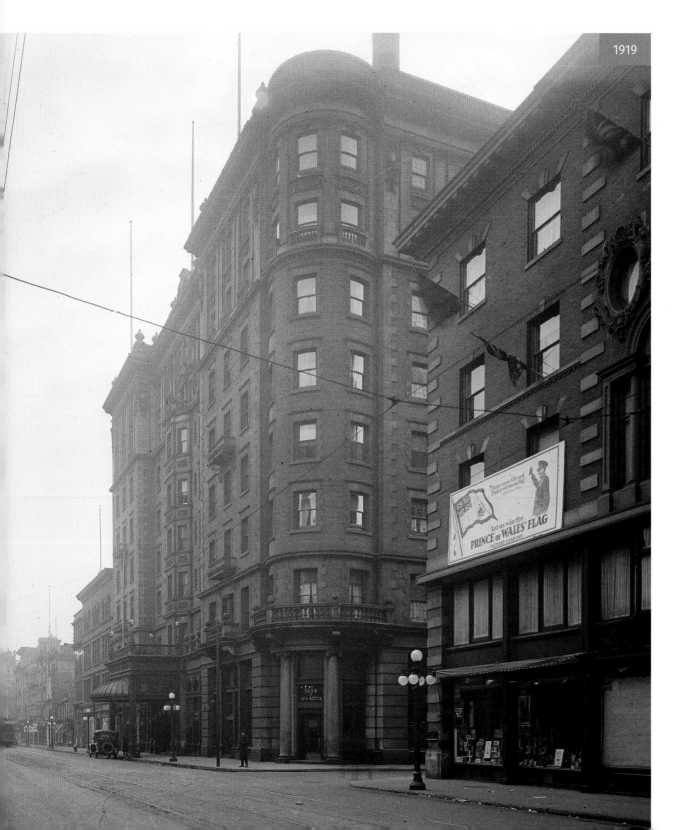

1919

KING EDWARD HOTEL

Guests have included Mark Twain, Elvis Presley, and Ernest Hemingway

LEFT: The King Edward Hotel at 37 King Street East was constructed where the town of York's early-day jail once stood. The first prisoner executed there was John Sullivan, who was hanged on October 11, 1798 for stealing a forged note having a value of one dollar. On the site of the old jail, George Gooderham, a prominent businessman, industrialist, and real estate magnate, built the King Edward Hotel and named it after King Edward VII, whose reign commenced the year construction began on the hotel. It was designed by one of America's leading architects, Henry Ives Cobb, in collaboration with Toronto's architect, E. J. Lennox, the designer of the Old City Hall. The hotel opened in 1903, advertised as "Toronto's first luxury hotel." It was immediately embraced by the elite of the city and remained Toronto's finest hostelry for over six decades. The photo below shows a Toronto Press Club dinner at the hotel on May 3, 1910.

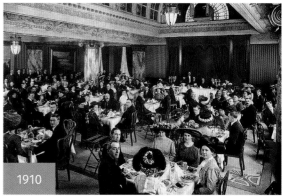

1910

RIGHT: A year after the hotel opened, a disastrous fire swept through downtown Toronto, destroying many buildings. The fire raged for over eight hours, firefighters from Buffalo and Hamilton rushing to Toronto to assist the local brigades. Those that arrived after 5 a.m. were in time for a complimentary breakfast served by the hotel. Between the years 1920 and 1921, on the east side of the hotel, an 18-storey addition was added to the "King Eddy," as it became affectionately known. One of the most popular features in the new addition was the Crystal Ballroom, located on the top floor. By the 1970s, the area surrounding the hotel became less fashionable and it appeared that the hotel might be demolished. However, in 1980–81 the building was renovated and restored to its former glory. In 2009 the hotel acquired new owners and a part of it was renovated to create condominiums. In 2013, it again changed ownership and was renamed the Omni King Edward Hotel.

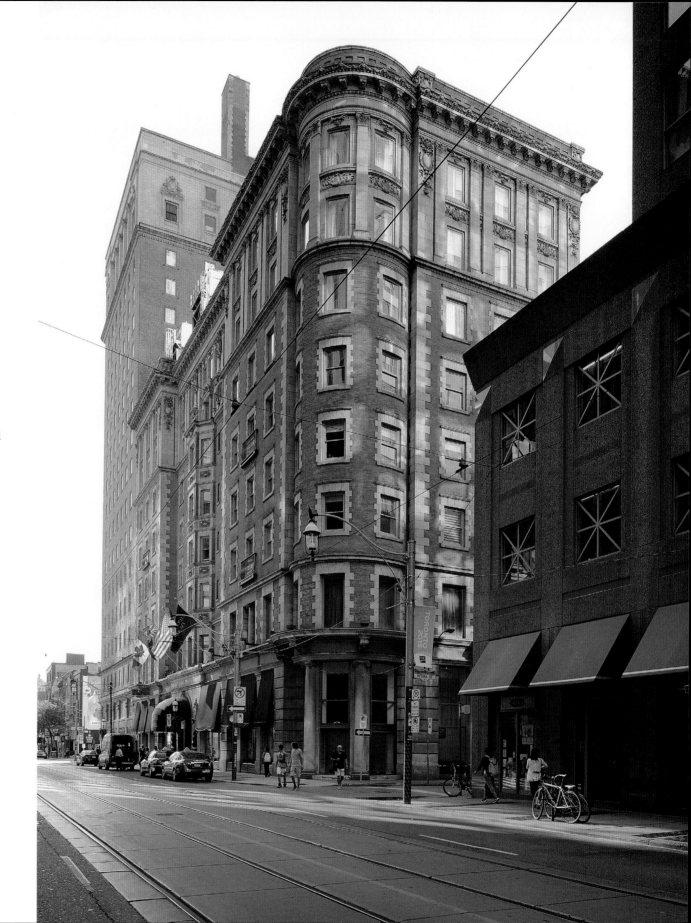

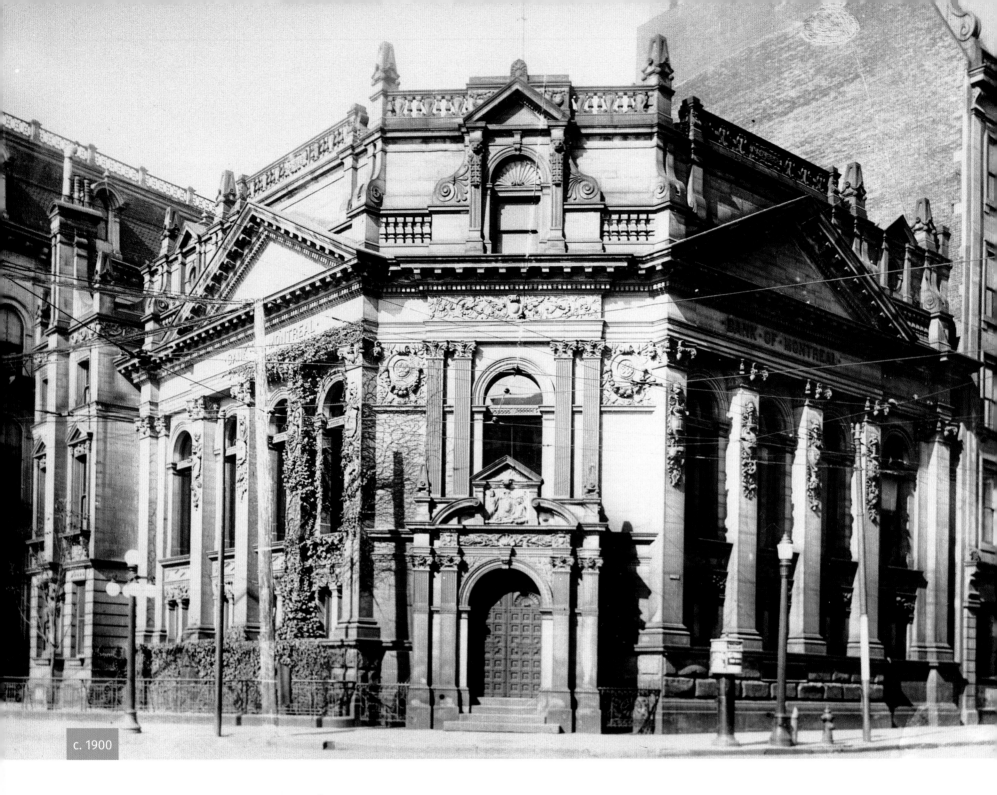

c. 1900

BANK OF MONTREAL / HOCKEY HALL OF FAME
The coveted Stanley Cup is stored safely in the vault

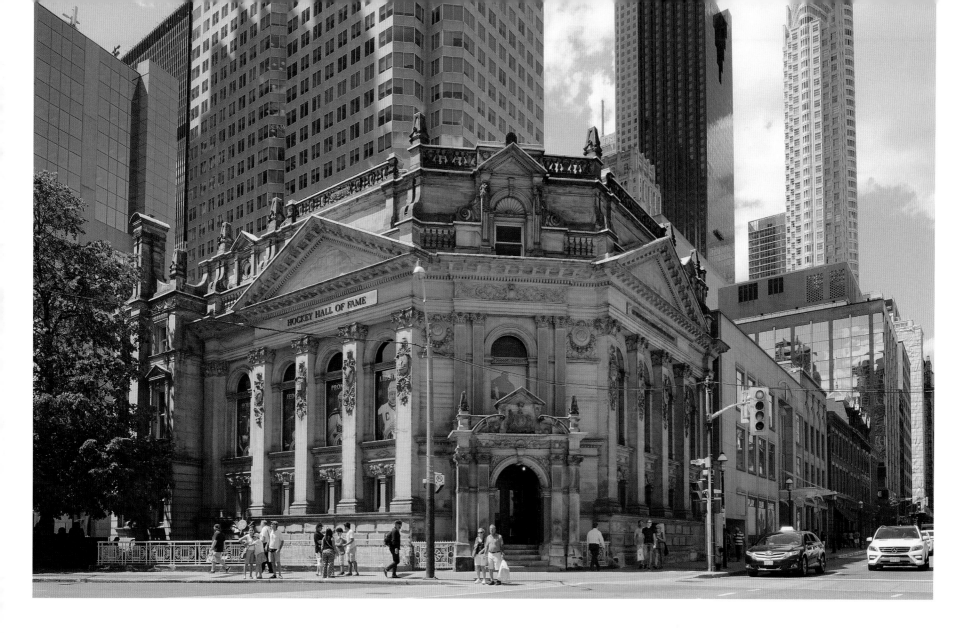

LEFT: The Bank of Montreal at Yonge and Front Streets is one of the most impressive banks ever constructed in Toronto. Built between 1885 and 1886, it was designed by the architects Frank Darling and S. G. Curry, whose offices were located on Leader Lane, located on the east side of the King Edward Hotel. Mr. Darling attracted some of the brightest young architects of the decade to his Toronto firm. The 1880s was a period of great prosperity in Canada, the nation having finally emerged from the economic depression of the previous decade. No place in the country displayed more optimism than Toronto, as its factories boomed and trade increased. The Bank of Montreal at the corner of Yonge and Front Streets reflected this prosperity. Built in the Beaux-Arts style, it is richly ornamented, its facades displaying ostentatious stonework and classical designs.

ABOVE: The former Bank of Montreal is no longer a functioning bank, since today it houses Canada's Hockey Hall of Fame. The large rectangular windows are ideal for the display areas as they flood the interior with natural light. The decorative sculptures on its facades were created by Holbrook and Mollington. The cornice contains dentils, classical designs from ancient Greece, commonly found in many 19th-century structures throughout the western world. When the banking hall was built, it was said to be the finest in the Dominion. Its enormous 14-metre (45-foot) height includes a great dome with stained-glass windows atop it, the structure soaring impressively above the former banking hall. The building remained the head office of the Bank of Montreal until 1949, when larger premises were constructed. However, even after the head office was relocated, it remained its most important branch until the mid-1980s. It was in 1993 that the Hockey Hall of Fame relocated to the building, and the famous Stanley Cup is today stored in its vault room.

BANK OF NOVA SCOTIA AT BAY AND KING STREETS
Delayed by over 20 years, the building's original architect died before its completion

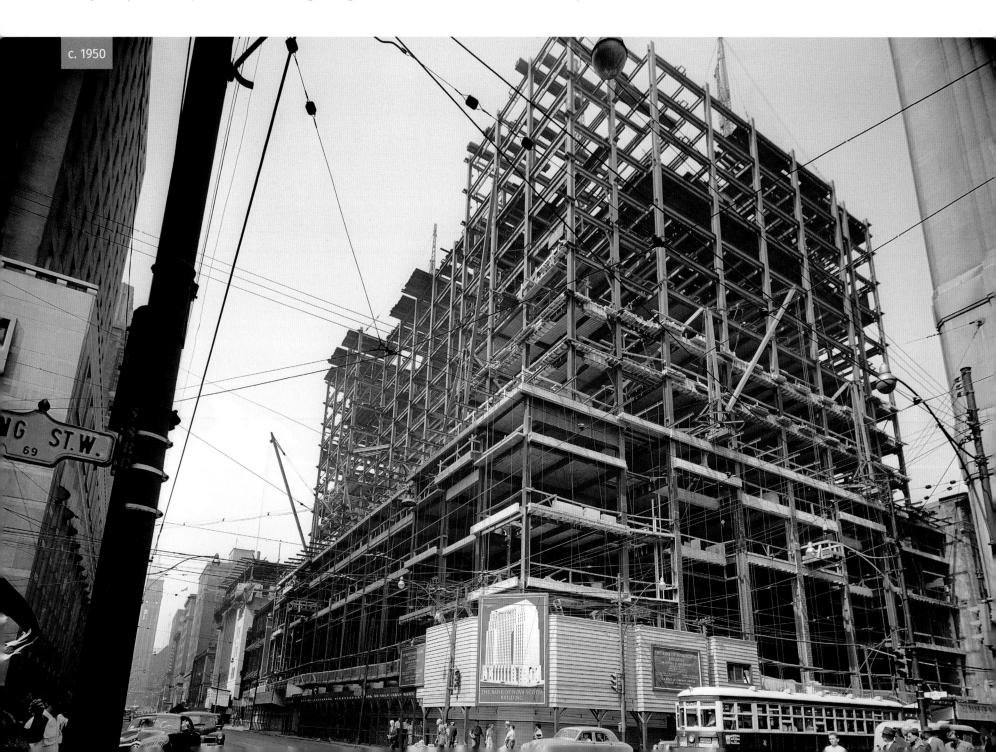

c. 1950

LEFT: This photo shows the impressive headquarters of the Bank of Nova Scotia when it was under construction between 1949 and 1951. The structural steel for the building's podium, and a few of the floors above it, had been completed when this photo was taken, but the structure had not attained its full height. The view gazes north on Bay Street; the Peter Witt streetcar in the foreground is westbound on King Street. These streetcars first appeared in the city in 1921. Located at 44 King Street West, in the photo the bank building is being erected on the northeast corner of Bay and King Streets. Its original architect was John M. Lyle, who also designed Union Station and the Royal Alexandra Theatre, as well as the Runnymede Library in the Bloor West Village. Lyle was a proponent of Art Deco and Beaux-Arts Classicism. Unfortunately, his design for the Bank of Nova Scotia was shelved in 1929 because of the Depression.

RIGHT: In the late-1940s, the plans for the building were revived, but Lyle had died in 1945. The architects Mathers and Haldenby, with Beck and Eadie, were commissioned to redesign the structure. They employed many of the original Art Deco aspects that Lyle had included in his plans of 1929. The cornerstone for the 24-storey bank was laid in 1949. When the 27-storey building had been completed in 1951, its facades contained stylized decorations that employed Canadian themes—flora, fauna, native people's motifs, local industry, and historic events. The building's massive smooth stones and elegant mullioned windows add to its Art Deco appearance. The sculptures on the facades depicting the mythical Neptune and Rhea were carved by Frederick Winkler. The building was designated a heritage site in 1975. Today it is one of the three buildings that form the Scotia Plaza complex, the tallest of them a 68-storey tower built in 1988. The three structures combined have 190,000 square metres (2 million square feet) of office space.

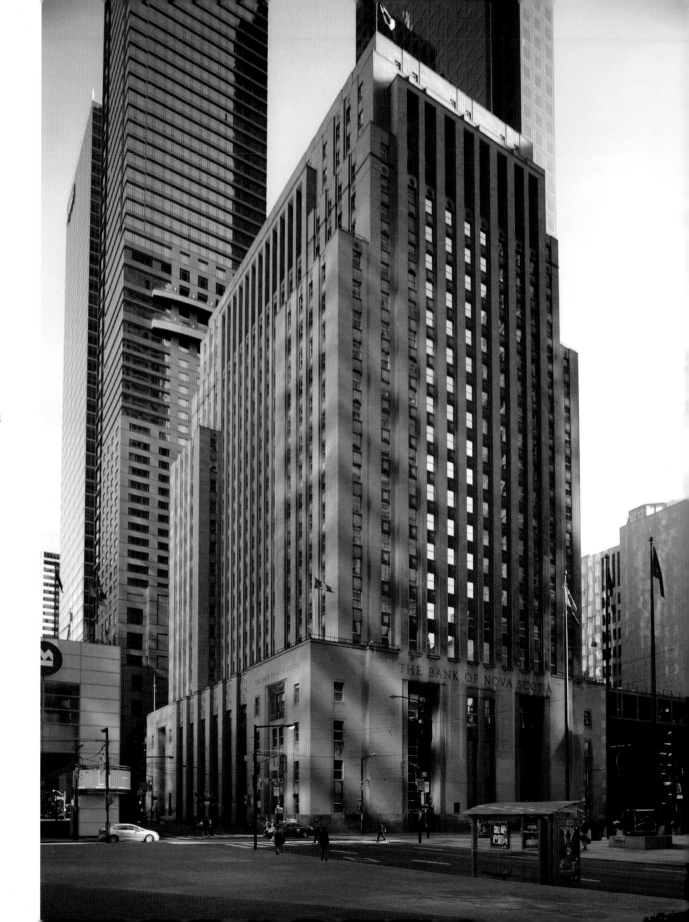

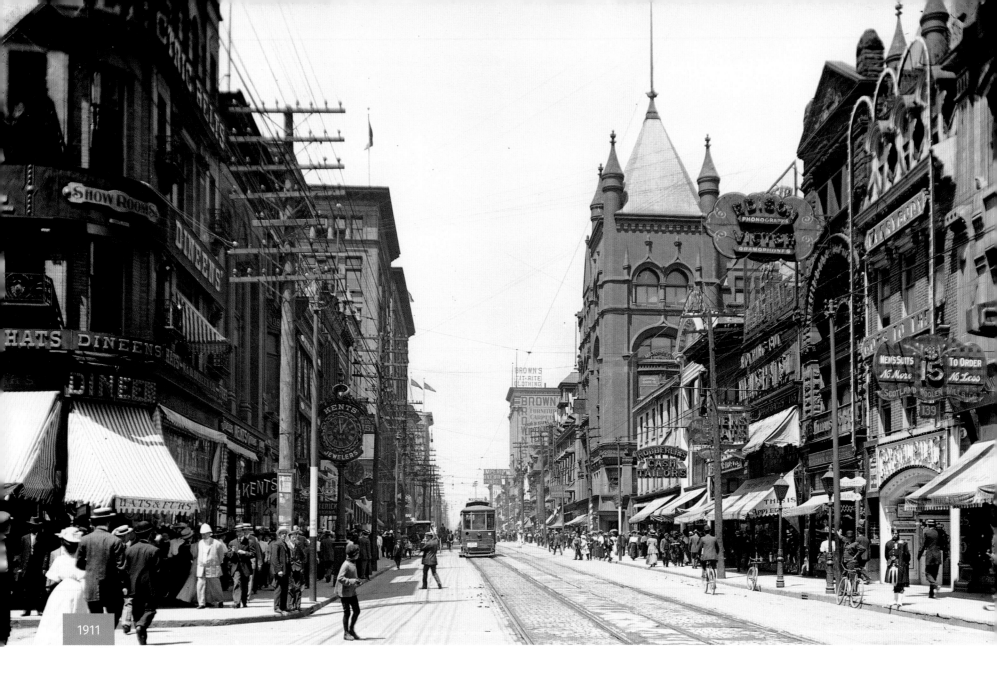

1911

DINEEN BUILDING

A beautifully preserved corner in the heart of the retail district

ABOVE: In this view from 1911, Yonge and Temperance Streets are in the foreground, with Queen Street in the distance, where the streetcar is visible. On the left-hand side of the picture, on the northwest corner of Yonge and Temperance Streets, is the Dineen Building at 140 Yonge Street. On the right-hand side of the photo, the east side of Yonge, is the Confederation Life Building, an impressive Romanesque-style building with a pointed tower. The Dineen Hat and Fur Company relocated to the Yonge Street premises in 1897, the cost of the new building being $30,000. They maintained their showroom on the first floor, and on the upper floors they manufactured hats and fur coats. Large security safes were installed to store the valuable furs. The Dineen Hat and Fur Company rented any space in the building that was in excess of their needs in order to generate further income.

ABOVE AND RIGHT: The Dineen Building was damaged by fire in 1917 and was sold to a commercial real estate group, which repaired it and rented it to various tenants. Despite being designated a Heritage Property in 1973, the building deteriorated and was in need of renovation when Clayton Smith of the Commercial Realty Group purchased it in 2011. During the renovations, which were completed in 2013, a large safe was discovered behind drywall in one of the rooms. It had remained shut for 90 years, and since it was over 100 years old, it could not be reopened without the supervision of the historic authorities. Unfortunately, it contained nothing of value. Today, it is possible to rent space in the Dineen Building on a daily basis or by the hour, whatever a client prefers. There is also a lounge area in the basement that is suitable for conferences and meetings. When the Dineen Building opened in 1897, it was in the heart of the retail district of Toronto, which centred on Queen and Yonge Streets, where the Eaton's and Simpson's department stores were located. Its central location remains an asset today and explains its popularity as a rental site.

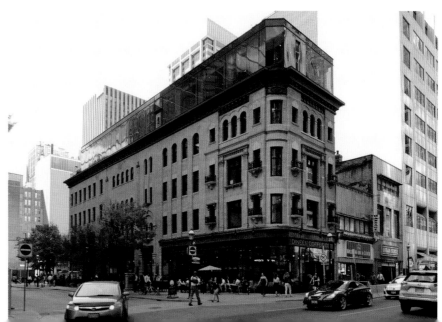

1919

CONFEDERATION LIFE BUILDING

This grand Romanesque Revival building survived a devastating fire in 1981

LEFT: This view is looking west along Richmond Street toward Yonge Street. The Richmond Street facade of the Confederation Life Building is in the foreground on the right-hand (north side) of the street. The south facade of Simpson's (now Hudson's Bay) retail store is visible in the distance. In 1889, the Confederation Life Insurance Company held an architectural contest for designs for their new prestigious office building at 14 Richmond Street East. The firm of Knox, Elliot and Jarvis won the contract. When completed in 1892, the fanciful castle-like building was among the tallest in the city, rising to a height of six storeys, though its massive stone blocks created the impression of a taller structure. Buildings began increasing in height during the last decades of the 19th century due to the invention of elevators in 1853. In its day, Confederation Life was considered the most modern office building in the city. The late 1970s view below shows the green copper roof of the Confederation Life Building with Eaton's department store visible behind.

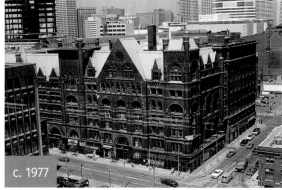

c. 1977

RIGHT: The building remained the headquarters of Confederation Life until 1955. It was declared a Heritage Property in 1975, and was extensively restored in the 1980s. It presently supplies office space for various companies. Today, its textured facades create architectural contrast in the city's downtown core, as there are now so many structures of smooth glass and steel built in the International Style. The building's impressive facade on Richmond Street stretches a full city block, between Yonge and Victoria Streets. Flamboyant in style, with its towers, turrets and ornate archways, it was constructed in the Richardsonian Romanesque style, similar to Toronto's Old City Hall. The sandstone blocks at the base of the building were quarried from the Credit River Valley. They are enormous, as they support the weight of the floors above them. The many carvings on its facades are rich in classical and medieval symbolism. During the years 1898 to 1900, the Confederation Life Building was renovated, and it was altered again in 1908. In 1981, a devastating fire created much damage, but, thankfully, it was restored.

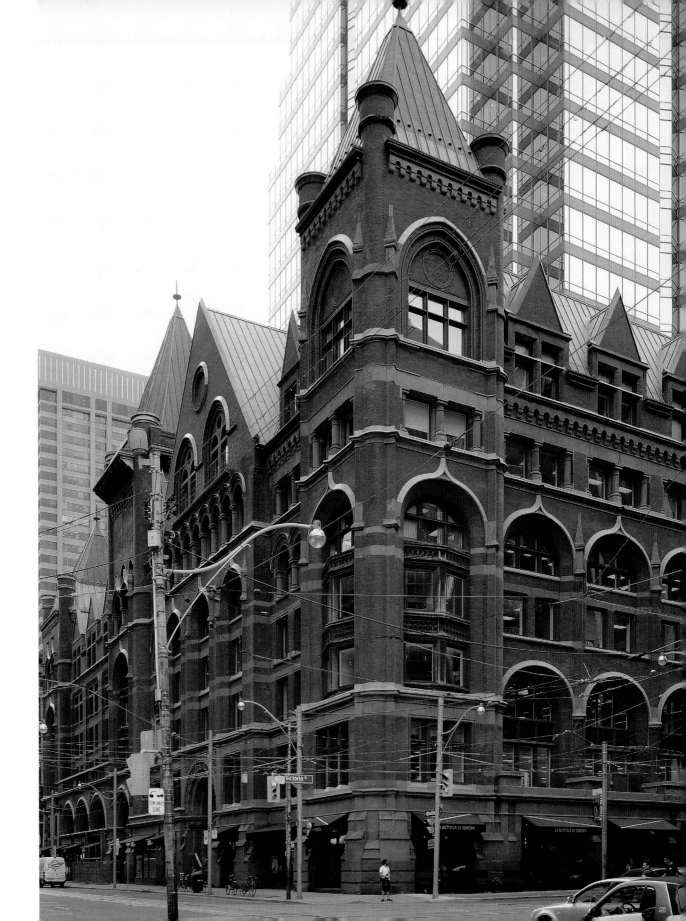

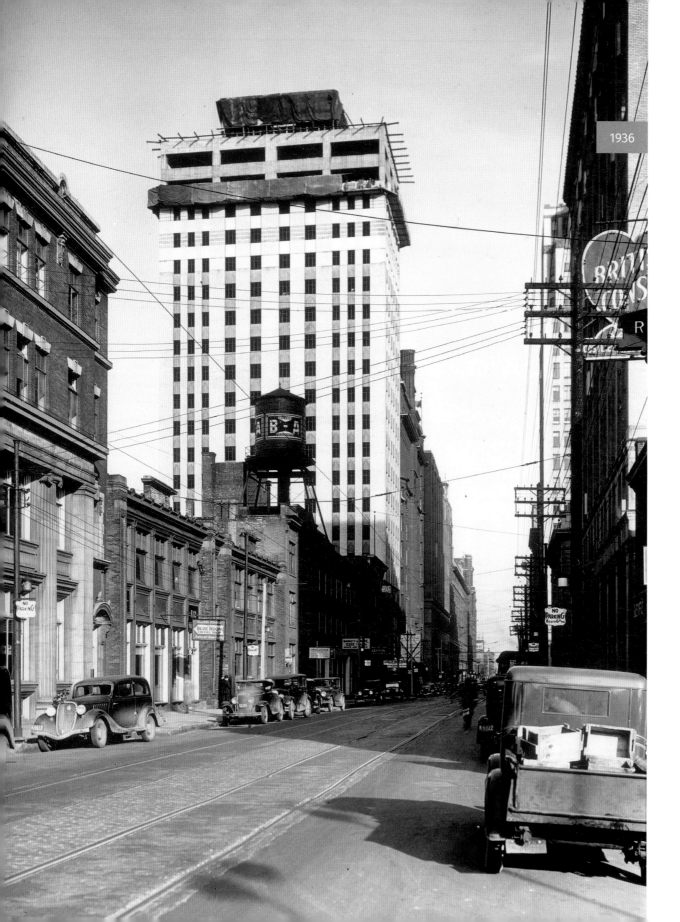

1936

VICTORY BUILDING

Construction was stalled for eight years
following the Stock Market Crash of 1929

LEFT: This photo shows the Victory Building at 80
Richmond Street West, a short distance to the west
of Yonge Street, on November 6, 1936. Erected on the
site of the old Gaiety Theatre, the Victory Building
was designed by the architectural firm of Baldwin and
Greene. Work commenced on the building in May 1929
and continued feverishly through the summer months
and early autumn. However, construction stopped
when the stock market crashed in October of that year.
Originally intended to be 29 stories, building work was
stalled when the bricks had only reached the 18th
floor. It remained in an unfinished state for eight years.
One of the newspapers at the time referred to it as
a "ghost tower." It was finally completed in 1937 and
the first tenants moved in on April 1 of that year. The
businesses that occupied offices in the Victory Building
enjoyed the modern conveniences of year-round air
conditioning and central heating.

RIGHT AND BELOW: When one examines the Art Deco building today, it appears quite modern as it tends to blend with the more recent structures that surround it, especially since its west facade is now entirely hidden from view by other towers. Unfortunately, the original grill work over the doorway of the Victory Building, the creation of Emil Wenger, has been removed. The building, which is still rented as office space, has 20 storeys. On the top of the building there is an extra storey that is smaller, although it is not visible from the ground level as it is recessed. The tall rectangular windows and the column-like spaces between the windows create a strong vertical presentation. No detailing was placed on the cornice, since it was felt that the height of the structure would prevent it from being viewed from below. Above the doorway, on the second floor, there are decorative horizontal rows of bricks, consisting of contrasting colours. They are readily seen by those who enter the building or pass it on the street.

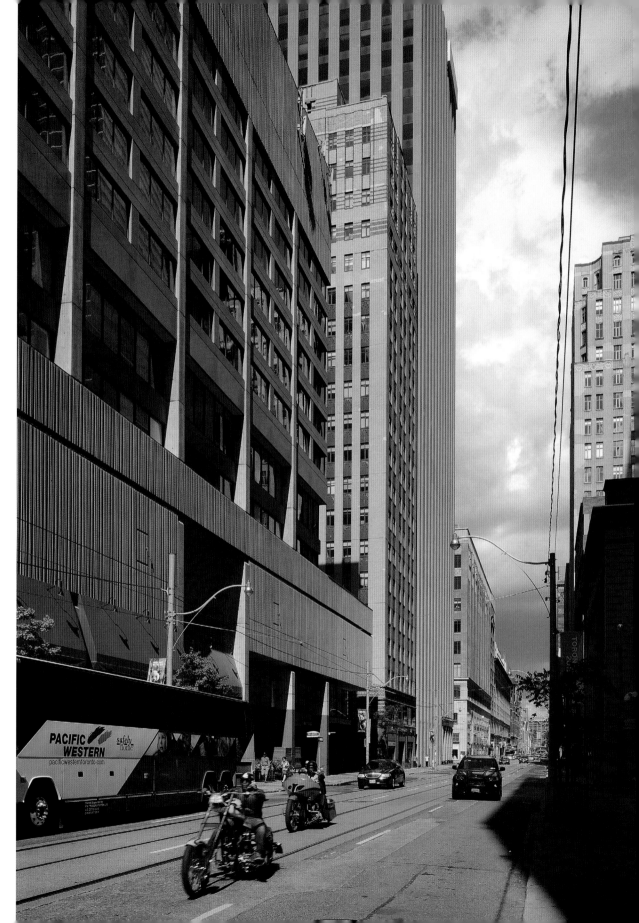

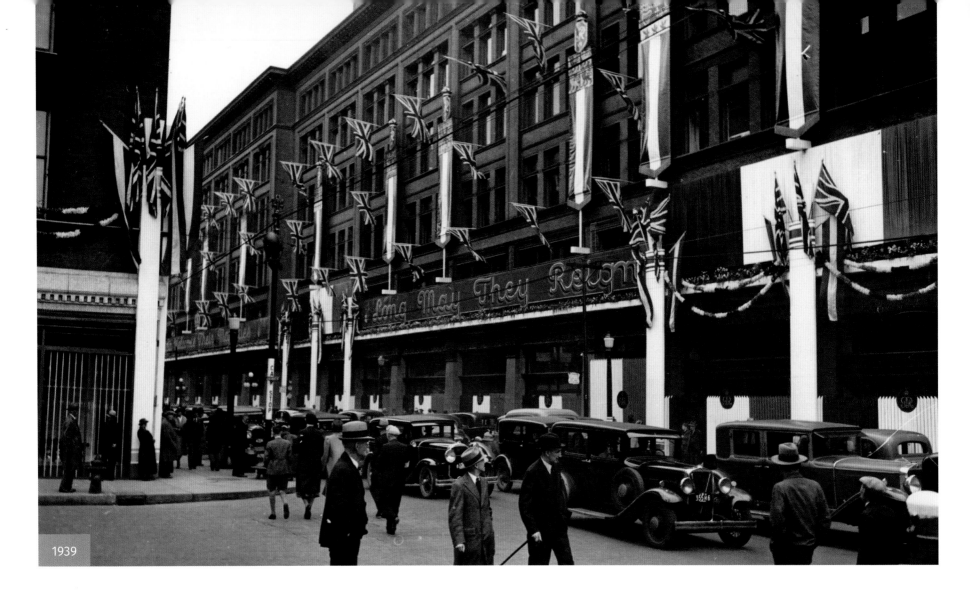

1939

SIMPSON'S / HUDSON'S BAY
A flagship in Canada's largest department store chain

ABOVE: This view is looking east along Queen Street West toward Yonge Street and shows the north facade of the Simpson's Store, decorated for the royal visit of King George VI and Queen Elizabeth in 1939. Robert Simpson, who built the store, was born in Inverness, Scotland in 1834 and immigrated to Canada. In 1872, he opened a dry goods store on Yonge Street, north of Queen. In 1881, he relocated his shop to the southwest corner of Queen and Yonge Streets. Simpson shocked the residents of staid old Toronto by advertising women's corsets in the newspapers and hiring a female clerk in the women's department. Because his business prospered, he decided to engage in another daring new enterprise—the high-rise department store. He hired the firm of Burke and Harwood to design the building and, in 1894, opened his six-storey department store. In less than a year it was destroyed by fire. The store was rebuilt on the same site within a year of the fire. The photo on the right, taken on Richmond Street West, shows horse-drawn wagons being loaded for the day's deliveries.

1913

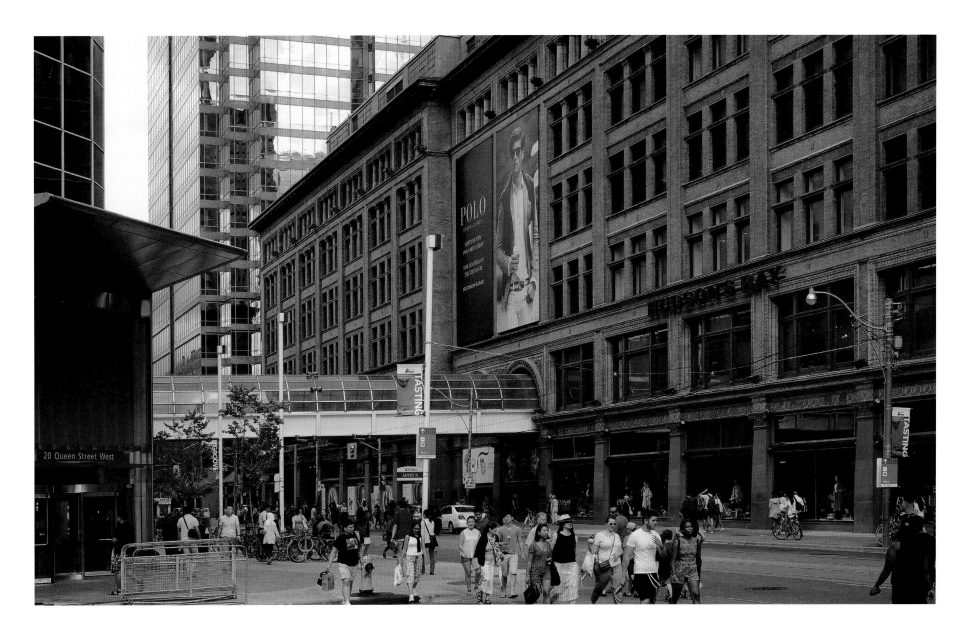

ABOVE: Simpson's continued to build and expand, with a nine-storey addition added to the Queen Street side (to the west of the original building) in 1907–8. In 1912, another wing was constructed facing Yonge Street, extending the store south to Richmond Street. Simpson's was now the largest retail store in Canada. It was expanded further west along Queen Street in 1923 and by 1928 all the various facades were unified to create a harmonized appearance. In 1928–29, at Bay and Richmond Streets, an Art Deco building was added to the complex, which included the Arcadian Court Restaurant. The store continued to grow in the 1970s. In 1971, at the corner of Bay and Queen, a glass tower was added and in the late 1970s a glass-covered bridge was built connecting the store to the Eaton Centre (left). The Hudson's Bay Company bought the store in 1978, but did not operate it under its own name until 1991, when it became The Bay. Hudson's Bay, as it is formally known, is presently American-owned and managed.

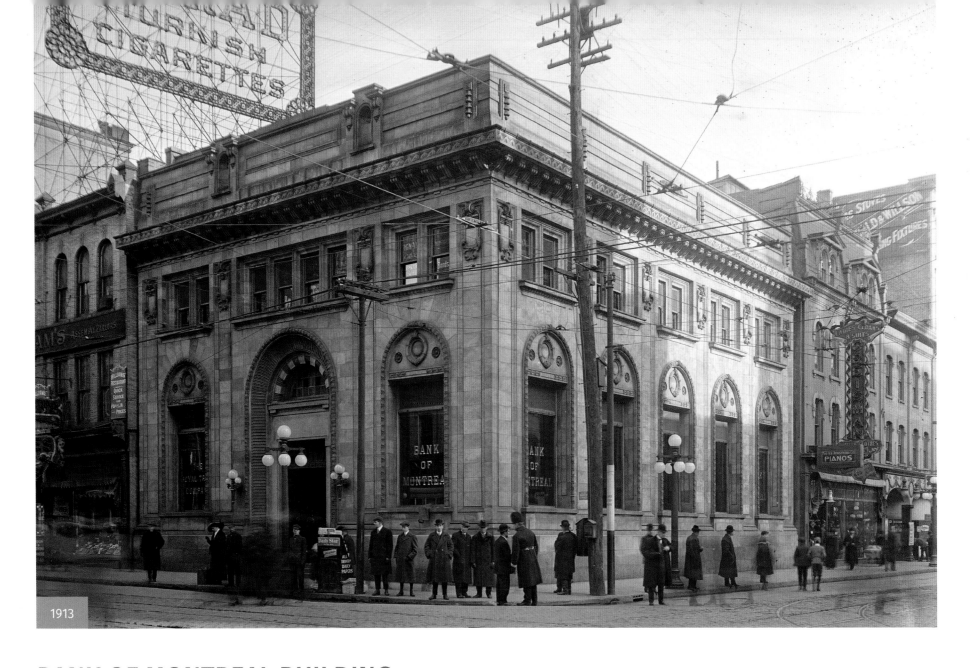

1913

BANK OF MONTREAL BUILDING

An architectural gem at the corner of Yonge and Queen Streets

ABOVE: This photo of the former Bank of Montreal at 173 Yonge Street was taken on December 30, 1913. The bank was located at Queen East and Yonge Streets, sharing the important commercial intersection with Toronto's two largest retailers—Eaton's and Simpson's. The stately Edwardian structure was built in 1910, designed by the architects Frank Darling and John Pearson. They chose the Italianate Renaissance style, containing a myriad of classical detailing. The west and south facades were clad with terracotta tiles that imitated carved stone, supplied by Doulton and

Company. The tiles around the windows and doorway on the Yonge Street facade were richly ornamented with garlands, leaves and wreaths. The building was designed with a heavy cornice, with large modillions (brackets) beneath it. The ornate classical designs of the exterior were continued inside the banking hall, where marble trim and intricate plaster mouldings added to the impressive space.

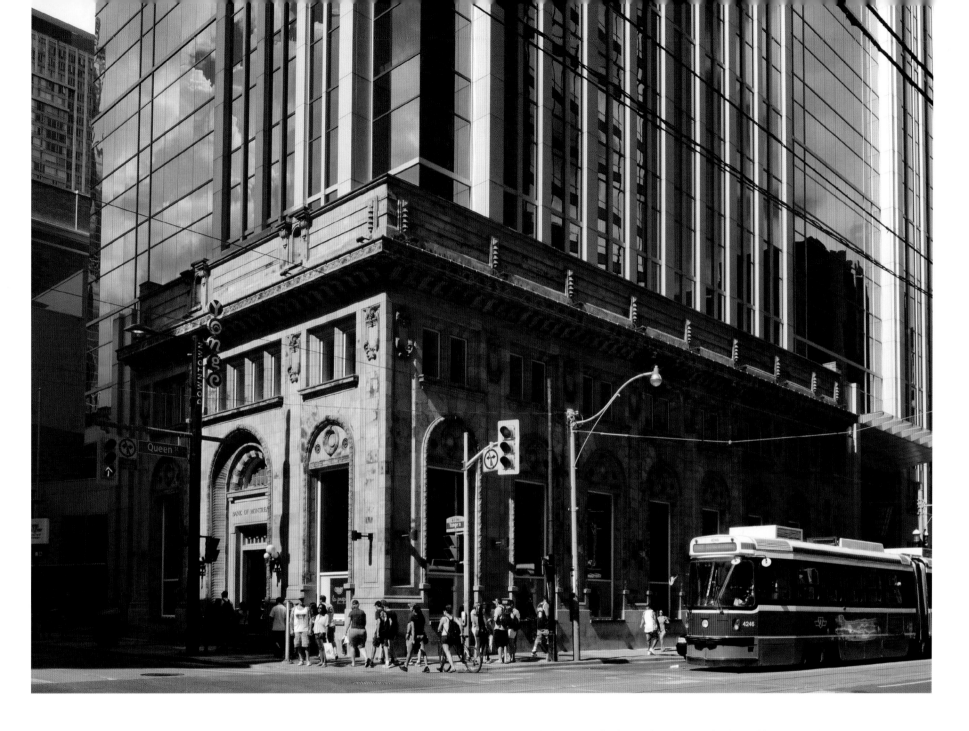

ABOVE: At the beginning of the 21st century, rather than demolish the former bank, its facades were restored and its interior renovated to serve the needs of the modern era. Thus, the ornate trim and classical designs on the building's exterior were preserved and the banking hall was converted into an entrance to Queen Street subway station on the Yonge–University line. A café was included where customers were able to relax amid the well-crafted ornamentations of the former banking institution. The banking hall's support-beams in the ceiling were faithfully restored; they contain decorative plaster displays of flowers, fruits, and ornamental leaves. Because of the building's excellent location, an office tower of glass and steel was constructed on top of the old bank to create a more profitable use of the site. Despite the changes that the many decades have imposed, the bank building remains an important architectural feature of the intersection and dominates the scene, despite the glass structure that towers over it.

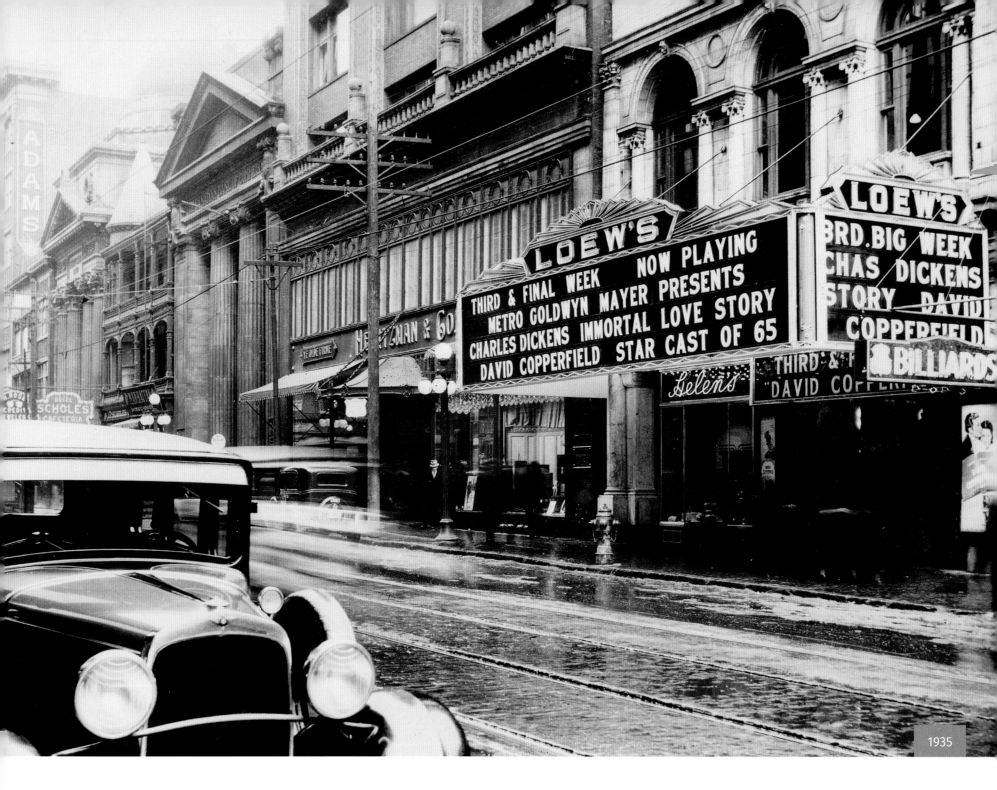

1935

LOEW'S YONGE STREET THEATRE / ELGIN THEATRE & WINTER GARDEN

This gloriously restored "double-decker" theatre has been entertaining audiences since 1913

LEFT: Loew's Yonge Street Theatre opened on December 15, 1913, and was named after Marcus Loew, the American financier who built it. Many celebrities from New York attended its inauguration, including Irving Berlin. The long hallway that led to the auditorium resembled a European palace, while the auditorium itself possessed rich wall fabrics, faux marble columns, and gilded plaster trim. Its architect was Thomas Lamb of New York, who also designed a second theatre on the same site, located above Loew's Yonge Street. It was named the Winter Garden, and it opened on February 16, 1914, its decor resembling a roof-top garden. On the ceiling were real beech leaves and cotton blooms, dipped in preservatives. It offered only one show per evening. All seats were reserved and were more expensive than in the downstairs theatre, which each day featured several shows with eight to ten vaudeville acts.

RIGHT: Because of the decline of vaudeville, the Winter Garden closed in 1928. However, the ground-floor theatre remained open and was eventually renovated to screen films. The Toronto premiere of *Gone With the Wind* (1939) was in the theatre, which by then had been renamed Loew's Downtown. In 1978, its name was changed to the Elgin and it screened third-rate movies, from noon until midnight. When the theatre declined, it commenced screening soft-corn porn and was eventually in danger of being demolished. Fortunately, it was purchased by the Ontario Heritage Foundation. The restorations of the theatres began in 1987, under the supervision of Mendel Sprachman. The Winter Garden was reasonably well preserved as its heating system had never been closed off. The facade on Yonge Street had been altered through the years but it was returned to its original appearance, as was the "bird-cage" box office. On December 15, 1989, the theatres were reopened, appearing as glorious as during the early years of the 20th century.

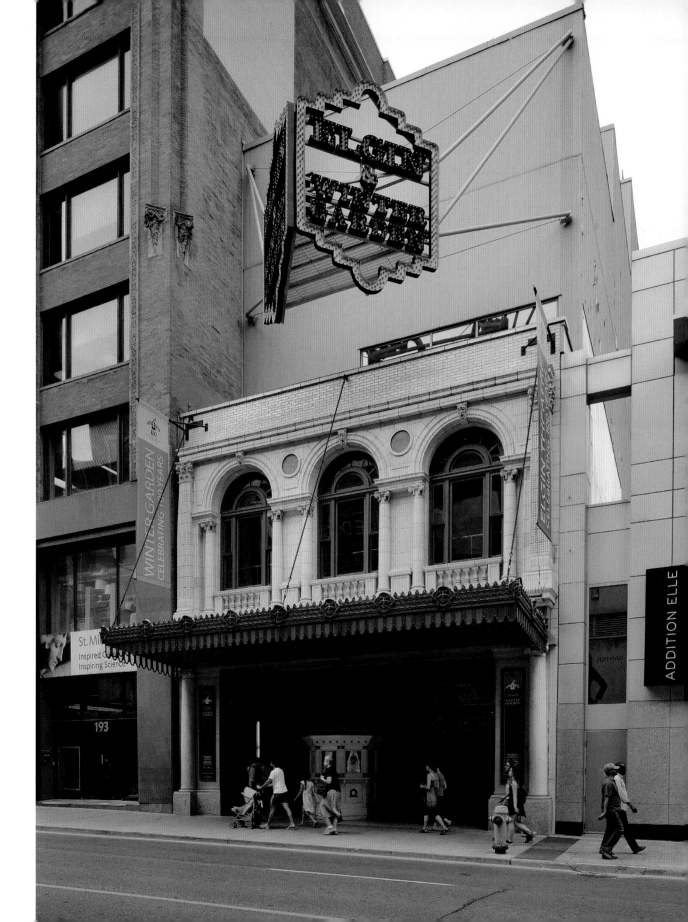

IMPERIAL THEATRE / ED MIRVISH THEATRE

The Pantages, as it was originally known, was the largest theatre in Canada when it opened in 1920

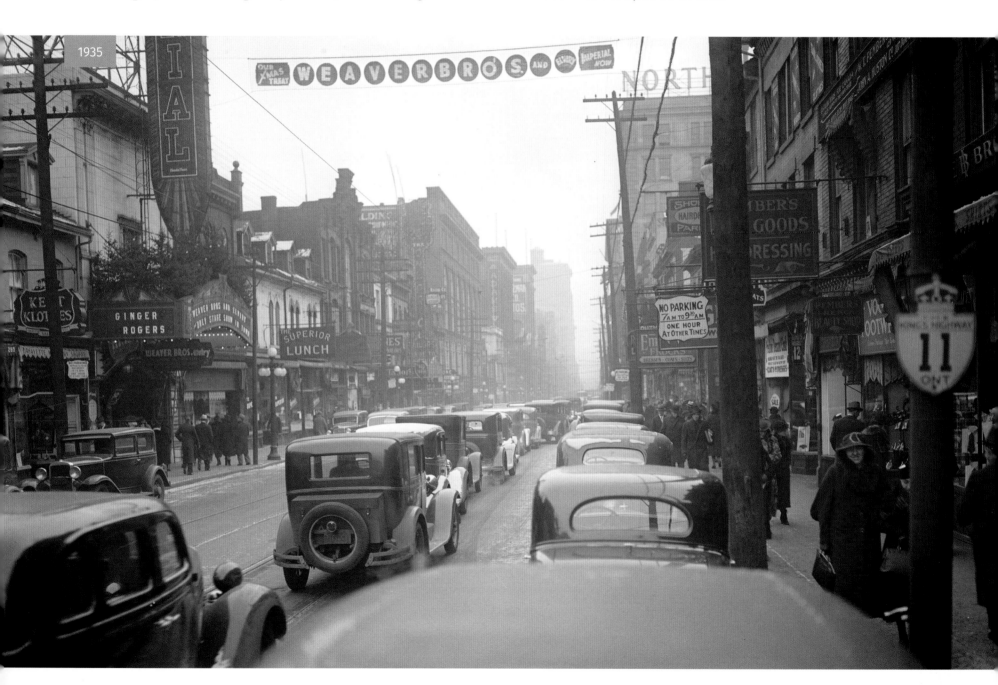

LEFT: This view of Yonge Street from south of Dundas Street was taken on December 21, 1935. On the left-hand side of the picture, at 263 Yonge Street, is the Imperial Theatre, designed by Thomas W. Lamb. When it opened on August 20, 1920, it was among the city's most opulent early 20th-century movie palaces. Owned by the Famous Players cinema chain, it was originally named the Pantages, after Alexander Pantages, whose company managed it. The Pantages could seat over 3,300 and was the largest theatre in Canada when it opened. It originally featured silent movies and vaudeville, but, in May 1929, it was converted for sound films. Its interior was lavish, containing many classical ornamentations, especially surrounding the stage and on its great domed ceiling. In 1929, following a ruinous Hollywood scandal, Pantages relinquished most of his investments in theatres. In 1930, the Pantages was renamed the Imperial, but remained under the ownership of Famous Players.

BELOW: In 1973, the Imperial was converted by the architect Mandel Sprachman to a multiplex theatre and renamed the Imperial Six. In 1986, Cineplex Odeon purchased the theatre from Famous Players Corporation and it was renovated and restored to accommodate live performances. It reopened as the "new Pantages," featuring Andrew Lloyd Weber's *Phantom of the Opera*. This musical drama played for the next ten years. Cineplex Odeon lost control of the theatre in 1999, and in 2001 it was renamed the Canon, under the ownership of Clear Channel/Live Entertainment Ltd. Later the same year, it was purchased by David Mirvish and the seating capacity, including the orchestra and the balcony, was reduced to 2,300. The theatre has featured such famous musicals as *Les Miserables*, *Chicago*, *A Chorus Line*, and *Wicked*. In December 2011, it was renamed the Ed Mirvish Theatre, in honour of the owner's father, a Toronto entrepreneur and benefactor of his adopted city.

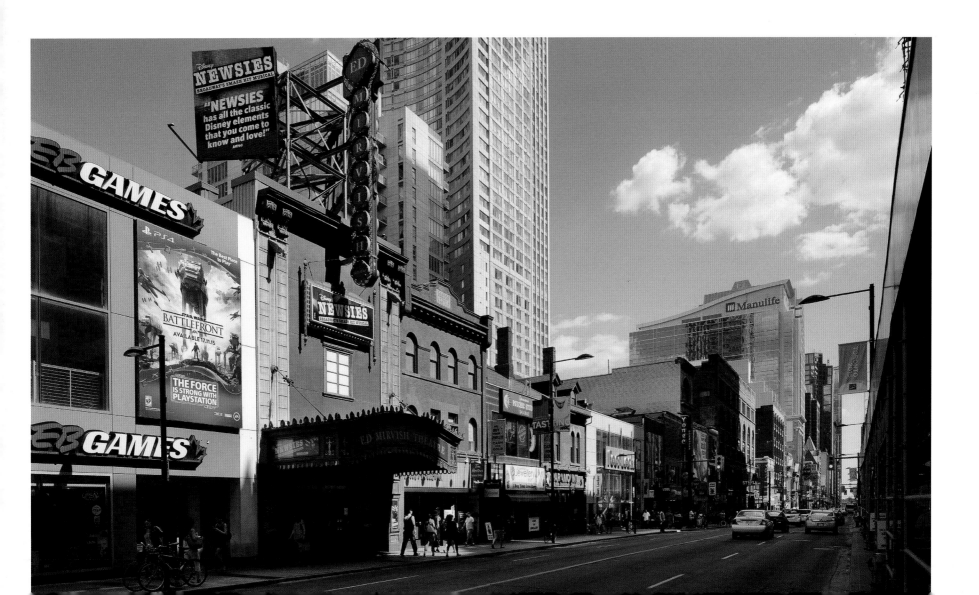

ST. GEORGE'S HALL (ARTS AND LETTERS CLUB OF TORONTO)

A gathering place for artists since the 1920s

1919

LEFT: The majestic St. George's Hall at 14 Elm Street resembled a castle, with its massive stone base, turrets above the windows, and the Roman arch over the entrance harkening back to the days of medieval knights. Built in the Richardsonian Romanesque style, it was designed by Edwards and Webster. St. George's Hall, which was completed in 1891, was constructed for the St. George's Society, an organization founded in 1834. The society was dedicated to maintaining British traditions in North America and assisting needy families. The artist Tom Thomson, who inspired the work of the Group of Seven, was familiar with this building as he rented a room on Elm Street when he arrived in Toronto as a young man in 1905. In the 1920s, the Arts and Letters Club took possession of the premises. The club renovated the building and hired Henry Sproatt to design a Great Hall in its interior, in the Tudor style. The photo below shows a dinner in the Great Hall to celebrate the coronation of King George VI and Queen Elizabeth.

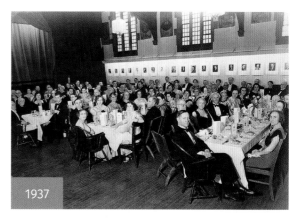

1937

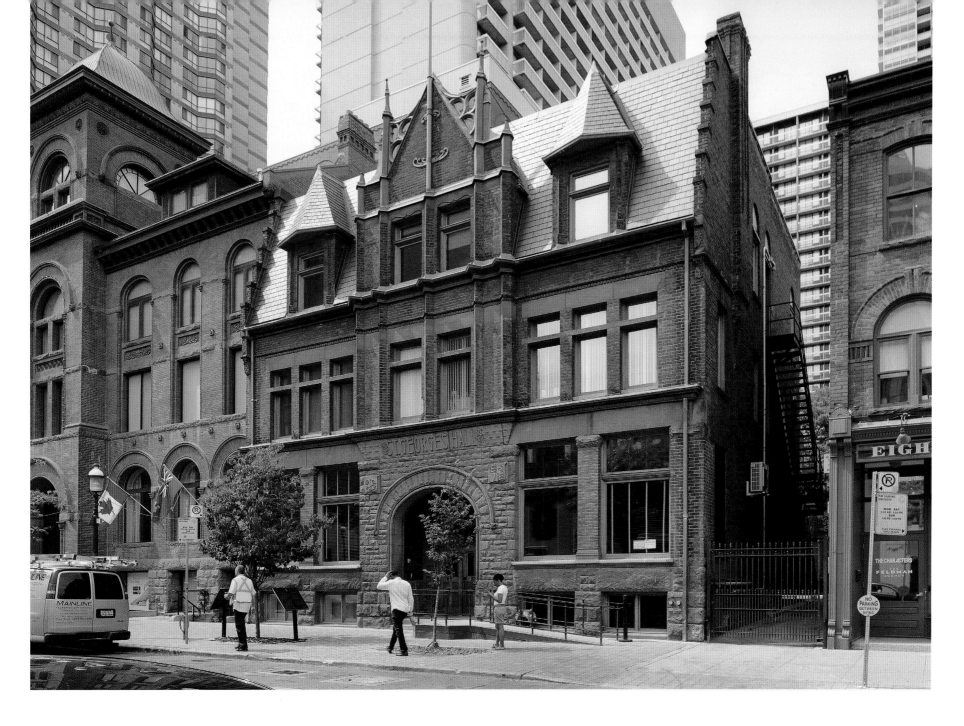

ABOVE: After the Great Hall was completed, the Arts and Letters Club on Elm Street became a popular dining place for Toronto's art community. Beside the Hall's baronial fireplace under the timbered ceiling, members spent winter evenings discussing cultural events and literary trends, as well as viewing pageants, plays, and musicals. The club had been founded in 1908, and in 1910 met on the second floor of the old County of York's Magistrates building at 57 Adelaide Street West. It was formed by a group of men dedicated to promoting the arts in Toronto. In 1913, they hosted Sir Wilfred Laurier, and through the years entertained other notables such as Vincent Massey, Sir Ernest MacMillan, Dr. Healey Willan, and Sir William Mulock.

Today, the Arts and Letters Club at St. George's Hall continues to be a gathering place for artists, its walls containing artwork and memorabilia that reflect Canadian culture. The building was officially designated a National Historic Site of Canada in 2007.

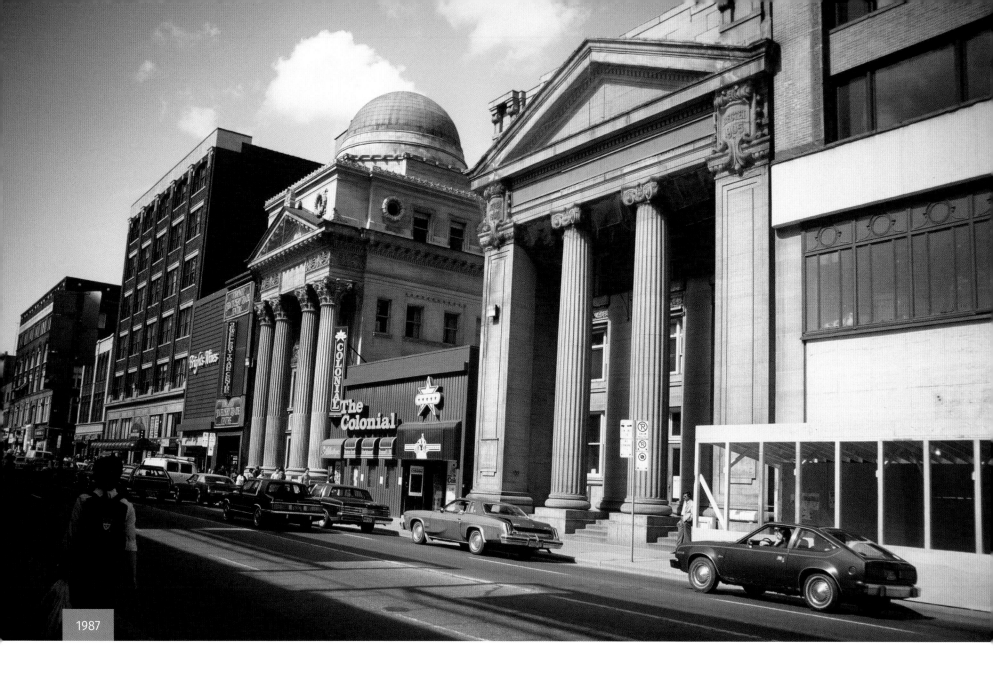

1987

BANK OF TORONTO AND BANK OF COMMERCE BUILDINGS
These former bank buildings continue to make an impression on Yonge Street

ABOVE: This photo shows two impressive neoclassical-style buildings that were formerly banks, located on the east side of Yonge Street, opposite the Eaton Centre. Between the two historic structures is the Colonial Tavern, which, during the 1950s and 1960s, hosted some of the most famous jazz and blues musicians. This picture was taken in 1987, the year the Colonial Tavern was demolished. The bank to the south (right-hand side) of the tavern, at 197 Yonge Street, was a branch of the Bank of Commerce, built in 1905. It later became the CIBC. The bank building to the north of the Colonial was formerly the Bank of Toronto, at 205 Yonge Street. It became the Toronto Dominion (TD) Bank. The former TD Bank, also erected in 1905, was designed by E. J. Lennox, the famous Toronto architect who designed Casa Loma and the Old City Hall at Bay and Queen Streets.

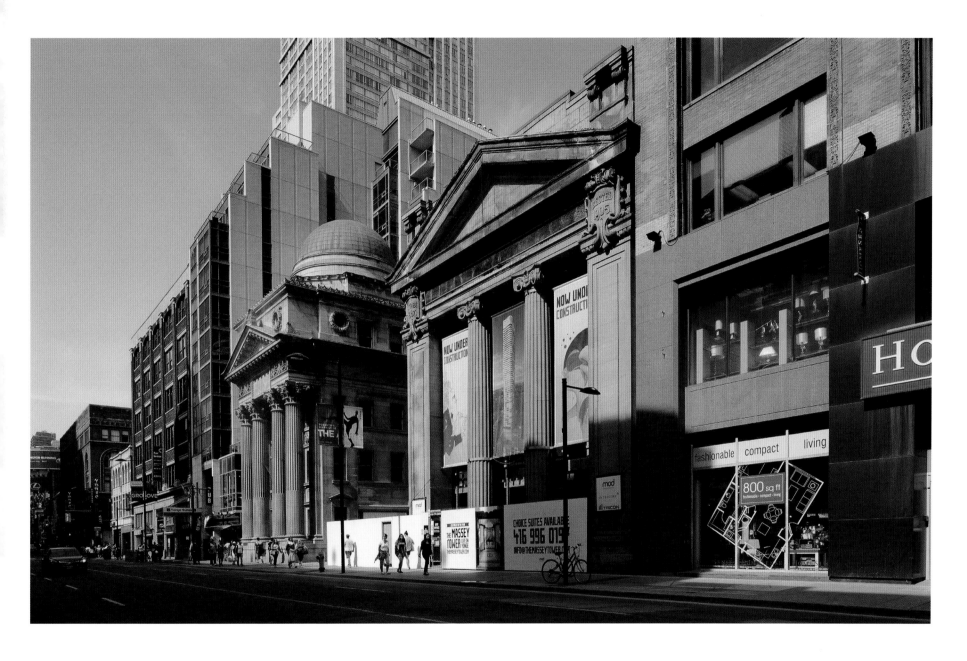

ABOVE: The gap between the two banks is today an open space, though it cannot be seen in the photo due to the white hoarding. The former Bank of Commerce at 197 Yonge Street (to the right of the hoarding) has a narrow portico supported by two enormous pillars with Ionic capitals. It is being restored to form the entranceway to a luxury condominium, which will be constructed behind it. The Bank of Toronto at 205 Yonge Street, on the other side of the hoarding, though neoclassical, possesses touches of Beaux-Arts. It has a passing similarity to the Pantheon, Rome's greatest temple, built by the Emperor Hadrian as a temple to all the gods. However, the bank on Yonge Street is much smaller and more ornamented. Its Yonge Street facade is faced with Indiana limestone. Though constructed on a narrow piece of land, the building appears taller than it actually is due to its great dome. The structure is today an Ontario Heritage site, and is presently vacant, awaiting redevelopment.

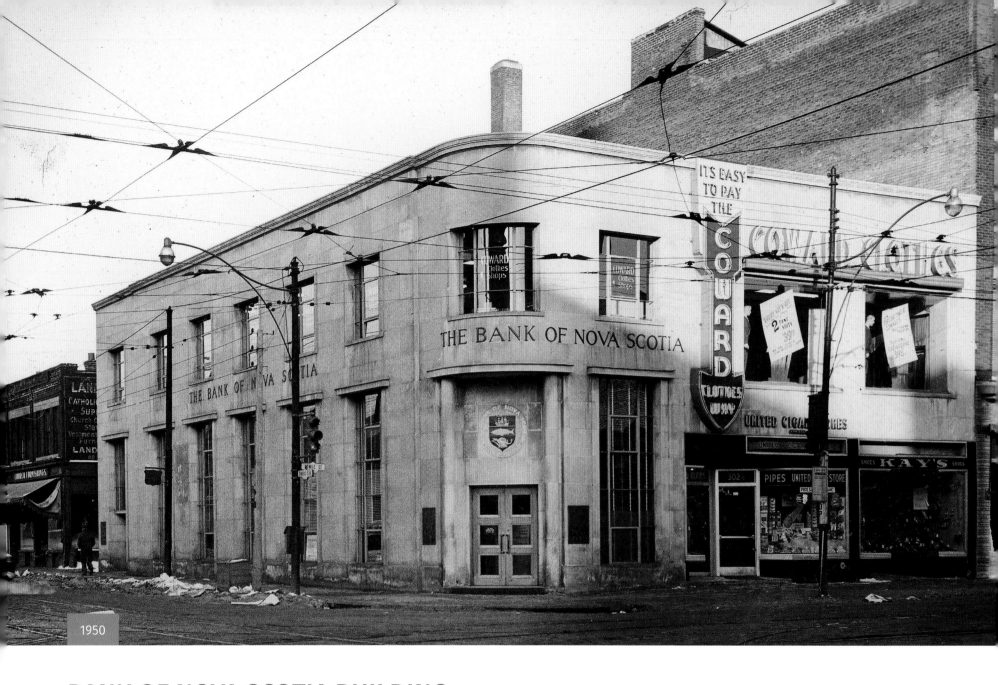

1950

BANK OF NOVA SCOTIA BUILDING

While this two-storey building remains, the surrounding area has changed dramatically

ABOVE: The Bank of Nova Scotia, on the northwest corner of Yonge and Dundas Streets, is shown here sharing the ground-floor level of the building with the United Cigar Store and Kay's Shoes, and the second floor with Coward Clothes. The first building erected on this site was in 1890, occupied by T. D. Ball and Company, "gent's furnishings." In *Goad's Atlas* of 1899, this section of Dundas was then named Agnes Street. In 1925, a United Cigar Store was on the corner, and remained on the premises until 1950, when the Bank of Nova Scotia constructed the present-day building. When the bank opened, it shared the premises, but eventually it occupied the entire building. They then renovated the structure, placing a huge Bank of Nova Scotia crest above the small door on the northeast corner of the building.

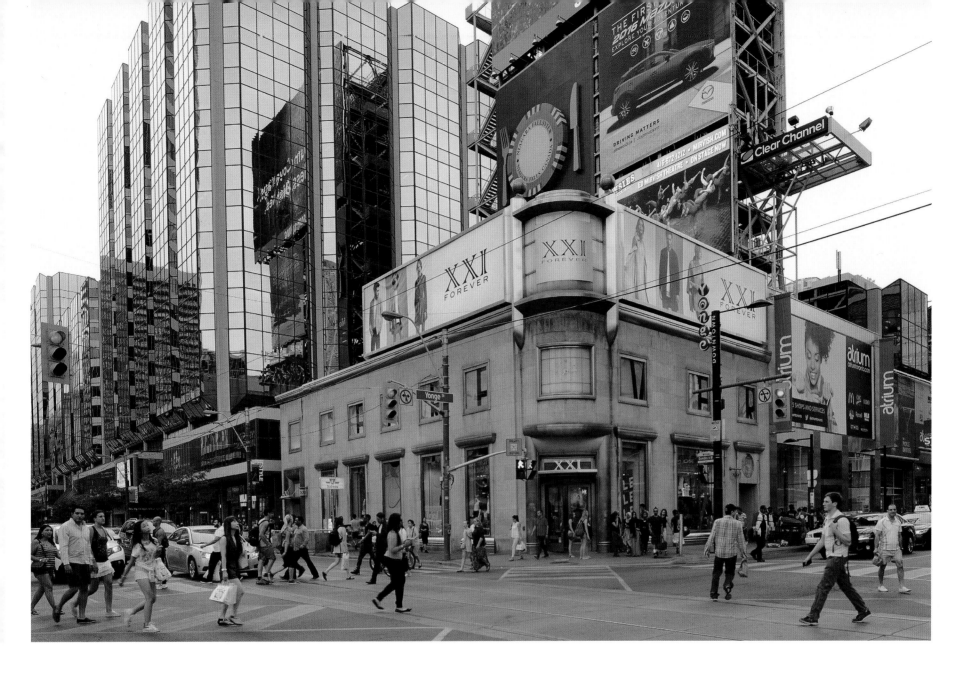

ABOVE: The Bank of Nova Scotia at Yonge and Dundas Street remained a functioning branch into the 1990s. Since the bank vacated the premises, various commercial enterprises have occupied the site, but the large crest of the bank (shown right) has remained, a touch of the past that survives into the modern era. Today, however, the surroundings of the bank have greatly changed. It is now located on one of the city's most lively and vibrant intersections, which attracts crowds at all hours of the day and night. Dundas Square is on the southeast quadrant of the intersection, surrounded by garish signs that after sunset illuminate the night sky. The southwest corner is occupied by the Eaton Centre; in front of it is an open space for buskers. From 1949 until 1974, the northeast corner was the site of the famous Brown Derby Tavern, but today the commercial block at 10 Dundas East occupies the site. Within it is a Cineplex Odeon Theatre complex.

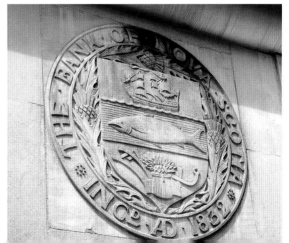

RYRIE BUILDING

Home to the popular Silver Rail Tavern from 1947 to 1998

LEFT: Located at 229 Yonge Street, on the northeast corner of Shuter and Yonge, the first phase of the Ryrie Building was erected in 1899. Designed by Burke and Horwood, it absorbed a building already on the site, which had been built in 1891. In 1912, the owners of the Ryrie Building purchased the property next to it and renovated its facade to match their own building. This is the structure that remains on the site today. In 1912, the cornice on the combined buildings was quite elaborate, but it has since been removed. The building was an investment enterprise of "Ryrie Brothers Jewellers," previously located at 113 Yonge Street. The firm eventually amalgamated with Henry Birk and Son of Montreal. In the 1930s, another partner joined the company and it became known as Ryrie, Birks, and Ellis. Birks Jewellers survives to this day and has retail stores across Canada. The photo below shows the Silver Rail Tavern, which opened on the ground-floor southwest corner of the Ryrie Building in 1947.

1919

c. 1950

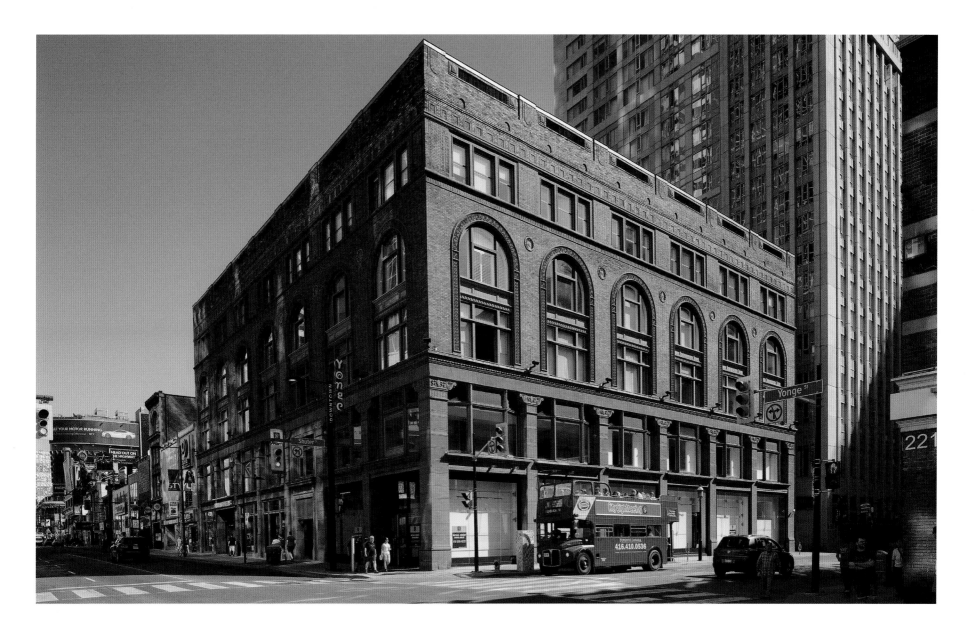

ABOVE: Today, the optimism of the first decade of the 20th century remains evident in the ornate detailing on the facades of the Ryrie Building. It was restored by Everest Restoration and E.R.A. Architects Inc. in the late 1990s. The well-known Silver Rail Tavern, which opened on April 2, 1947, was located in the southwest corner of the building. It occupied the site that had previously been Muirhead's Grill and Cafeteria. Muirhead's possessed a magnificent silver railing, from which the Silver Rail received its name. The Silver Rail's 33.5-metre (110-foot) chrome and neon bar on the first floor (where Oscar Peterson once gave an impromptu concert) extended the length of the building. The restaurant in the basement, with its white table cloths and formal seating, was a favourite with the employees of Eaton's and Simpson's stores at Yonge and Queen. The Silver Rail Tavern closed in 1998 and the site has since been occupied by several retail stores. Today, the upper floors of the Ryrie Building are occupied by offices, while the Silver Rail's former premises are awaiting new tenants.

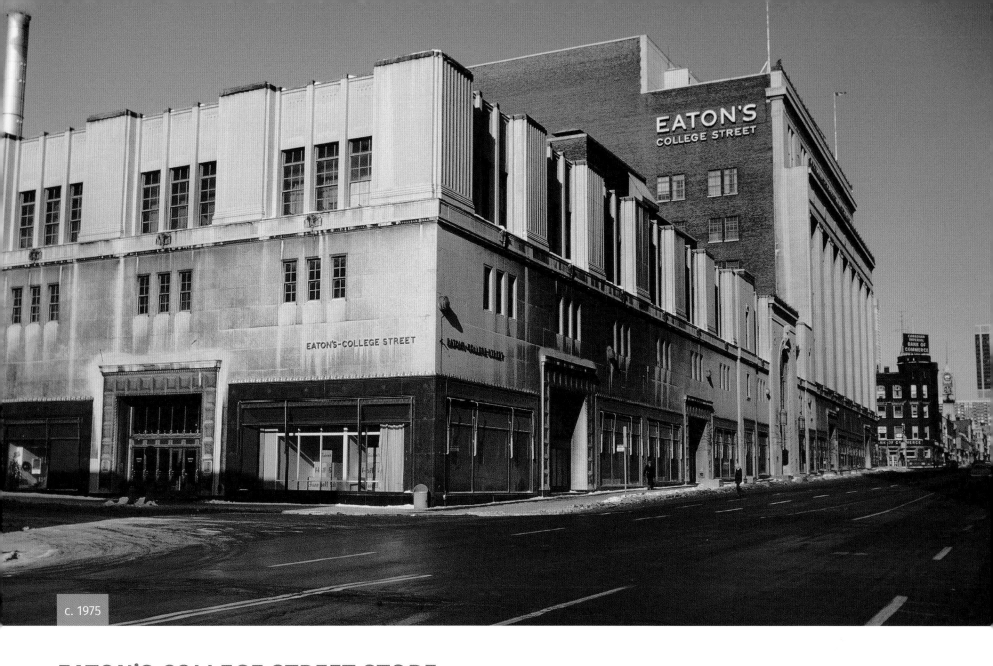

c. 1975

EATON'S COLLEGE STREET STORE

Once the jewel in the crown of Eaton's retail empire

ABOVE: This photo gazes north on Yonge Street toward College Street. Construction on Eaton's College Street store commenced in 1928 and it opened on October 30, 1930. The magnificent structure, the jewel in the crown of the retail empire of the T. Eaton Company, was designed in the Stripped Classical style that reflected Italian Art Deco architecture of the period. The building's architects were the firm of Ross and Macdonald, in association with Sproatt and Rolph. The store was intended to appeal to affluent customers, but by the time it opened the Great Depression had descended across the nation. The 40-storey skyscraper, planned for future years on the northwest side of the building at Bay and College was never completed. However, the interior of the section that was finished was perhaps the most magnificent retail store in Canada at that time. Its interior was trimmed with marble and granite, especially on the first-floor level.

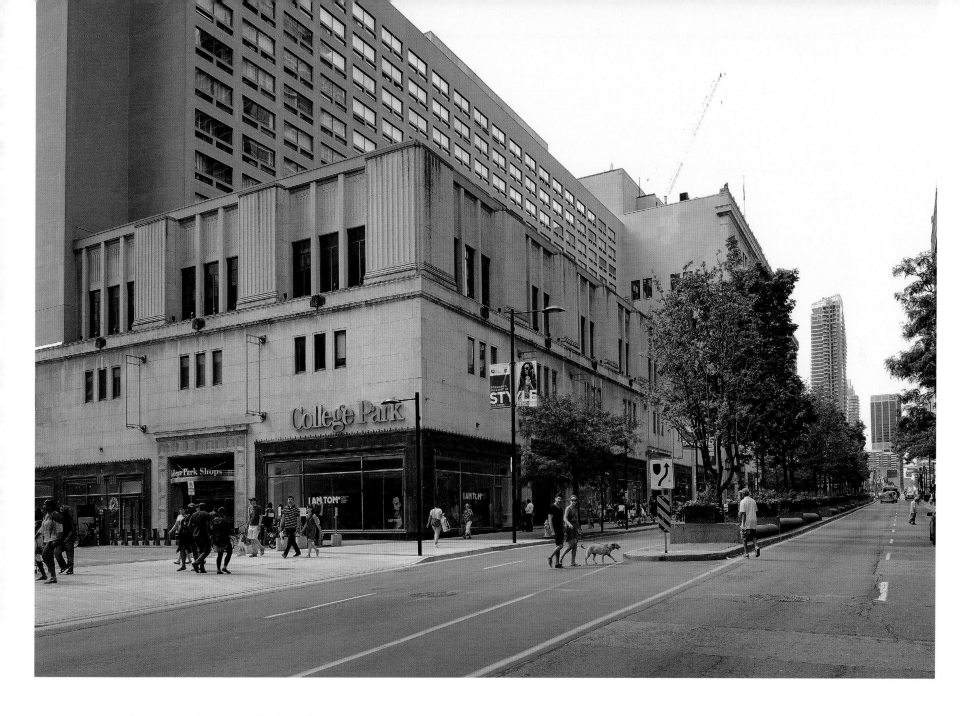

ABOVE: In 1978, work commenced on renovating the building to accommodate various shops, law courts, and offices under a new name of College Park. Condominiums were also built on top of the three-storey section. However, the developers disputed that Eaton's Auditorium (a theatre venue on the seventh floor) was under heritage designation. After a lengthy court case, its heritage value was respected. It was restored and opened in 2003 as the Carlu, named after its French designer Jacques Carlu. The Art Moderne auditorium once hosted performers such as Billie Holiday, Duke Ellington, and Frank Sinatra. Today, the building that was Eaton's College Street remains one of the grandest structures in Toronto. The lower portion of the building remains similar to when it was erected, and it continues to dominate the intersection of College and Yonge Streets with its classical lines, ornate trim, and ornamentations. The cladding on its facades is ivory-coloured Tyndall limestone from a quarry east of Winnipeg. In the building's interior, the brown granite was quarried in Gananoque and the black granite in Mount Joseph, Quebec. Marble for the exposed pillars and the colonnade in the interior were imported from Europe. The former department store building is now a designated heritage site under the Ontario Heritage Act.

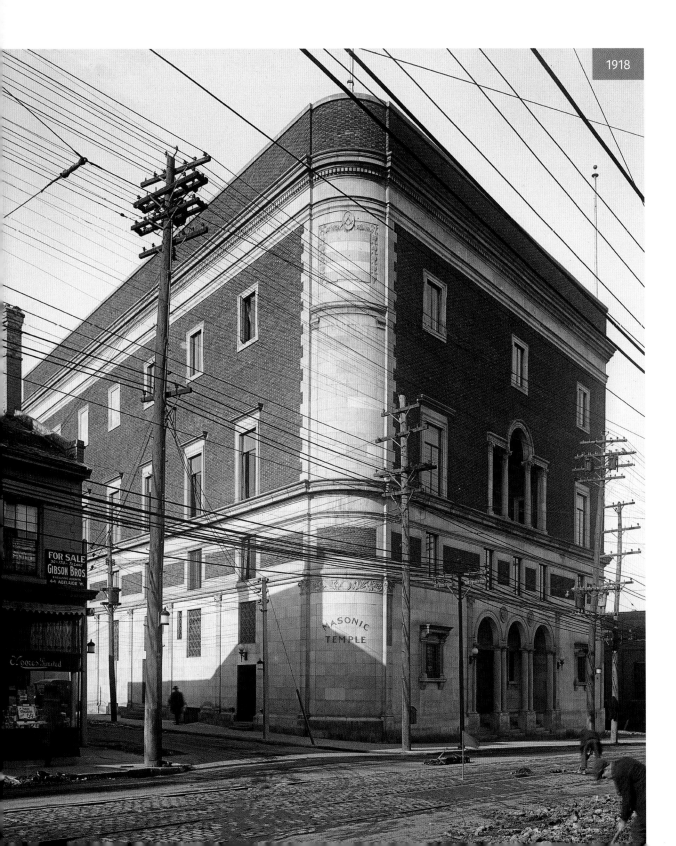

MASONIC TEMPLE

The Temple's auditorium has played host to Frank Sinatra, Tina Turner, David Bowie, and Led Zeppelin

LEFT: The Masonic Temple at 888 Yonge Street, on the corner of Davenport Road and Yonge Street, was built in 1917 and designed in the Italian Renaissance Revival style by architect W. J. Sparling. One of the prime motivators behind its construction was John Ross Robertson (1841–1918), a prominent Mason and founder of the now defunct *Toronto Telegram* newspaper. When the Masons chose this site, a church was located on the property; it was demolished to permit the construction of the temple. By the time it was completed, the cost was a controversial $220,864. The final stone for the new temple was ceremoniously placed in position on November 17, 1917 and the structure was consecrated with corn, oil, and wine. The first lodge meeting was held on January 1, 1918. The upper floors, which were reserved solely for the use of the Masons, featured patterned tiled floors and ornamental Masonic carvings.

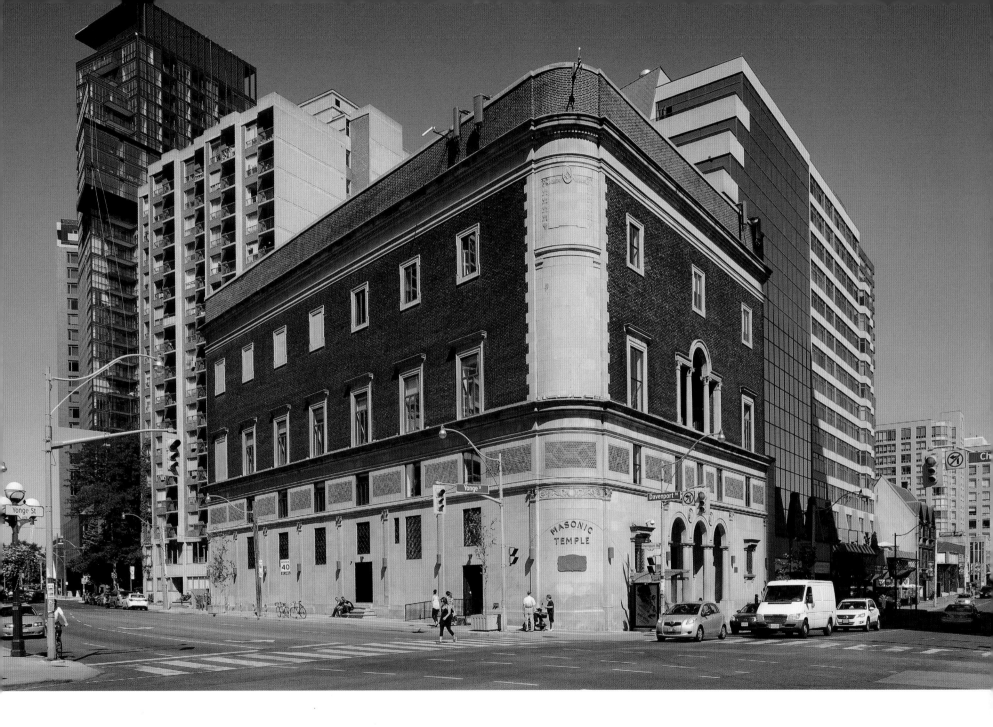

ABOVE: During the 1930s, the Masonic Temple's auditorium became one of the most popular ballrooms in Toronto. Every New Year's Eve, tickets disappeared long in advance of the date. Bing Crosby and Frank Sinatra once crooned within its walls. Other famous entertainers who performed in the hall include Tina Turner, The Ramones, David Bowie, and Led Zeppelin.

The latter held their first Toronto concert in the building in 1969. In 1970, the Masonic Temple was leased by a company known as the Rockpile, and in 1974 the building was designated a Heritage Property. During the 1980s, it was rented by various groups, but the income never exceeded the costs of maintaining the building. In 1998, the Masons sold the property to

CTV for use as a TV studio and *Open Mike with Mike Bullard* was broadcast from the premises. It became home to Bell Media (MTV) in 2006 and most recently Info-Tech Research Group, who took ownership of the building in 2013.

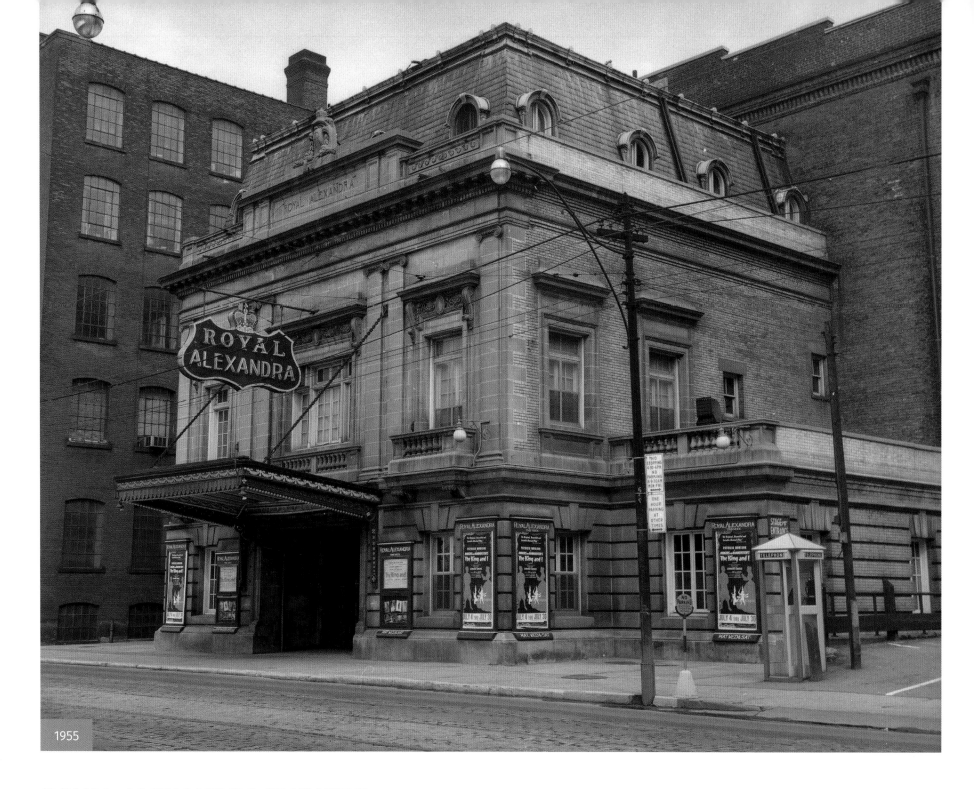

1955

ROYAL ALEXANDRA THEATRE
One of the oldest continuously operating theatres in North America

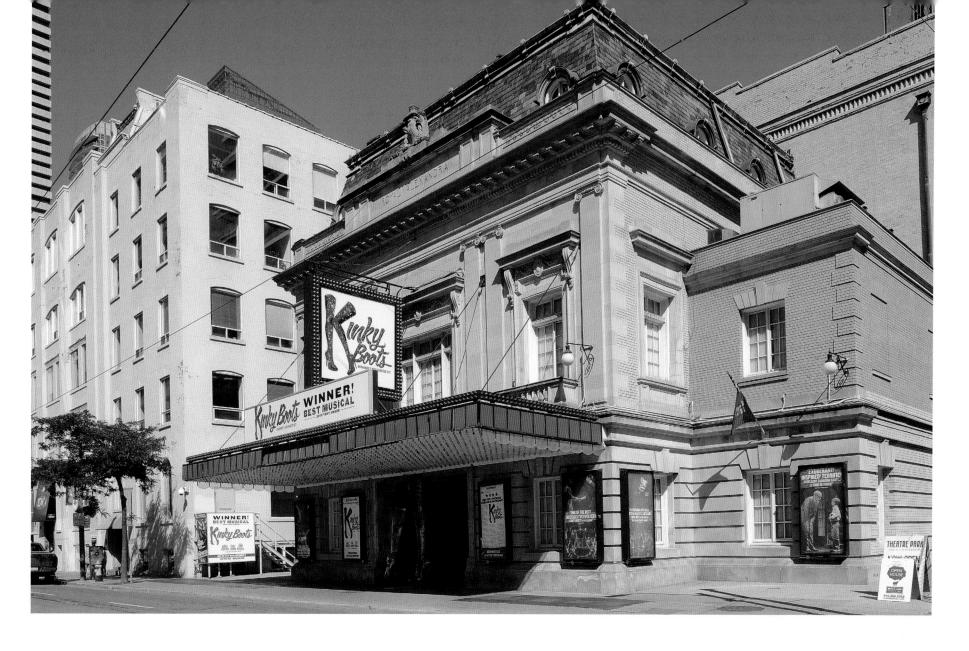

LEFT: In the 19th century, Toronto's King Street was one of the city's most fashionable residential streets and business thoroughfares. Government House, the residence of the Lieutenant Governor of Ontario, was located at Simcoe and John Streets, the location of today's Roy Thomson Hall. In the first decade of the 20th century, philanthropist Cawthra Mulock and a group of businessmen decided to finance the construction of a theatre to showcase legitimate theatrical productions. They purchased a 30.5-metre (100-foot)-wide lot at 260 King Street West, on the north side of the street, between Simcoe and John Streets. The syndicate hired the architect John M. Lyle, who in later years designed Union Station on Front Street. Royal permission was granted to name the theatre after the consort of King Edward VII, Queen Alexandra. The Royal Alexandra Theatre opened on August 26, 1907 with the musical production *Top o' th' World*.

ABOVE: By the late-1950s, the area surrounding the Royal Alexandra had deteriorated and the theatre was in danger of being demolished to create a parking lot. In 1963, theatrical impresario Ed Mirvish purchased the theatre and restored it. Built in the Beaux-Arts style, its restoration was aided by the fact that it had been constructed on a steel frame, not common when it was erected, and the exterior walls and floors were reinforced concrete. When it was built, it was the only truly fire-proof theatre in North America, and it set the standard for theatres throughout the continent. The imposing King Street facade is covered in sandstone blocks while its Mansard roof includes eye-windows. Inside, there are no internal pillars, so no seat in the theatre has an obstructed view. Still a thriving theatre today, its stage is of sufficient size for the demands of the majority of productions. The Royal Alexandra is one of the oldest continuously operating theatres in North America.

RICHARDSON HOUSE

A landmark in the Spadina district since 1873

1914

LEFT: In 1873, Samuel Richardson erected a two-storey frame home on the northwest corner of this intersection at Spadina Avenue and King Street. He added a third floor to the house in 1875, with a Mansard roof and ornate gables. When completed, the premises opened as the Richardson House, a hotel and tavern serving the businessmen of the western part of the city. In 1885, a four-storey brick addition was added to the north side of the hotel, on Spadina Avenue, and two years later another extension was added, doubling the number of rooms. The hotel advertised hot-water heating in every room, all for the low rate of $2.00 per day. Weekly boarders received a special rate of $1.50 per day. Samuel Richardson died in 1904, and in 1906 the premises were renamed the Hotel Falconer. Its name was changed again in 1914, when it became Zeigler's Hotel.

BELOW: In 1916, Zeigler's Hotel became the Spadina Hotel—a name it retained for over 80 years. In the 1950s, the large room on the second floor was redecorated and named the Cabana Room. During the same period, the Spadina Hotel restored the first-floor dining room to its 1883 splendour, with Canadian walnut and chestnut panelling. The old doors and the wood panelling remained, reflecting a little of its elegant past. The hotel became a centre for the avant-garde community of the city, especially students of the Ontario College of Art (now OCAD). In 1997, the glorious old establishment became a hostel for student backpackers. It contained 185 beds, with four occupants to a room. The hostel's brightly painted exterior walls, ornate gables and garish trim made it a conspicuous landmark in the Spadina district. In 2014, the Backpackers' Hotel closed and restoration of the building commenced. The layers of paint were removed from the red-brick facades and the gabled windows restored. It now contains offices and retail space, with a coffee shop on the ground floor.

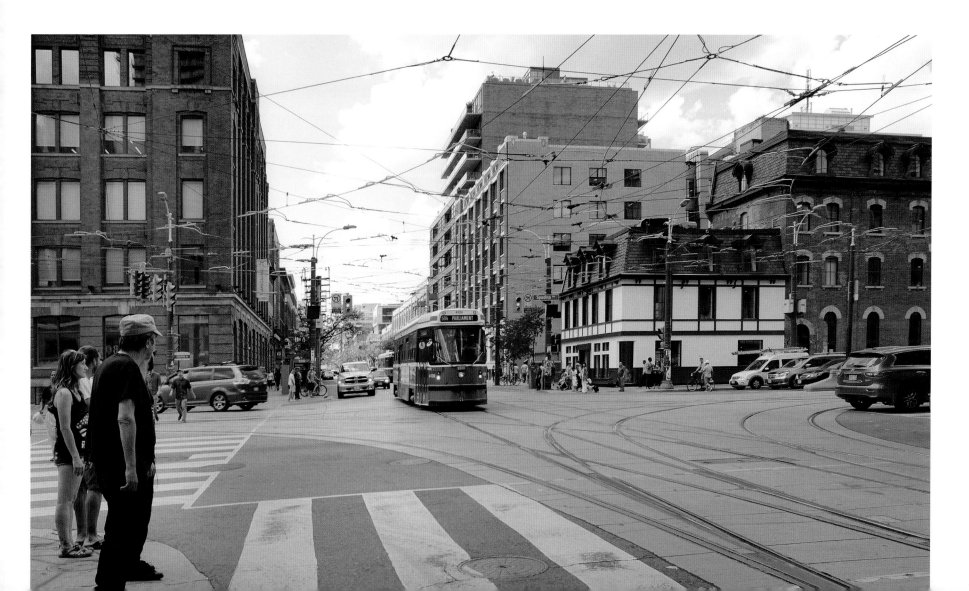

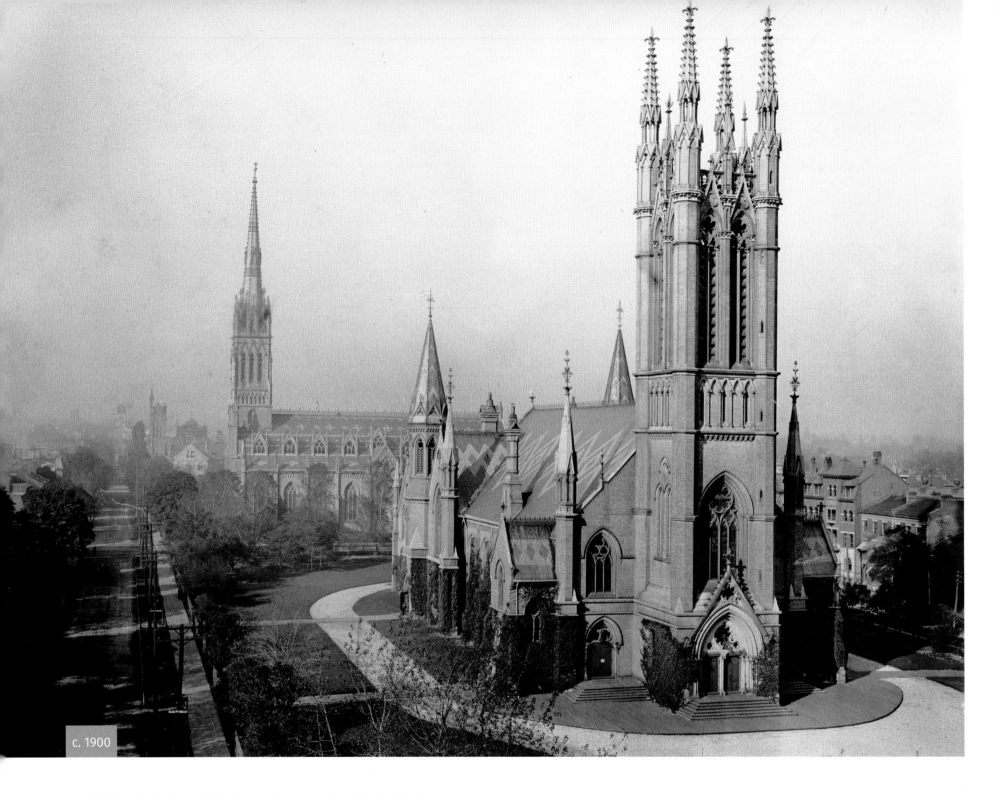

c. 1900

METROPOLITAN UNITED CHURCH

This striking neo-Gothic church is now surrounded by downtown high-rises

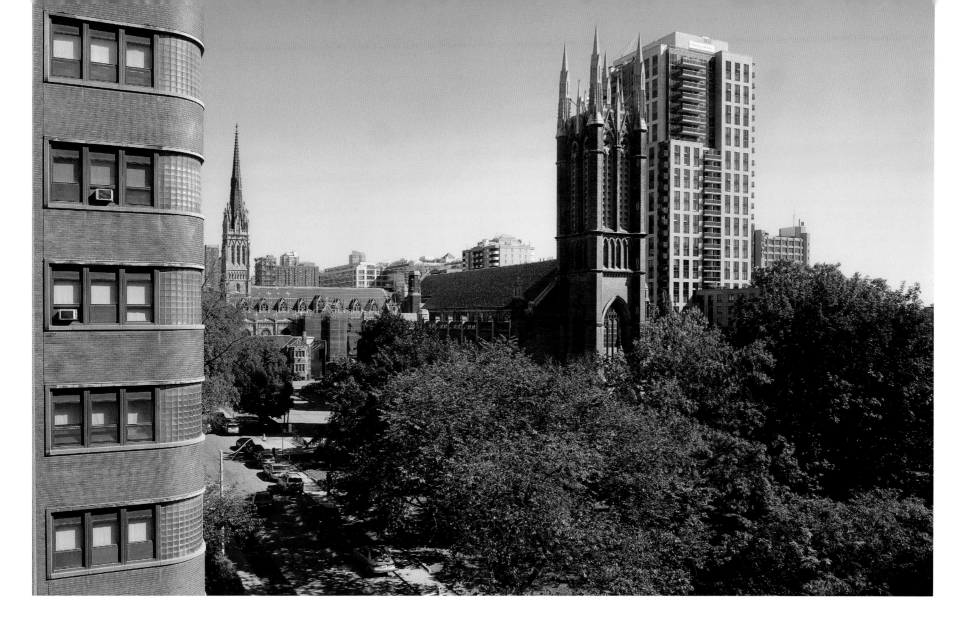

LEFT: This view of Metropolitan United Church at 56 Queen Street East was taken prior to the fire of 1928, since the overly tall pinnacles on the original tower are evident. St. Michael's Cathedral is visible in the background. In 1868, the Metropolitan Methodist Church (now the United Church) purchased McGill Square on Queen Street East for $25,000. The church was designed by architect Henry Langley and the first services were held in 1872. In 1922, a 23-bell, 17-ton carillon was added to the tower. On January 30, 1928, a disastrous fire broke out in the church, leaving only sections of the exterior walls and the tower remaining. Within five months, the church was being rebuilt and its cornerstone was laid in December 1928. John Gibb Morton, the architect who received the commission, preserved much of the south facade of the old church. However, the over-size pinnacles on the tower were removed.

ABOVE: The church's surroundings have vastly changed from the days when it was built, as it is now nestled amidst modern downtown high-rises and mature trees. In 1925, the Methodist congregation joined the United Church of Canada. When the church was rebuilt after the fire of 1928, it contained larger transepts and the balcony was built across the south end of the nave, rather than on three sides. The Globe Furniture Company of Waterloo installed the woodwork and Robert McCausland designed the Memorial Window. In the sanctuary, the communion table, carved from California oak, depicts Leonardo da Vinci's painting of The Last Supper. The first services in the new church were held in December 1929 and the following year a Casavant organ, manufactured in Quebec, was installed. In 1934, a Silver Band was formed, which continues to play for special occasions to this very day. Today, the bells of Metropolitan United peel across McGill Square and the surrounding streets every Sunday morning, as they have for many decades.

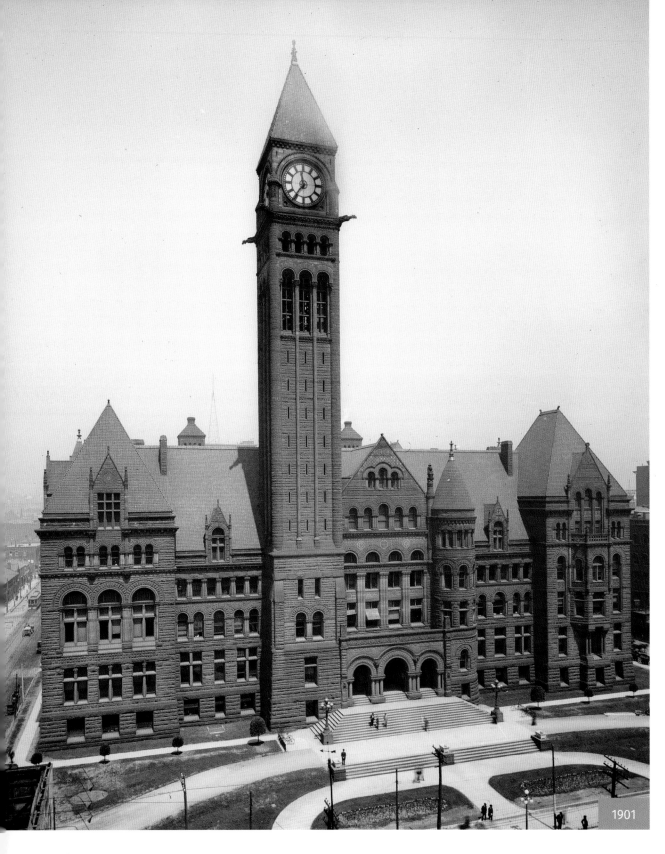

1901

OLD CITY HALL
The soaring clock tower was once the tallest structure on Toronto's skyline

LEFT: This photo of what is now known as the Old City Hall on Queen Street was taken in 1901, two years after it officially opened. By 1885, a new city hall was badly needed and an international contest was held for its design, in which 50 architects offered submissions. The chosen site was on Queen Street, at the head of Bay Street. Arguments over the cost of the project created extensive delays, to the frustration of the city officials and voters, but to the delight of the children of the city, who used the site as an ice rink. Finally, agreements were signed for the building, which was to include a court house as well as a city hall. They hired the Toronto architect E. J. Lennox to design a structure that would fulfill both functions. The total cost was expected to be $300,000, but the price eventually spiralled. The photo below was taken for the opening day ceremony on September 18, 1899.

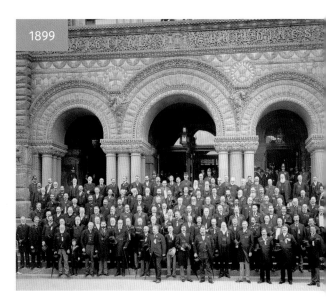

1899

RIGHT: The City Hall's architect E. J. Lennox admired H. H. Richardson's Chicago designs, and incorporated some of his ideas when he chose a Romanesque Revival style. The structure's massive red sandstone blocks were quarried at the Forks of the Credit River. When the building was officially opened by Mayor Shaw on September 18, 1899, it contained 5.4 acres of floor space. The final cost was $2,500,000, the increased cost creating great controversy, with much criticism directed at E. J. Lennox. Similar to the CN Tower of today, the clock tower of the Old City Hall, soaring over 91 metres (300 feet), was visible from many vantage points throughout the city. Civic officials climbed the tower on December 31, 1899 to "ring-in" the 20th century. In the early decades of the 20th century, when people crossed the harbour to attend a baseball game or visit the amusement park at Hanlan's Point, the tower was the tallest structure on the skyline. The building is now referred to as the Old City Hall to distinguish it from the New City Hall that opened to the west of it in 1965. The Old City Hall is currently used as a court house for the Ontario Court of Justice.

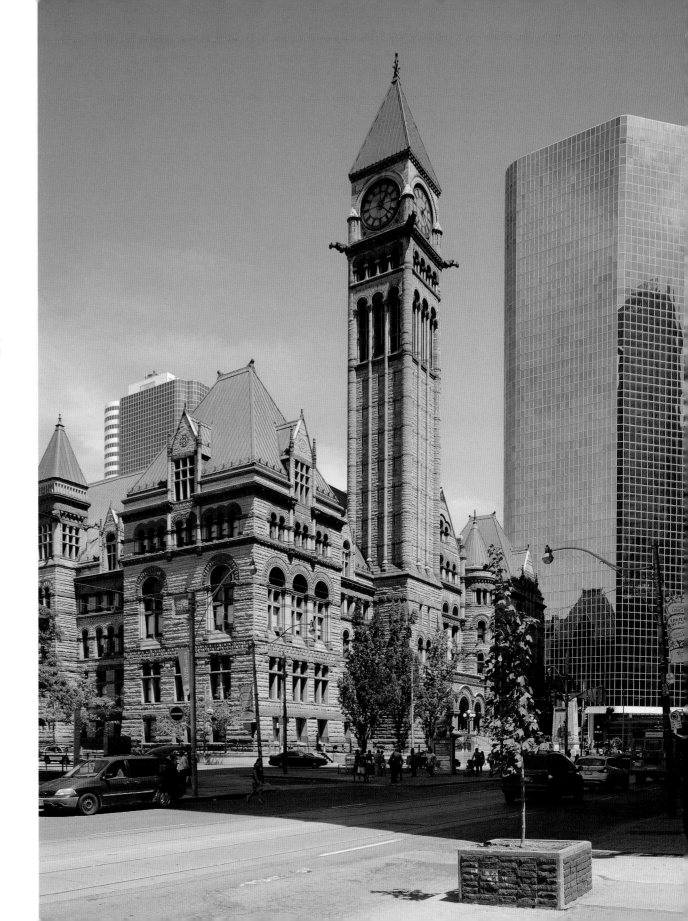

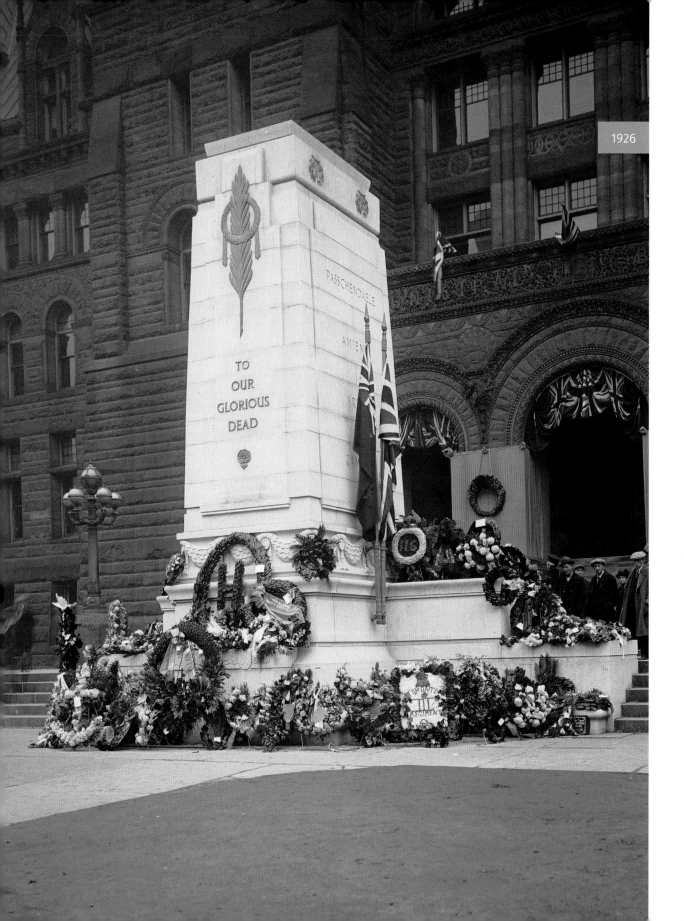

CENOTAPH AT OLD CITY HALL

The focal point of Toronto's Remembrance Day ceremonies

LEFT: This photo of the cenotaph at Toronto's Old City Hall was taken in May 1926, the year following its dedication. Cenotaphs are not usually considered among a city's architectural structures, but similar to heritage buildings, they required an architect, architectural drawings and skilled workmen. The Ontario Association of Architects assumed responsibility for its design and declared an open competition. William M. Ferguson, a Scotsman who collaborated with Thomas Pomphrey, won the contract. The chosen design was similar to the cenotaph in London, England, designed by Edwin Lutyens. Toronto's was carved from granite quarried in the Canadian Shield. The cornerstone was laid on July 24, 1924 by Earl Haig, Commander-in-Chief of the British Forces during World War I. The first memorial service at the cenotaph was on November 11, 1925, at which Governor General Byng laid the commemorative wreath. During the years ahead, the names of the battles on the monument included those of World War II and the Korean Conflict.

RIGHT AND BELOW: For almost 90 years, the cenotaph at the Old City Hall has graced the head of Bay Street. Each November 11, it is the focal point of the city's Remembrance Day ceremonies, where crowds gather on this solemn occasion, with the city's mayor officiating. It was not always the case. Similar to other cities throughout the world, prior to World War I, citizens of Toronto had gathered to pay homage to those who had given their lives in battle. Services had been held at the South African War Memorial at University Avenue and Queen Street. However, remembrance services increased in importance following World War I and they were relocated to the space in front of today's Old City Hall. When it was decided that a new monument was required, the cenotaph was naturally constructed on the same site as the ceremonies.

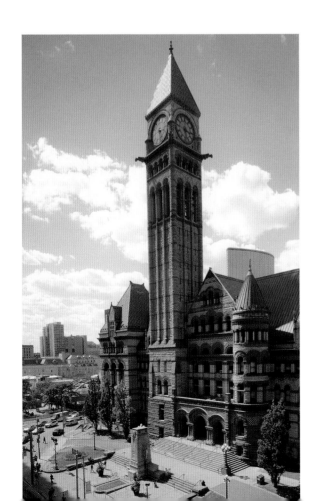

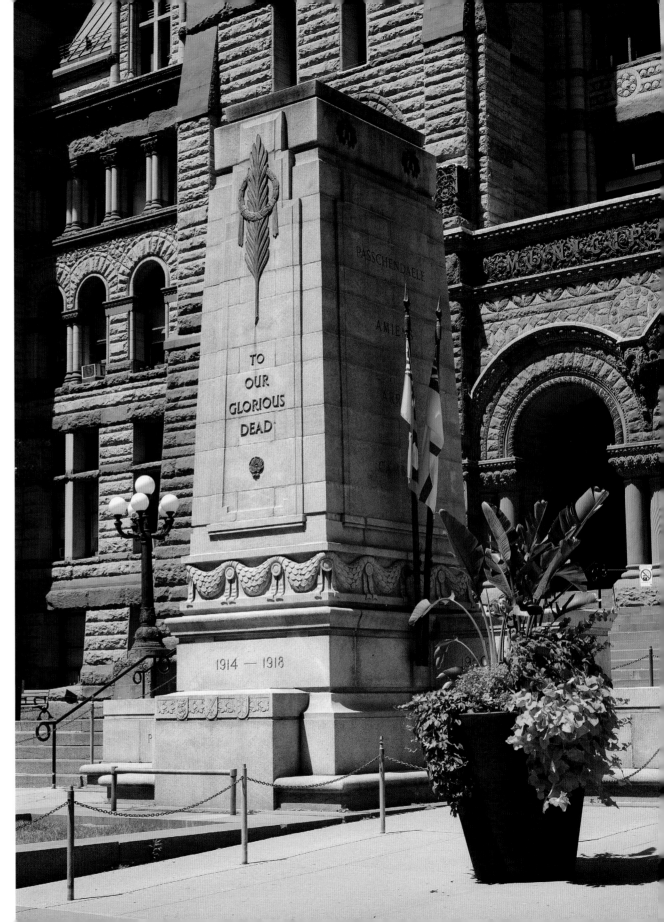

1856

OSGOODE HALL

This neoclassical landmark is now a National Historic Site

ABOVE: This early photo of Osgoode Hall focuses on the building's east wing (on the right), which was built between 1829 and 1832. To the left is the west wing, constructed between 1844 and 1846. The impetus that led to the building of the east wing goes back to 1820, when the Law Society of Upper Canada (Ontario) promoted the construction of a building for their headquarters. In 1825, they petitioned the government for a grant, while individual members also pledged funds. Land was purchased on the northwest edge of the city from Attorney-General John Beverley Robinson, and construction commenced in 1829 under the supervision of Dr. W. W. Baldwin, the Treasurer of the Society. When the east wing of Osgoode Hall was completed in 1832, it was a plain, square-shaped, red-brick building, two and a half storeys in height. In 1844, Henry Bower Lane was hired to design the west wing, which was completed in 1846. The finished building owed its name to William Osgoode, the province's first chief justice.

ABOVE: Positioned on the north side of Queen Street, at the head of York Street, the original 1829 building was an ambitious endeavour for the small colonial town of York. Osgoode Hall suffered considerable damage during the six years that British troops were garrisoned inside it after the 1837 Rebellion. Following essential renovation work, the hall was once again refurbished in 1857. The firm of Cumberland and Storm added a cream-coloured limestone to the facades, and the interior of the centre block was redesigned to create the appearance of a great Roman villa, with a centre columned courtyard (peristyle) and a mosaic-style floor. Today, Osgoode Hall remains as one of the finest examples of Victorian Classical architecture in Canada. Today, Osgoode Hall contains the Court of Appeal for the Province of Ontario. During the summer months, free guided tours of the historic building are provided for the public. The library (shown right), where the Prince of Wales (later King Edward VII) was entertained in 1860, is the highlight of the tours.

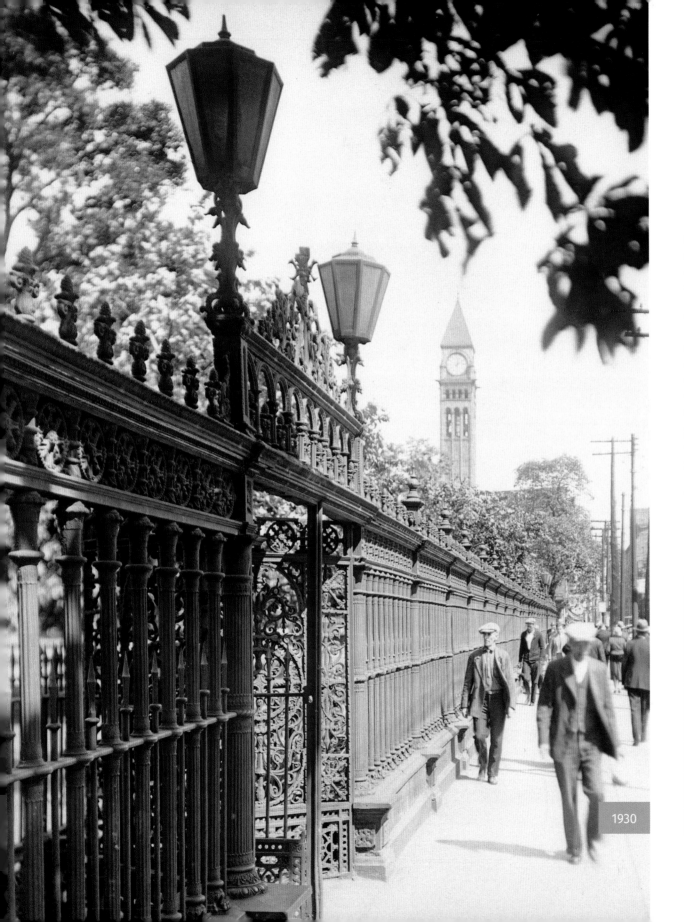

OSGOODE HALL FENCE
Famous for its "kissing gate"

LEFT: This photo from 1930 shows the fence surrounding Osgoode Hall, located on the north side of Queen Street West, east of University Avenue. On May 23, 1865, the firm of Cumberland and Storm was contracted to construct a cast iron fence around the impressive building. The following year, casting of the fence commenced in the St. Lawrence Foundry, a large enterprise located on Front Street, extending as far north as King Street. The stones for the footings of the fence were quarried near Georgetown by the firm of Ramsey and Farquar. The installation of the foundations, the cast iron fence, and the gates was completed in Confederation year—1867. The gates were inspired by those that at one time were common throughout Great Britain, known as "kissing gates." Traditional kissing gates consist of two panels constructed in a V-shape, with a hinged gate between them that allows one person to pass through at a time. Below is a hand-painted photograph of the Osgoode Hall kissing gate from around 1900.

1930

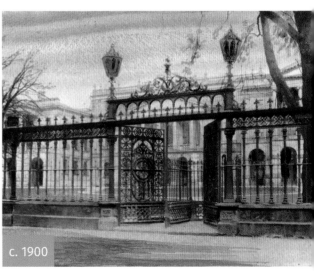

c. 1900

RIGHT: Today, anyone who passes through the 50-centimetre (20-inch) opening of one of the gates of Osgoode Hall is readily able to perceive why they were referred to as "kissing gates." To pass through the gate, a person walked around the panel to travel from one side to the other. If another person were passing through the gate in the opposite direction, he or she directly faced the individual, providing an excellent opportunity for kissing. However, tradition says that the gates on Queen Street, with their narrow openings, were actually designed to prevent cows from entering the interior space. This might have been a possibility when construction began on the east wing of Osgoode in 1829, as the site was to the northwest of the town, where domestic animals roamed freely. However, by the year 1867, the city had grown considerably and extended beyond the area where the building was located. Today, the fence is located beside one of the busiest pedestrian walkways in the downtown area, but few are aware that the fence was installed in Canada's Confederation year, when the nation was born.

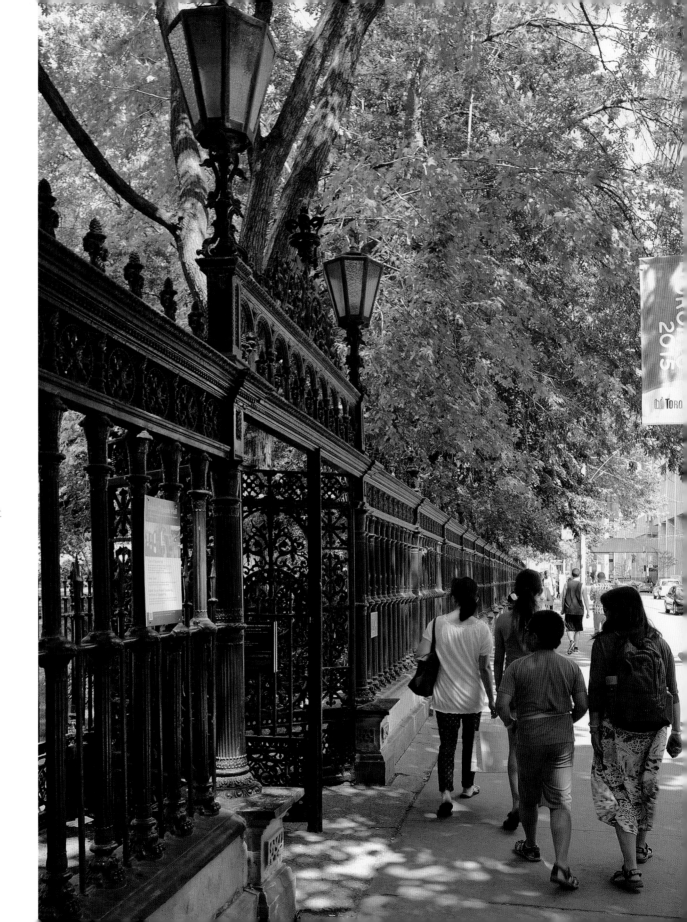

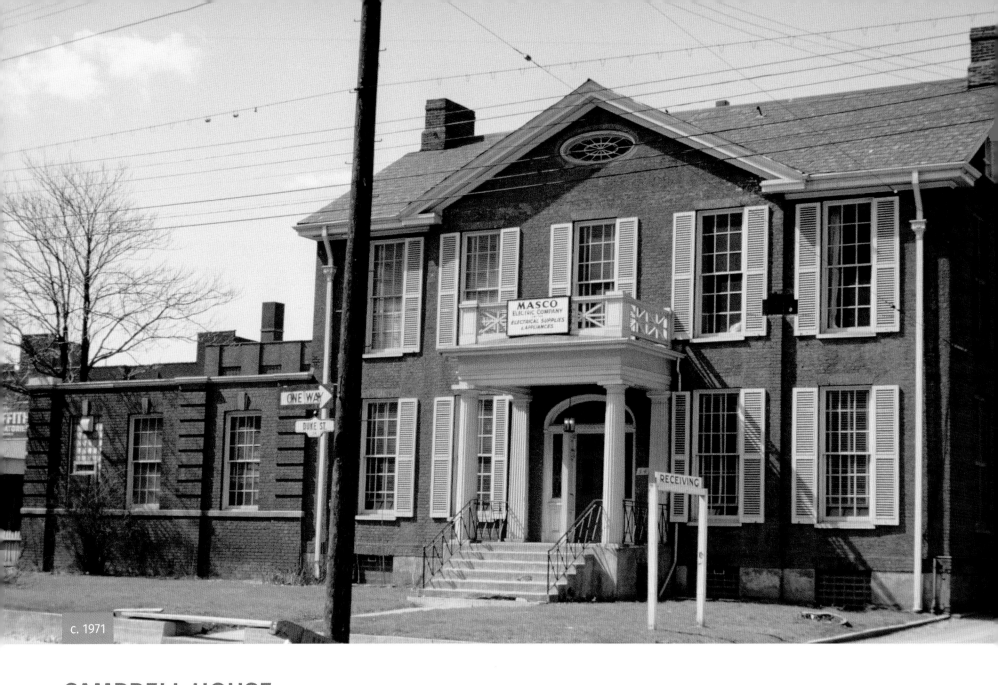

c. 1971

CAMPBELL HOUSE

The "house on wheels" moved from Adelaide Street to Queen Street West in 1972

ABOVE: This photo shows Campbell House when it was on Adelaide Street, prior to its being relocated in 1972. In 1816, Sir William Campbell, Chief Justice of the Supreme Court of Upper Canada (Ontario), purchased land on Duke Street (Adelaide Street), with an unobstructed view of the lake. The land was in the heart of the old town, and in 1822 he began constructing a home on the site, one of the first brick houses in York. Built on stone foundations, it possessed typical Georgian architectural refinements such as an elliptical fanlight window over the door and sidelight windows on either side of the door to allow daylight to enter the hallway within. The facade had nine large windows containing small square panes, with shutters on either side of them. The side walls of the house contained two quadrant windows, one on either side of the bricks containing the chimney flue. These small windows allowed daylight to enter the attic rooms.

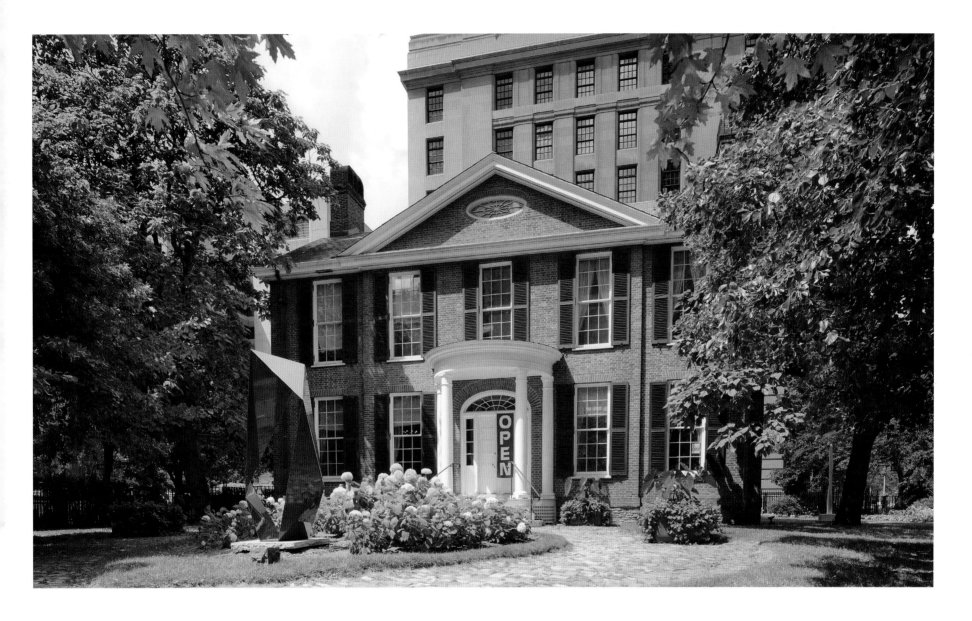

ABOVE: By the turn of the 20th century, the area surrounding Campbell House became industrial. Coutts Hallmark (a greeting card company) bought the home in 1962 for offices and a distribution centre. By the early 1970s, the company wanted to use the land to expand their parking facilities. They vacated the building and offered it to anyone who would remove it from the site. The Advocates' Society, a group of approximately 600 lawyers, formed a foundation to raise the funds to relocate the house to the northwest corner of Queen and University. They pledged $300,000 and the Ontario Government provided a grant of $50,000. The land for it was bought for the sum of $160,000 from the Canada Life Assurance Company. The total cost of moving the house and restoring it eventually cost almost a half million dollars. The relocation of the 300-ton house was on Good Friday, March 31, 1972. Crowds gathered to watch the "house on wheels" being moved 1,617 metres (5,305 feet) through downtown Toronto. It required two years to restore the structure. The home was officially opened to the public by the Queen Mother (Elizabeth) during her visit to Canada in 1974. The house is now a museum and the home of the Advocates' Society.

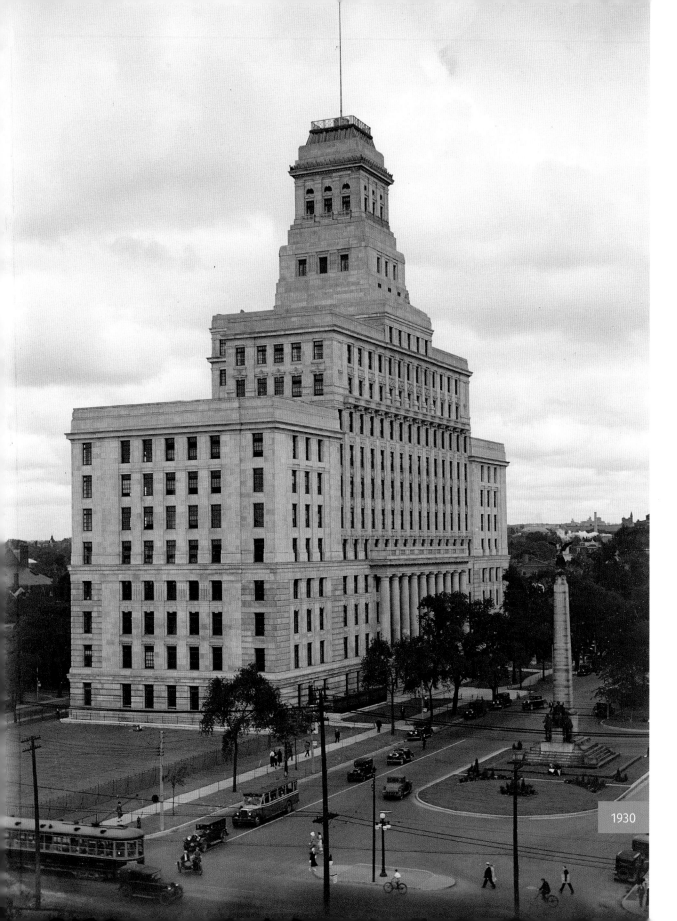

CANADA LIFE BUILDING

Famous for its colourful weather-forecasting beacon

LEFT: The Canada Life Building dominates this view of University Avenue, with the South African War Memorial in the foreground. The 15-storey headquarters of the Canada Life Assurance Company was erected between 1929 and 1931, and the staff moved into it on March 23, 1931. The architects were Henry Sproatt and Ernest Rolph, who chose the Art Deco style. Henry Sproatt, who partnered with various associates, designed the Royal York Hotel and the Eaton's College Street store. During the late-1920s, the city entertained plans to create a grand square with a traffic circle at the intersection of Queen and University. It was to be named Vimy Square to commemorate the strategic battle of April 1917. Due to the Great Depression, the square was never built. The only building erected as part of the ambitious scheme was the Canada Life Building. The photo below shows one of the final stones being put into place.

1930

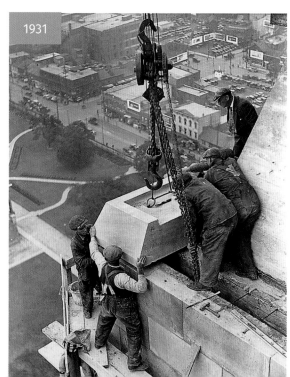

1931

RIGHT: The Great Depression that descended in 1929 not only ended the plans for Vimy Square, but forced Canada Life to reduce the height of its building. From its inception, the public was permitted to visit the Tower Room near the top of the tower. However, by the 1950s, there were several buildings that were much higher, and, because fewer people were visiting it, the observatory was closed. Throughout the years, the Tower Room has been used for receptions and on occasion employed as a space to hold exams for actuarial students. The Canada Life Beacon was installed above the Tower Room in August 1951. This weather-forecasting light, which shines across the downtown area, was inspired by a similar beacon in New York City. A system of changing lights gives the forecast—green indicating clear weather, solid red meaning cloudy, flashing red forecasting rain, flashing white warning of snow. The information is updated four times a day, and today is determined by computer data. The building is still the headquarters of the Canada Life Assurance Company.

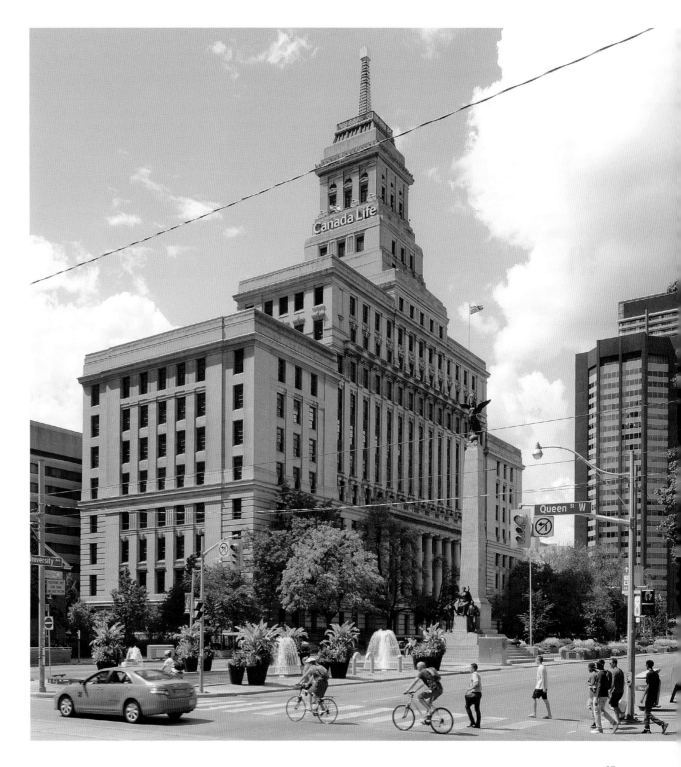

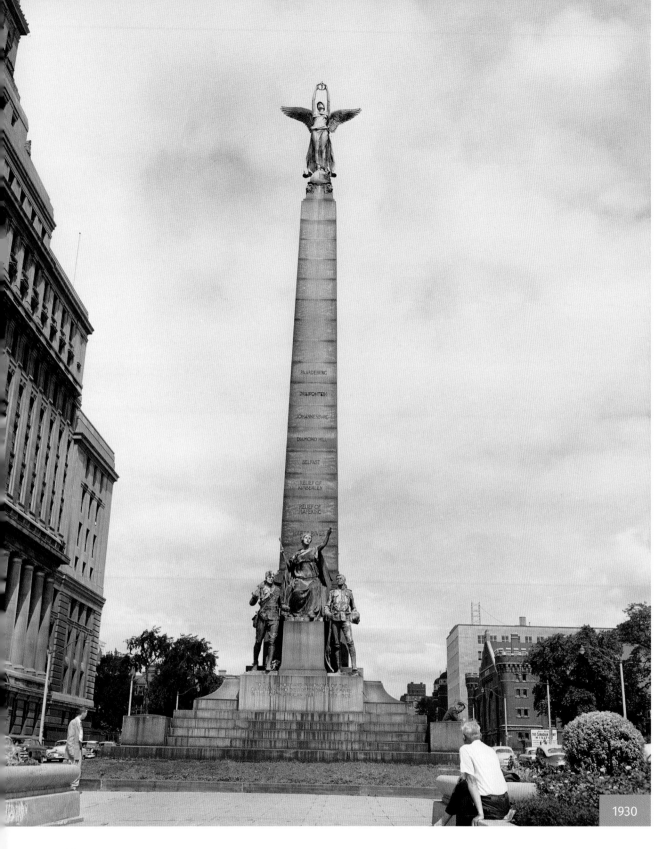

1930

SOUTH AFRICAN WAR MEMORIAL

A monument dedicated to Canadians who fought in the Boer War

LEFT: The Boer War monument, at University Avenue and Queen Street West, commemorates the war in South Africa that commenced in 1899 and ended in 1902; the last of the great imperial wars fought by the British Empire. Between 6,000 and 8,000 Canadians volunteered to fight for Great Britain against the Afrikaners, who were of Dutch heritage. The war was mainly fought against two Boer republics—the Orange Free State and the Transvaal Republic. Of the Canadians who fought in the war, about 90 were killed in combat and approximately 180 died of disease. City officials chose Walter Allward, one of Canada's most prominent sculptors, to design a memorial to honour those who had perished. Allward was born in Toronto in 1876 and attended Central Technical School, later studying in London and Paris. The South African War Memorial was dedicated in 1910 by Sir John French, Commander of the British Forces in World War I. The view below shows the South African War Memorial in the distance with the Canada LIfe Building on the left.

1939

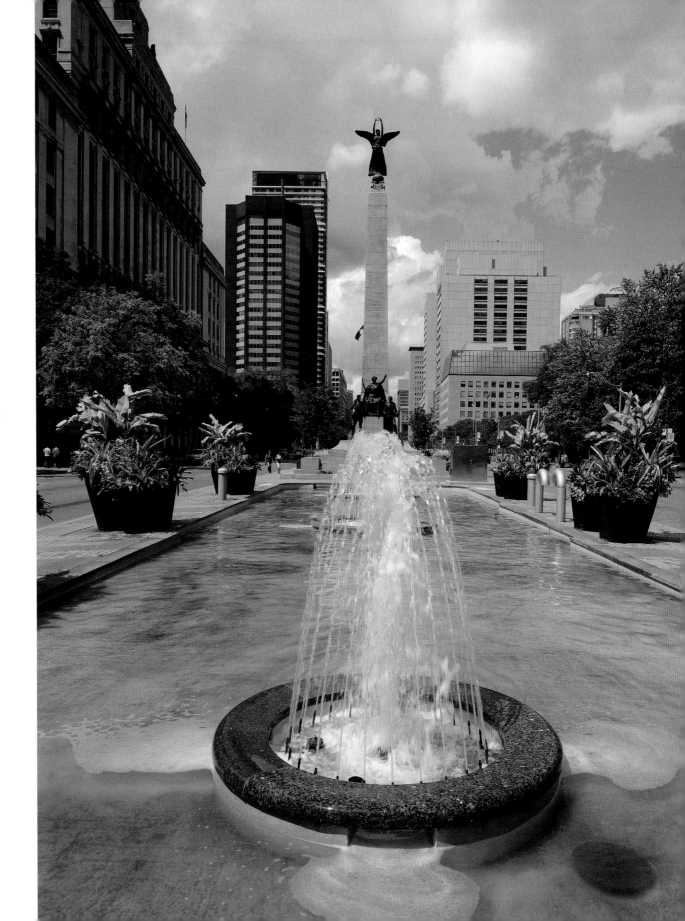

RIGHT: Walter Allward's South African War Memorial still stands proudly at University Avenue. The monument possesses a granite column, and at its base three figures cast in bronze. Two of them are soldiers with resolute countenances, and the third is a symbolic representation of Mother Britain. The monument is crowned by a winged figure holding a golden crown. When it was built, University Avenue terminated at Queen Street and was not extended further south until the 1930s. Today, to the south of the monument, there are ornamental fountains. On the east side of the avenue, a short distance north, was where the Toronto Armouries once stood. Court houses now occupy the site. Allward was later to design the great memorial at Vimy Ridge in France to commemorate the World War I battle of April 1917. Allward's Vimy Memorial was dedicated in July 1936 by King Edward VIII.

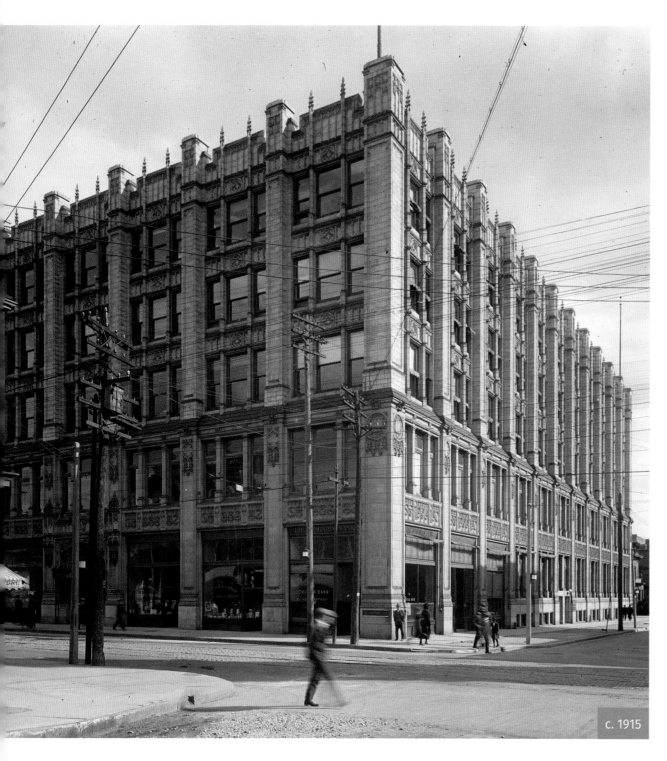

c. 1915

WESLEY BUILDING

Home to the Ryerson Press from
1919 to 1970

LEFT: The five-storey, white "industrial Gothic" Wesley
Building on the southeast corner of Queen West and
John Streets occupies land that was once a part of
the estate of John Beverley Robinson and, later, his
son, Christopher Robinson. Christopher was born in
York (Toronto) in 1828 and educated at Upper Canada
College. The Methodist Church purchased a section
of Robinson's property to construct a building for
its administrative offices and printing enterprises.
In 1913, the architectural firm Burke, Horwood and
White was chosen to design the building. Construction
commenced in 1914, and when completed it was named
the Wesley Building, in honour of John Wesley, the
founder of Methodism. It housed the Methodist Book
Publishing Company and was the headquarters of the
Methodist Church in Canada. In July 1919, its name was
changed to the Ryerson Press, in recognition of the
contributions of Rev. Egerton Ryerson to the Methodist
faith.

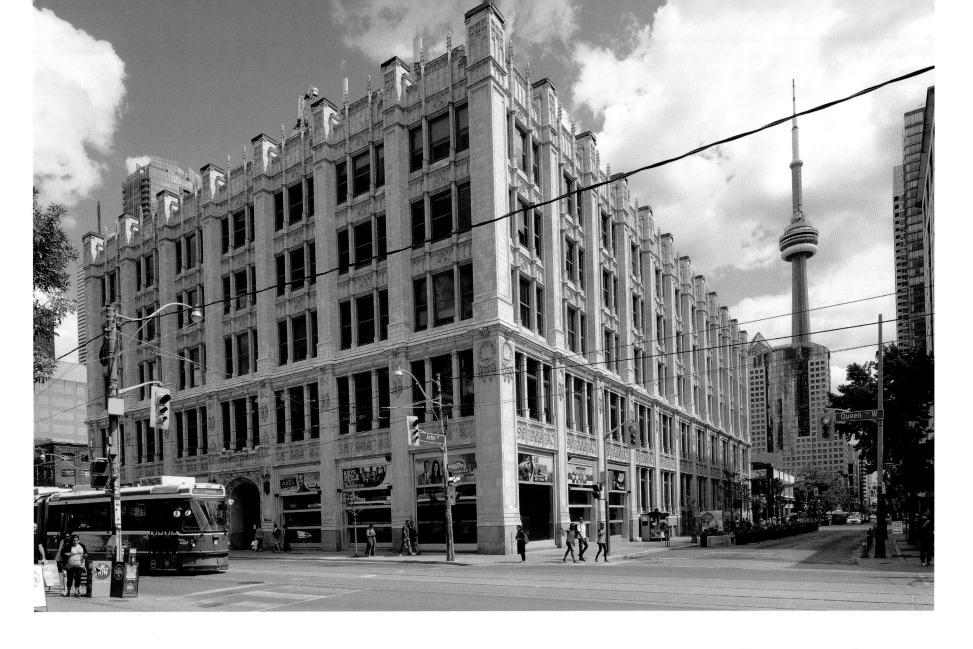

ABOVE: In 1925, most Methodist congregations across Canada became part of the United Church, and the printing facilities on Queen Street became the United Church Publishing House. In 1970, it was sold to an American Company, McGraw-Hill, and in 1984 the building was purchased by the radio station CHUM, which restored the aging structure. Next, it was owned by City TV, and then bought by Bell Media. The Much Music Awards are held each year outside the building. The structure is a mixture of Gothic and Romanesque styles. Three of its facades are covered with precast white terracotta tiles, which contain symbols inspired by the stone traceries in the windows of the great Gothic cathedrals of Europe. There are numerous quatrefoils (patterns with four lobes), and, at the tops of the pilasters, figures that represent "men of learning," some in monk's robes, holding books in their hands (shown right). A heritage preservation project, which was completed in 2007, restored the facades of the building to their former glory.

ST. PATRICK'S MARKET

This designated heritage site began trading in 1836

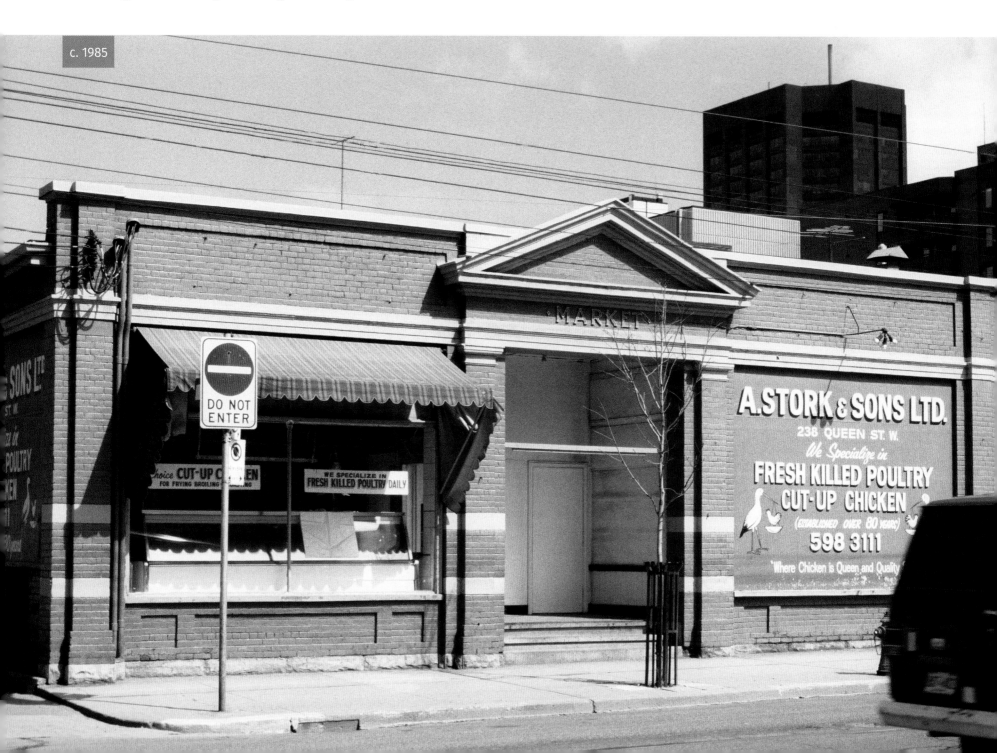

LEFT: This photo of 238 Queen Street West was taken in the 1980s, when St. Patrick's Market was commonly referred to as "the chicken market." A market on this site commenced in 1836, when D'Arcy Boulton (1785–1846), who resided at the Grange (now part of the Art Gallery of Ontario), donated land on Queen Street to the city on condition that it create a public market, open to everyone in perpetuity. The market square was to extend 37.5 metres (123 feet) back from Queen Street, as far as the laneway immediately north of Queen Street. It was Toronto's second market, after the St. Lawrence Market, which had opened 29 years earlier. The new market was to be named St. Patrick's Market as it was in St. Patrick's Ward. The city erected a frame building to protect shoppers from the elements, and farmers brought their produce to the stalls inside the structure.

BELOW: The market's original wooden building was replaced with a modest brick structure in 1856. Three prominent citizens provided the funds for the building, on condition that they would be reimbursed from the profits of the market. The market never became as popular as the St. Lawrence or St. Andrew's markets, but it was important to those who resided within walking distance of its interior stalls. The 1856 building was destroyed by fire and replaced by the market's present-day structure at Queen Street West in 1912. It was designated a heritage site in 1975. It was renovated and modernized several years ago, and the spaces inside the building are now occupied by new tenants. The market is located not far from the Bell Media Building on the southeast corner of John and Queen, on the ever-busy and vibrant Queen Street West.

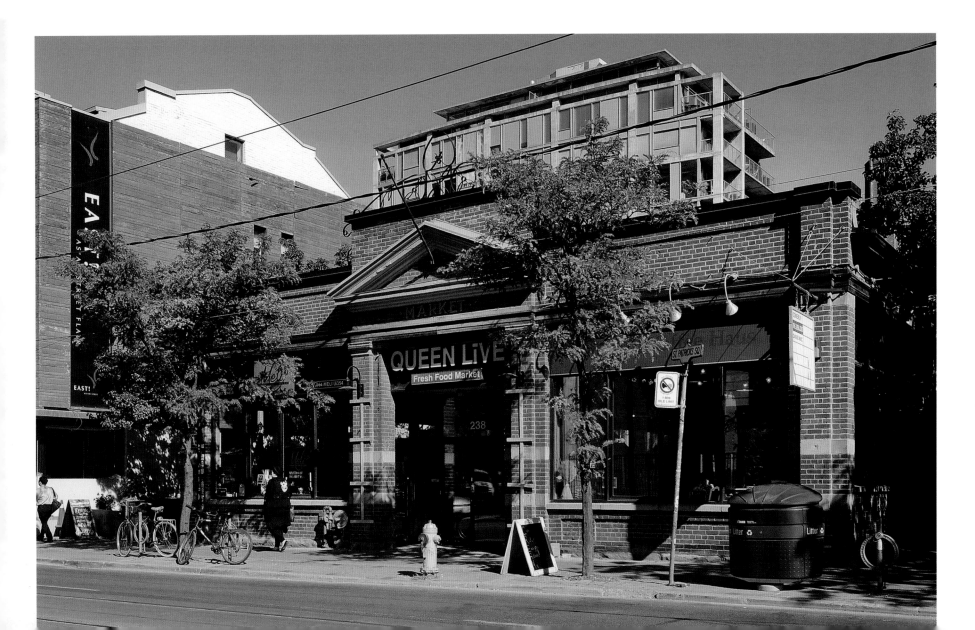

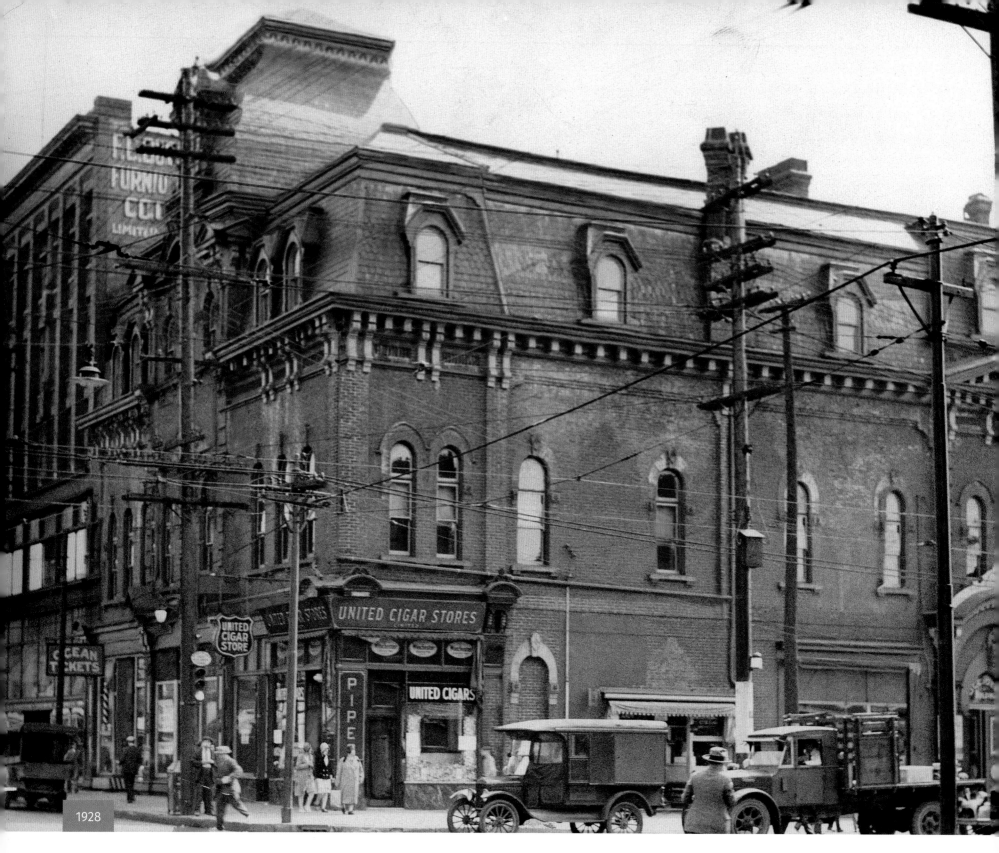

United Cigar Stores
UNITED CIGARS
PIPE
OCEAN TICKETS
UNITED CIGAR STORE

1928

102

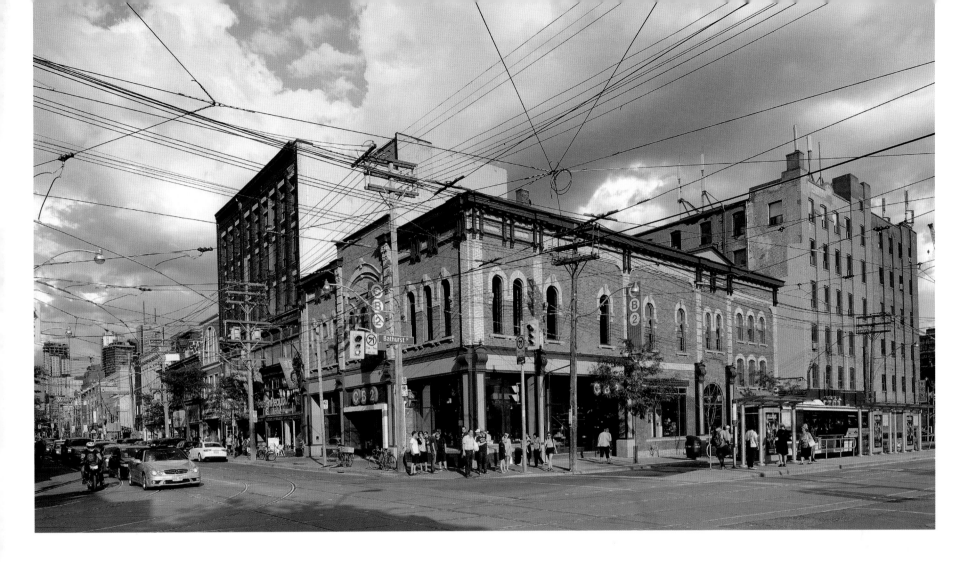

OCCIDENTAL HALL

A building that has changed and adapted through the years

LEFT: The Occidental Hall, located on the southeast corner of Queen Street West and Bathurst Street, was designed by E. J. Lennox, who designed Toronto's Old City Hall, Casa Loma, and over 70 other buildings in Toronto. For the Occidental Hall, constructed in 1876, Lennox chose the Second Empire style. The rooms on the third storey are in the sloped Mansard roof, and on the north and west sides of the Mansard roof there are gabled windows. Above the Queen Street facade there was a flat-topped tower. The Occident and St. George's Chapters of the Masons held their meetings within it. Most Masonic Halls in this era contained large spaces that they rented to derive income for the upkeep of the building. The Chapter Room in the Occidental Hall was considered one of the finest in the city at that time. Other rooms throughout the building were also reputed to contain the best of furnishings.

ABOVE: In 1948, the Occidental Building became the Holiday Tavern. Its Mansard roof and tower were removed, only the first and second floors of the original structure escaping demolition. The sadly reduced building that contained the Holiday Tavern served as a venue for stage shows, then jazz and R&B musicians, and finally as a place to enjoy a beer and watch strippers. In the mid-1980s, it became the Big Bop Night Club and Concert Hall. On the ground-floor level, the red-brick facades were covered with tiles and cement blocks were inserted in the windows. The second floor was painted a garish purple. The Big Bop attracted fans that enjoyed hardcore metal and other types of modern music. However, it closed in 2012. The new owners gutted the interior, replacing the massive pine support-pillars with steel girders. With the interior opened-up, a new space was created, housed within the facades of the old building. Following the three-million dollar restoration, it reopened as a retail store featuring home furnishings.

BANK OF HAMILTON / CANADIAN IMPERIAL BANK OF COMMERCE

A hub of banking for over 100 years

BELOW: This photo of the intersection of Queen and Spadina was taken on April 20, 1912, when the streetcar tracks in front of the Bank of Hamilton were being repaired. In the 1840s, on the northeast corner of the intersection, there was a wood-frame house that was converted into a hotel. In 1856, a tavern/grocery store occupied the site, and then the building became a hotel again. At the beginning of the 20th century, the Bank of Hamilton purchased the property, demolished the structure and the one next to it, and erected the impressive building shown here. Its architect was G. W. Gouinlock, who designed an ornate red-brick building with limestone trim, containing a stone facade on the ground-floor level. For customer convenience, the door was angled so that it was accessible from both Spadina and Queen Streets. Pilasters decorated either side of the main entrance, and above the doorway the architect placed a faux balcony containing pillar-like railings, with ornate, curled brackets for support.

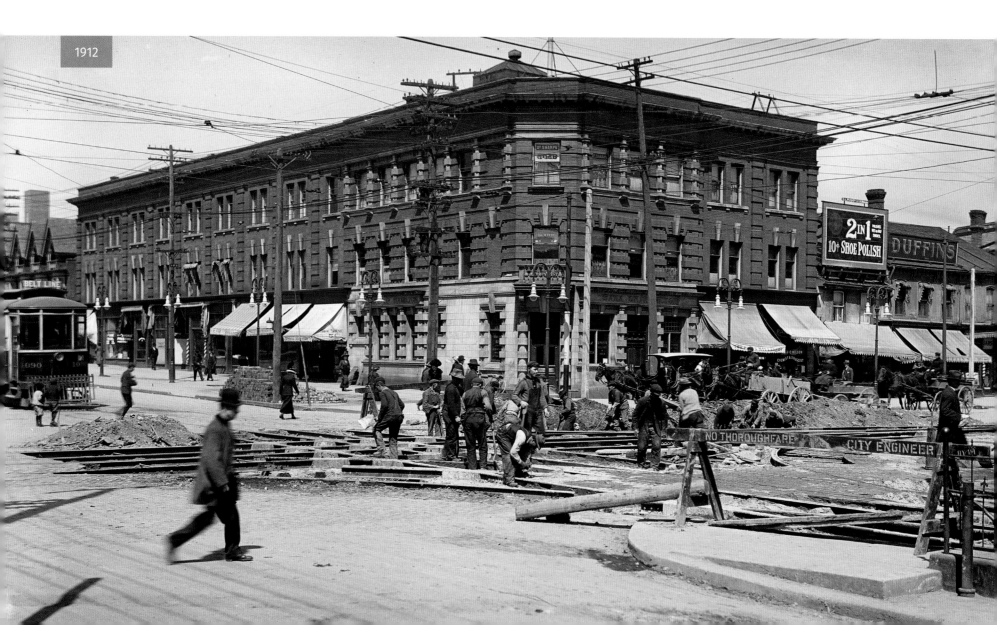

1912

BELOW: In 1925, the Bank of Commerce purchased the property. The Bank of Commerce and the Imperial Bank of Canada merged in 1961 to become the Canadian Imperial Bank of Commerce, and the CIBC still occupies the building today. By modern standards, some might consider the bank's architecture overly ornate due to its excess of decorative detail. It possesses dentils in the cornice and modillions (ornamented brackets) under the eaves, with cement keystones above the windows on the second floor. However, during the era it was built, its architecture was very much admired. The quality of the workmanship was of the highest calibre, putting to shame some of the modern structures that have been constructed near it in recent years. The building was well suited for a bank as it impressed customers with its solid, prosperous appearance. The space outside the bank is now well known for street musicians and buskers who entertain people at all hours of the day and night.

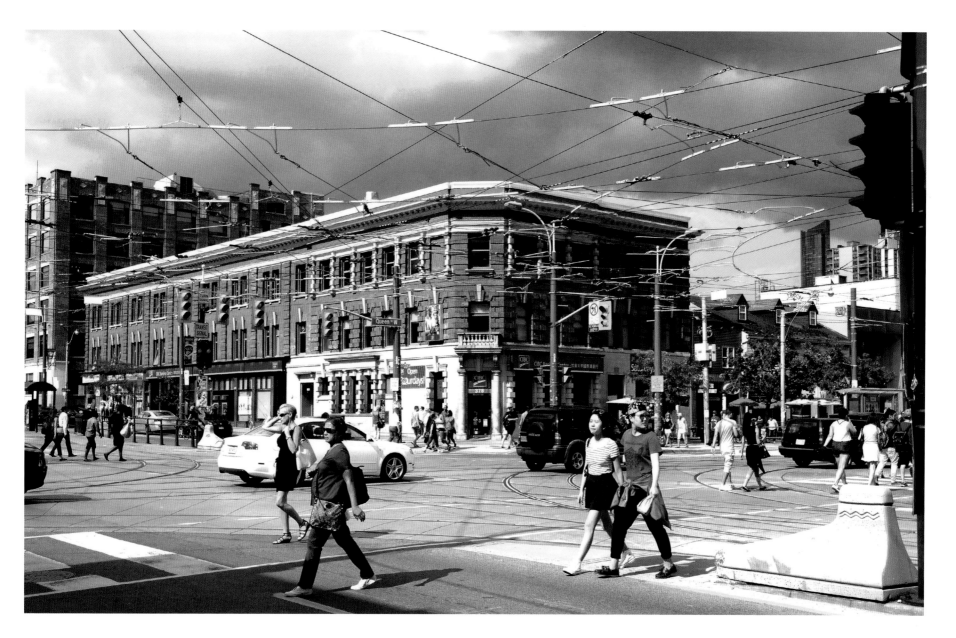

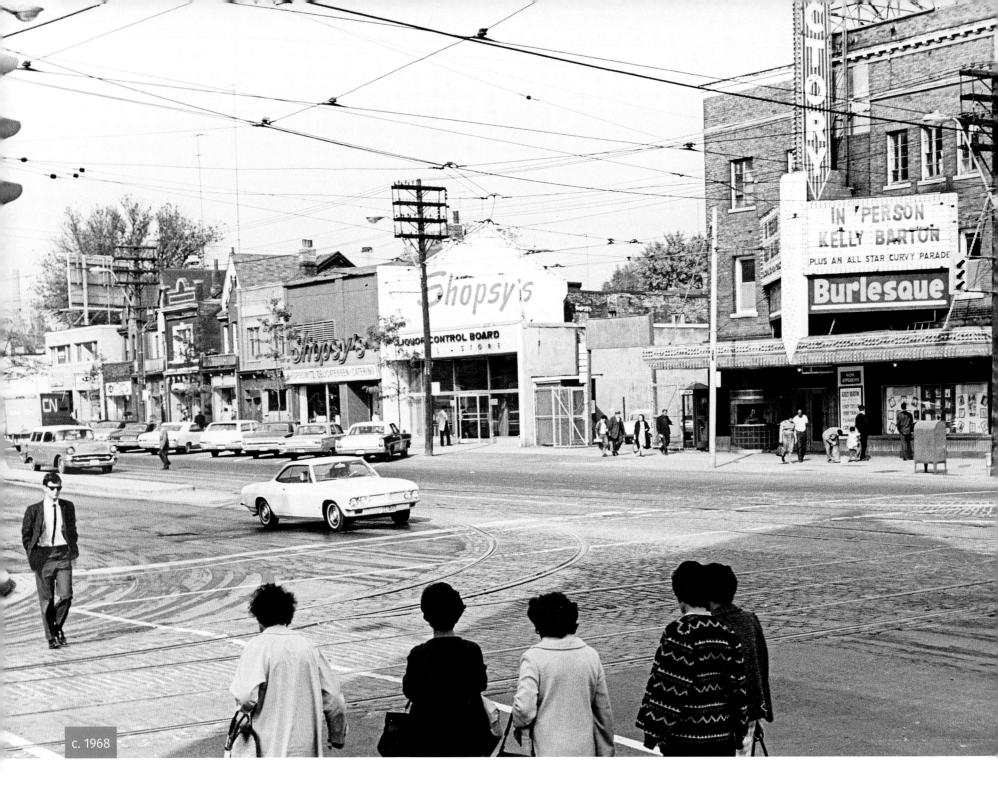

c. 1968

VICTORY THEATRE

Today's unassuming building was once home to risqué burlesque shows

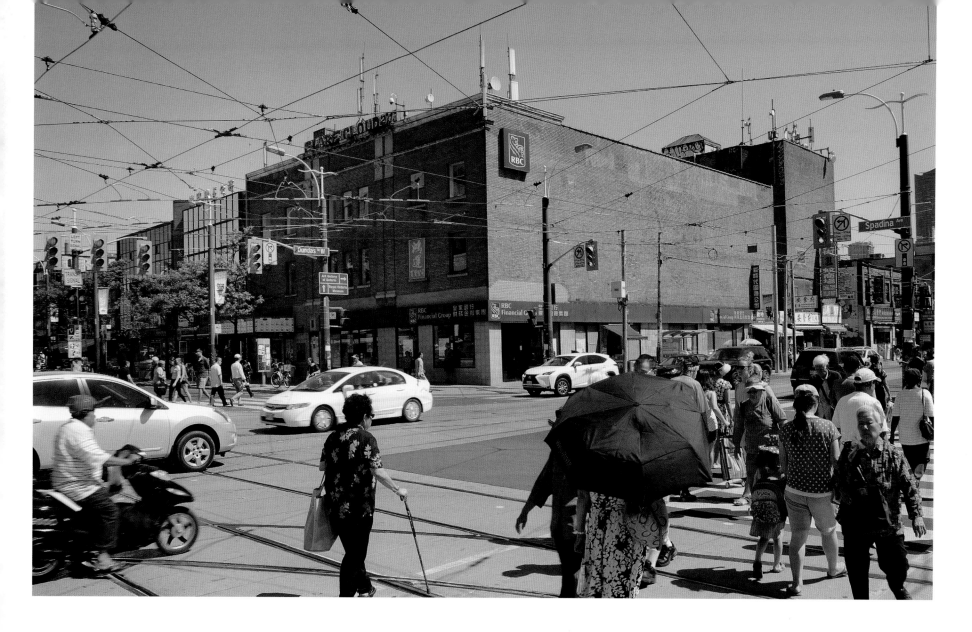

LEFT: This photo shows the Victory Theatre, on the northeast corner of Spadina Avenue and Dundas Street West, in the late 1960s. In this decade, the well-known Shopsy's Delicatessen was a few doors to the north of the theatre. Until 1921, a doctor's house was on the corner, but it was demolished to erect the Standard Theatre. Designed by Benjamin Brown, it was financed by selling shares to the local Jewish community. It became one of the finest Yiddish theatres in North America. A New York touring company performed the classics in the theatre, translating Shakespeare into Yiddish. In 1935, the theatre was renamed the Strand and became primarily a movie house. To celebrate the end of World War II, the theatre's name was changed to the Victory. In this decade, it also changed its format and began featuring burlesque and live theatre, some of the female dancers on its stage becoming notorious, such as Ineda Mann and Jewel Brynner, who was bald.

ABOVE: The building that housed the infamous theatre is today located in the centre of one of Toronto's Chinatowns. It is difficult to believe that in the 1960s it was a risqué burlesque house that brought numerous complaints from outraged citizens. Under constant scrutiny by the morality squad, it was frequently raided. In 1962, the theatre was cited for displaying signs on the sidewalk showing semi-clad girls. The Victory Theatre became a favourite hangout for university students and others who enjoyed watching burlesque shows, though by modern standards it was all quite tame. During the 1970s, the demographics of the area surrounding the theatre slowly changed, and the district became the focal point for an Asian community. In 1975, Hang Hing bought the theatre, renovated it, and renamed it the Golden Harvest Theatre to screen Asian films. Finally, the theatre was closed and the building was converted for other commercial purposes, including several shops and a bank. However, inside the structure, the old theatre's auditorium remains intact.

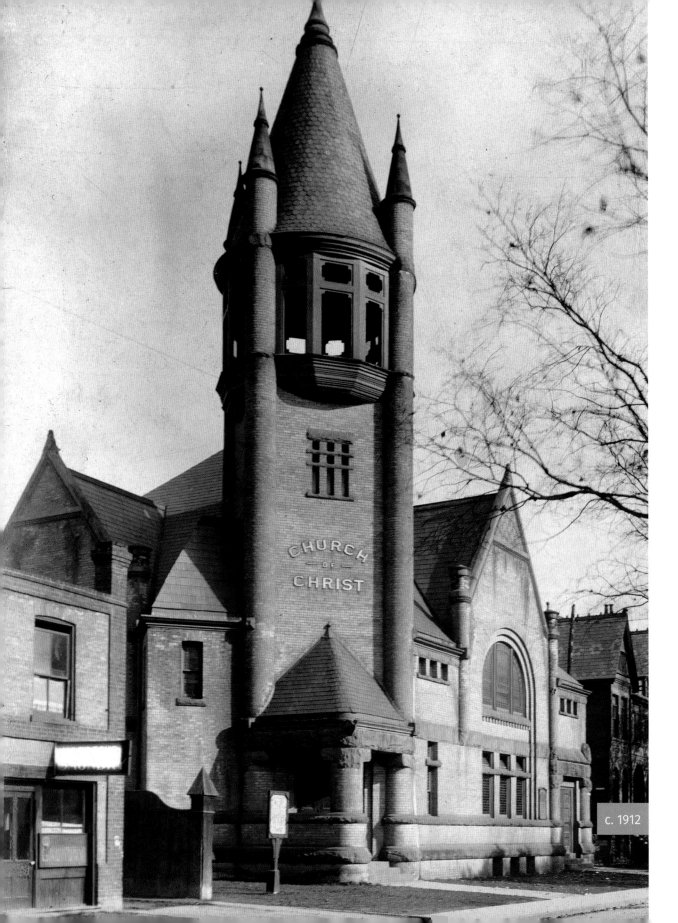

c. 1912

CHURCH OF CHRIST (DISCIPLES) / OSTROVTZER SYNAGOGUE

This place of worship is now a community centre

LEFT: The Church of Christ (Disciples) was constructed in 1891 at 58 Cecil Street—one block south of College Street, to the east of the ever-busy Spadina Avenue. The architects of the church were Knox and Elliott, who also designed the impressive Confederation Life Building on the northeast corner of Yonge and Richmond Streets. Similar to the Confederation Life Building, they chose a Romanesque Revival style. The church's heavy, fortress-like appearance contained large stones and solid shapes. The stained-glass windows facing Cecil Street possessed a large Roman arch above them. The stone foundations and the blocks above the small east door resembled those of Toronto's Old City Hall, another Romanesque Revival structure. The top of the 29-metre (95-foot) bell tower was pointed; at its base was a massive stone portico. The church was basically a 20-metre (65-foot) square, constructed of pale yellow bricks, containing large gables on the south and west sides.

RIGHT: When the demographics of the Spadina area changed, the congregation dwindled and the church was sold in 1925 for $20,000. It was purchased by the Ostrovtzer Synagogue, founded in Toronto in 1908, its name derived from a city in Poland. The building was renovated when it became a synagogue. The bell tower was replaced with a new tower that was aligned parallel to the street, containing a small dome instead of a pointed top. The demographic of the community changed again, and in 1966 the Jewish congregation sold the building to the Catholic Diocese for a centre to aid the Chinese community. The property changed hands again in the 1970s when the Community Homophile Association occupied it as a centre for promoting gay rights. In 1978, it was purchased by the City of Toronto and it became a community centre. Today, the community centre serves the needs of the residents in the Kensington area.

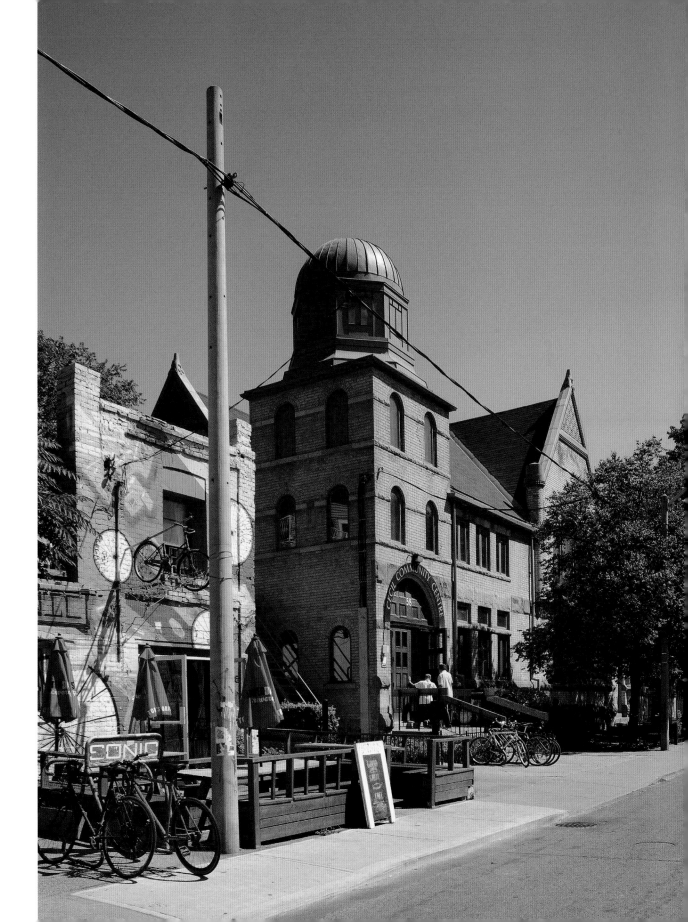

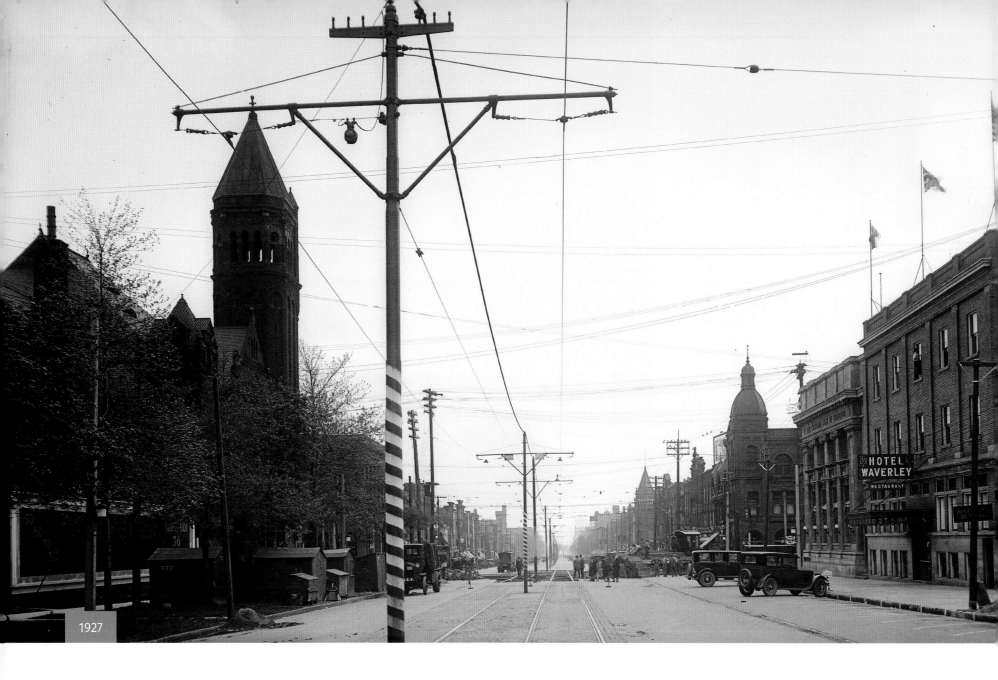

1927

HOTEL WAVERLY

The spelling may have changed but the hotel is still in business

ABOVE: This photo of Spadina Avenue, a short distance north of College Street, was taken on May 20, 1927. The Hotel Waverly, on the right-hand side of the photo, is to the north of the Bank of Commerce, which is on the northwest corner of Spadina and College. The corner was originally part of a market garden that extended north of College Street. Eventually, cottages were built on the site, but they were demolished in 1882 to permit the building of a three-storey YMCA, which contained a branch of

the Bank of Commerce on the ground floor. When the YMCA vacated the upper floors, they became the first location of the Hotel Waverly. In 1900, the YMCA building was demolished because the bank wished to construct a new building and occupy the entire site. J. J. Powell relocated the Hotel Waverley a short distance to the north, at 484 Spadina Avenue, and in 1925 increased the size of the hotel. The large building on the left, the Broadway Tabernacle Methodist Church, was demolished in 1930.

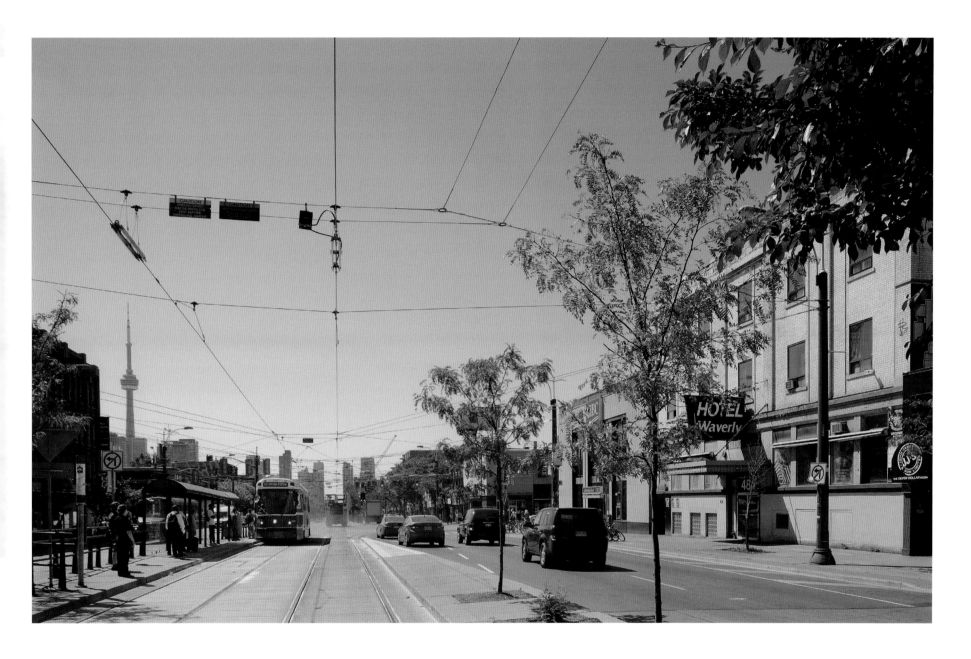

ABOVE: The spelling of the name of the hotel has not been consistent throughout the years. In the older photo it is spelled "Waverley" and in the present-day sign it is "Waverly." In 1955, the lounge in the hotel received a liquor license, and in 1958 the Silver Dollar Room was added on the north side of the building. An historic plaque on the east wall of the hotel states that Milton Acorn, who was born in Prince Edward Island, lived in the hotel from 1970 to 1977. He became a famous poet, and was often referred to as "The People's Poet." In 1976, he won the Governor General's Award for a collection of poems, *The Island Means Minago*. In 1984, the National Film Board produced a film featuring him, *In Love and Anger: Milton Acorn—Poet*, followed by another film about his life in 1988. Milton Acorn will forever be associated with the Hotel Waverly. The original Bank of Commerce was demolished in the 1970s and the site is now occupied by a branch of the Canadian Imperial Bank of Commerce (CIBC).

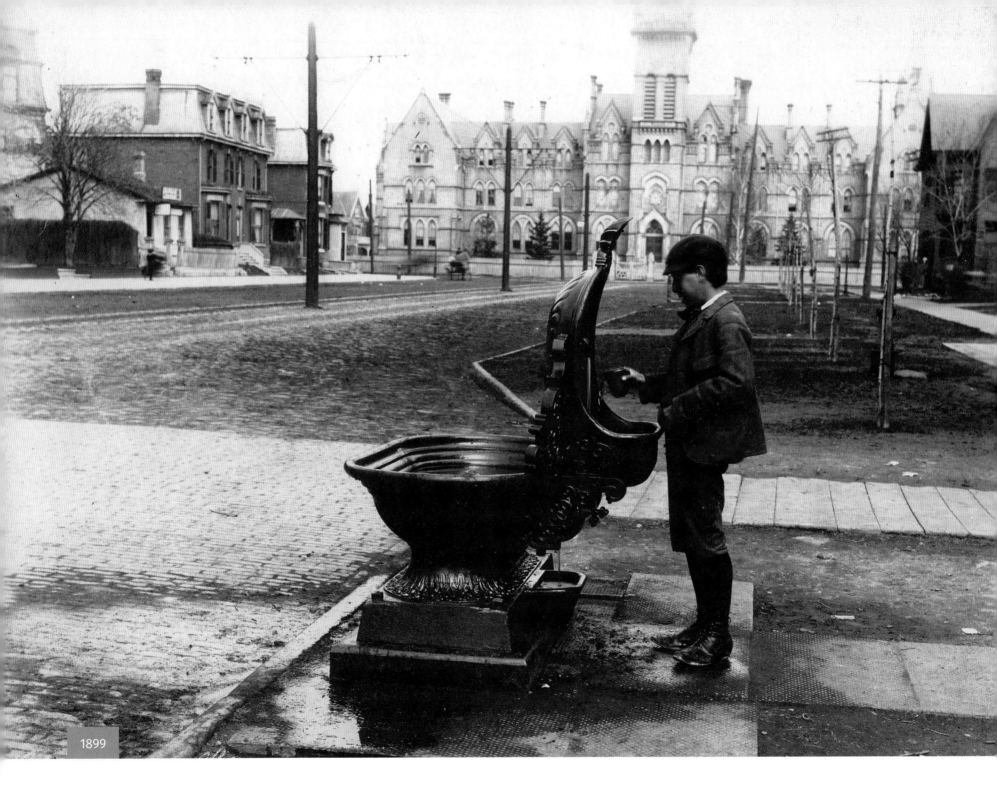

1899

KNOX COLLEGE

A Gothic Revival building with a reputation for being haunted

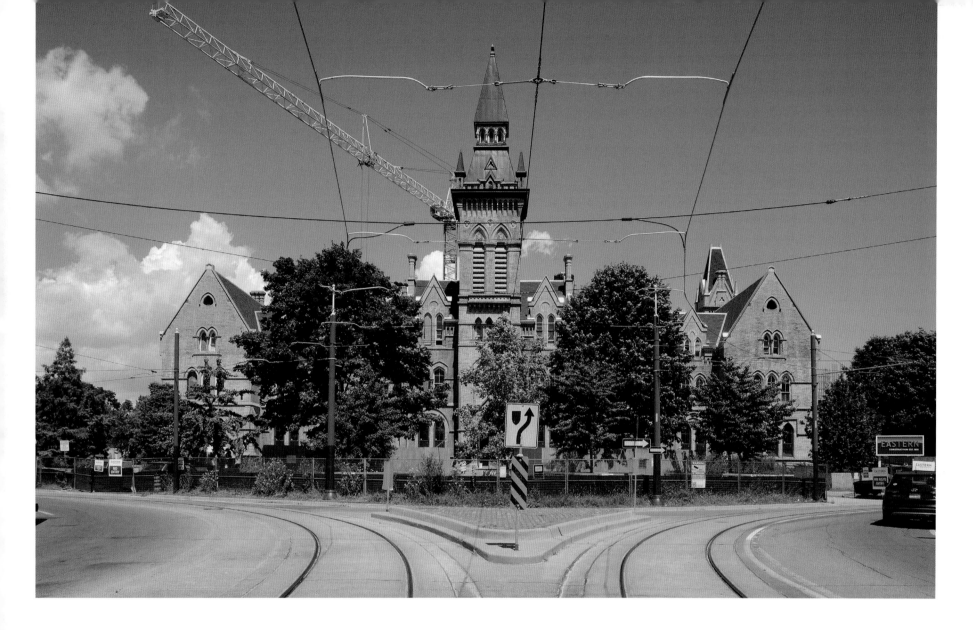

LEFT: This charming photo of a boy at a public fountain is looking north on Spadina Avenue from near College Street. At the head of Spadina Avenue, where the street divides and its name changes to Spadina Crescent, is one of Toronto's grand structures from the 19th century. The ornate building was the early-day site of Knox College. The Hon. J. McMurrich (1804–83) paid $10,000 for the land and donated it to the Presbyterian College to construct a large building for their faculty and students. They named it after the famous Scottish theological reformer, John Knox. The new college was designed by architects Smith and Gemmell. Its pointed Gothic windows, wall dormers, turrets, gables, and gargoyles reflected the Gothic Revival style of architecture. The college commenced conferring degrees in theology in 1881. In 1887, it federated with the University of Toronto, and in 1915 its staff and students relocated to King's College Circle.

ABOVE: After Knox College vacated the premises, the building served as the armouries for a Toronto regiment and later became the Spadina Military Hospital. For a few months in 1918, the famous pilot Amelia Earhart worked in the hospital as a nurse's aide. In 1943, the premises were purchased by the Connaught Laboratories, named after the Duke of Connaught, the third son of Queen Victoria, who served as Canada's Governor General from 1911 to 1916. The laboratory became a world leader in developing penicillin and insulin, which were manufactured on the premises. The University of Toronto acquired the property in the 1970s. Today, the old Knox College building has a reputation for being haunted. In 2001, a professor was murdered there and on September 10, 2009, a woman fell to her death from the third floor while on a ghost hunt. The building continues to sit prominently at the top of Spadina Avenue and is in the process of being restored.

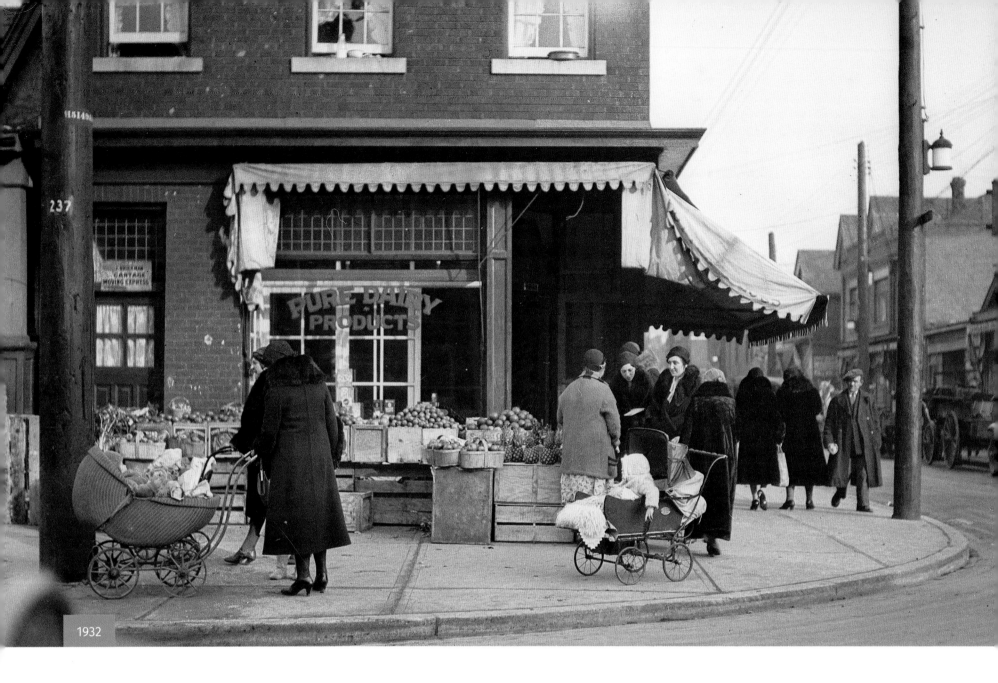

1932

KENSINGTON MARKET

By the 1930s the market was a vibrant shopping area with a European "shtetl" atmosphere

ABOVE: This unique photo of the northeast corner of Baldwin Street and Augusta Avenue in the Kensington Market was taken on January 14, 1932. The history of the market began around 1900, when many Jewish immigrants arrived in Toronto in an era when religious and ethnic tolerance was not the norm. As a result, Jewish workers earned a living in a manner that gave them independence. This allowed them to take time off work to worship on the Sabbath, which meant that though they lost a day's income, their source of livelihood was not threatened. Some commenced earning a living by selling goods from a knapsack and, as soon as possible, acquired a push-cart. Many chose the "rag trade," as its low prestige meant there was not much competition. Others sold fruit and vegetables from their carts. All these enterprises required very little capital and allowed the vendors freedom to worship on the Sabbath as their traditions instructed.

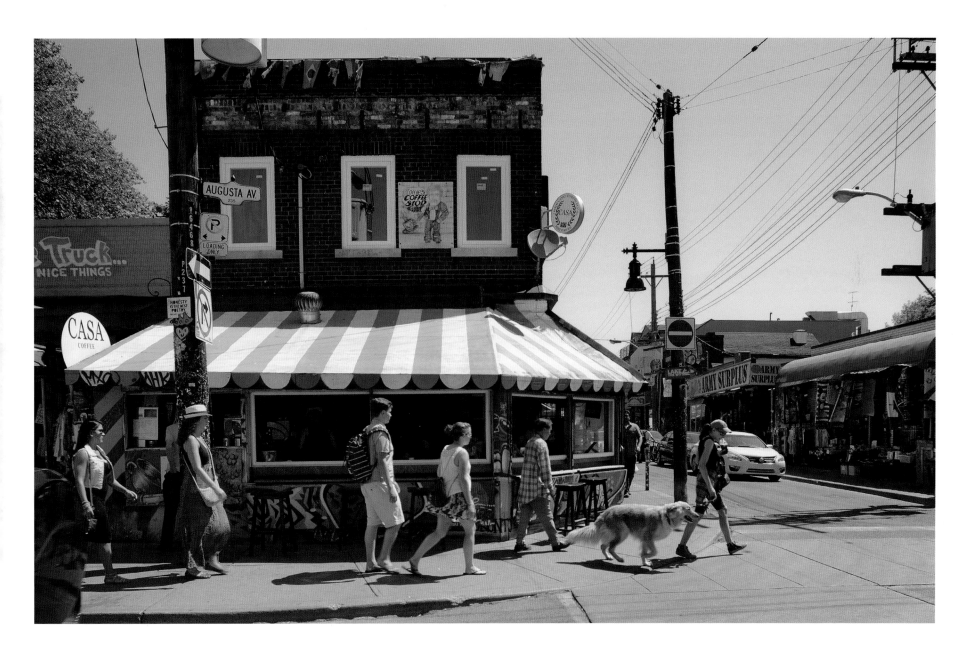

ABOVE: In the second decade of the 20th century, when Anglos moved out of the Kensington area, Jewish families moved in. Kensington was close to the garment shops on Spadina, and the small homes in the area, built on narrow streets, were inexpensive to purchase. Jewish families renovated the houses to suit their needs. When funds were available, some Jewish families built stalls across the front of their small homes and they sold goods, while others employed the front rooms of their houses. Eventually, stores were erected on the front of the homes. Merchants and their families lived above the stores or behind them. The district was transformed from a quiet residential Anglo community into a vibrant shopping area with a European "shtetl" atmosphere. The Kensington Market was born. It is no longer a Jewish market, but is mostly Asian, West Indian, and Portuguese shops, as well as vintage clothing stores.

THE GRANGE

Frank Gehry's extension to the Art Gallery of Ontario provides a dramatic backdrop for this Georgian mansion

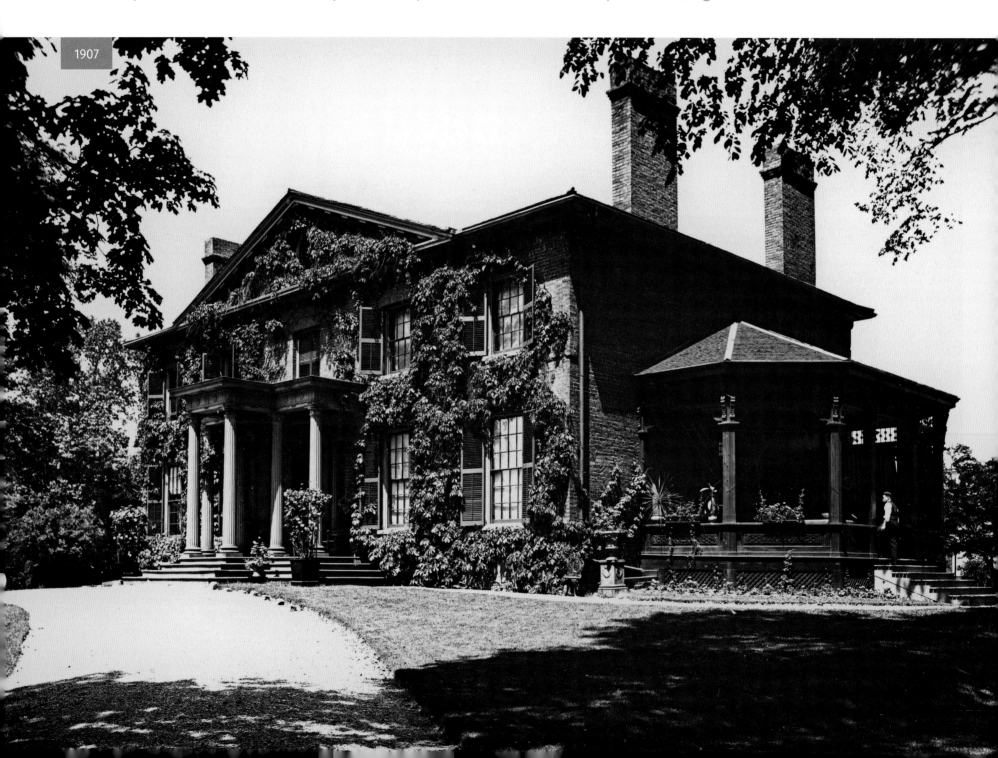

1907

LEFT: In 1808, Mr. D'Arcy Boulton Jr. purchased 13 acres on the edge of York (as Toronto was then known) and named it the Grange Estate, after his ancestral home in England. In 1817, he erected a residence at a time when brick buildings were first appearing in the small town. The original gates to the estate were located on today's Queen Street West, at John Street, as Queen Street was the southern boundary of his property. Inside the gates of the Grange, historical accounts state that two of Mr. Boulton's horses encountered a wild bear and fended off the attack. The carriageway that led from the Grange to Queen Street became the northern section of John Street, named in honour of Governor John Graves Simcoe. Another street, to the east of John Street, was also named after the governor—Graves Street. However, it was eventually changed to Simcoe Street and retains this name today.

BELOW: Today, the Grange is on the south side of the Art Gallery of Ontario. Frank Gehry's extension, which opened in 2008, includes the magnificent spiral staircase seen here hovering over the Grange. D'Arcy Boulton's eldest son, William Henry Boulton, inherited the Grange. He married Harriet Dixon in 1846, and they added an extension on the west side of the house. William died in 1874, and the following year Harriet married Goldwin Smith, a scholar who had taught history at Oxford and Cornell universities. They built another addition on the west side of the Grange to accommodate his library. They lived in the Grange for the remainder of their lives, entertaining guests such as a young Winston Churchill and the future King Edward VII. Harriet Smith died in 1909 and Goldwin passed away the following year. It was Harriet's idea to bequeath the Grange to the Art Museum of Toronto for a permanent site for its exhibitions. In 1970, the Grange was declared a National Historic Site.

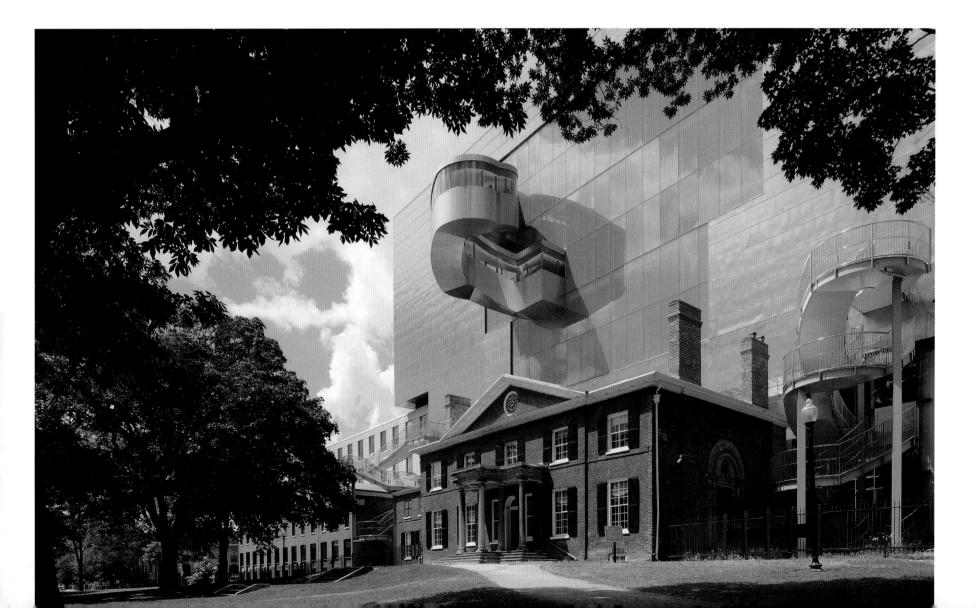

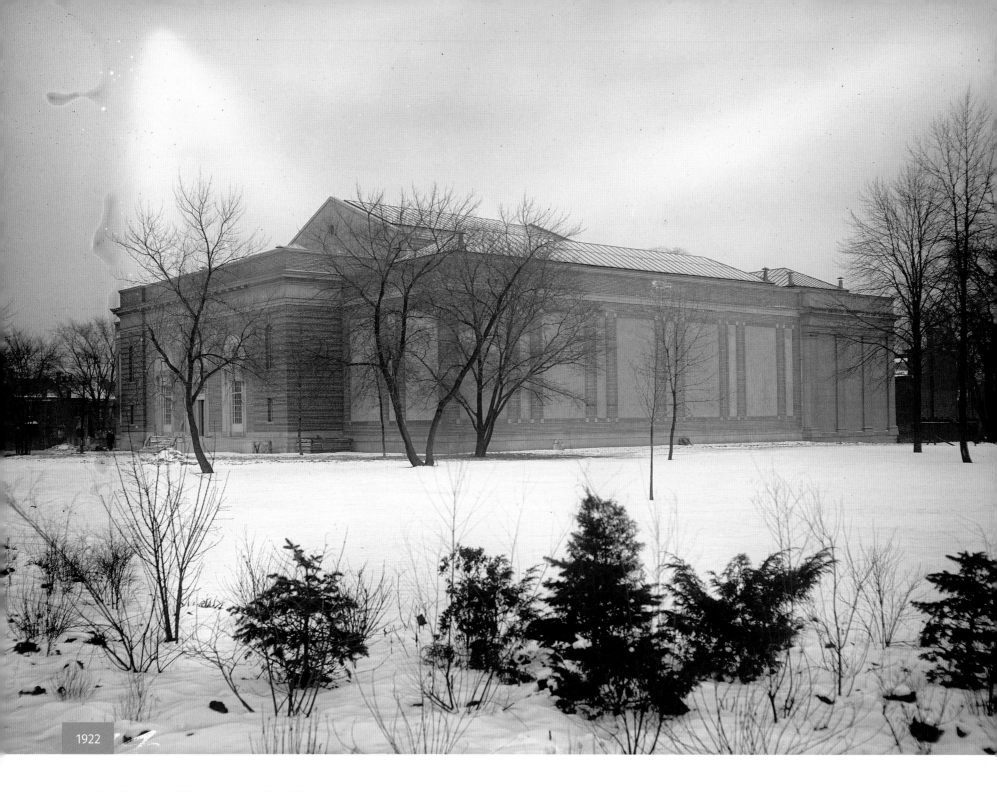

1922

ART GALLERY OF ONTARIO

Now home to the largest collection of Henry Moore sculptures in the world

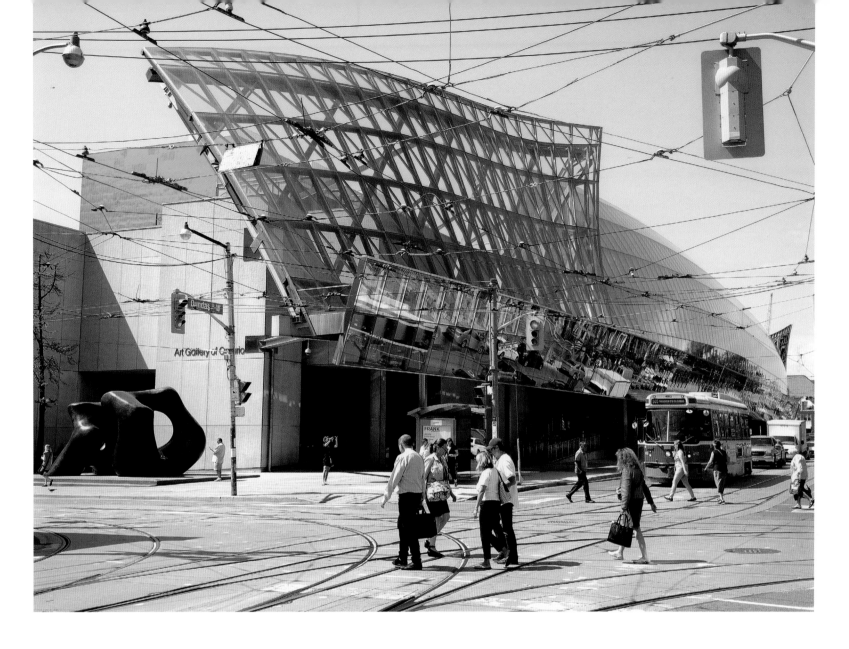

LEFT: This view of the Art Gallery of Toronto is taken from the southeast corner of Dundas and McCaul. In 1900, the Toronto painter George Reid, president of the Ontario Society of Artists, joined forces with a prominent banker Edmund Reid to raise funds to create the Art Museum of Toronto. In 1909, the Grange, the Georgian mansion of Goldwin and Harriet Smith, was bequeathed to the society for an art gallery. The home was located south of Dundas Street, between McCaul and Beverley Streets. The first exhibition in the Grange was on June 5, 1913. To allow the gallery to expand, the Ontario Government purchased land on Dundas Street to the north of the Grange. In 1916, construction commenced on the new gallery, designed in the Beaux-Arts style by architects Darling and Pearson. The square-shaped Art Museum of Toronto opened on April 4, 1918. In 1919, its name was changed to the Art Gallery of Toronto.

ABOVE: The first group exhibition of the Group of Seven landscape painters was held in the Art Gallery of Toronto in 1920. Another wing was added in 1926 and two more galleries in 1935. In 1966, it was renamed the Art Gallery of Ontario. During the 1970s, space was added for the gallery's Henry Moore sculptures, as well as a new Canadian wing. In 1993, the Tanenbaum Sculpture Atrium was built and in 2002 Toronto-born Frank Gehry began transforming the gallery. An enormous structure of glass and natural wood, named the Galleria Italia, was built on the side facing Dundas Street. On the south side of the gallery, behind the Grange, a four-storey wing was added. The total cost was $500 million. Ken Thomson donated $50 million of the funds, along with 2,000 works of art. In November 2008, the transformed gallery was opened. The Art Gallery of Ontario's collection contains 2,000 years of art history, over 80,000 works of art, and the largest collection of Henry Moore sculptures in the world.

MACKENZIE HOUSE

Once home to William Lyon Mackenzie, radical journalist, political reformer and the city's first mayor

LEFT: This photo shows Mackenzie House at 82 Bond Street in the mid-1950s. William Lyon Mackenzie, born in Scotland, immigrated to Upper Canada (Ontario) and eventually settled in the town of York (Toronto), the provincial capital. Through his newspaper, the *Colonial Advocate*, he agitated for Responsible Government in Upper Canada. In the autumn of 1837, he and a group of followers took up arms against the government, a struggle that became known as the Rebellion of 1837. It was crushed, and Mackenzie fled to the United States, where he lived in exile for 12 years. During his absence, Upper Canada achieved Responsible Government. In 1849 the government granted an amnesty to those who had participated in the rebellion, and in 1850 Mackenzie returned to Toronto. In 1859, the house on Bond Street was given to him by the grateful citizens of Toronto in recognition of the role he had played in reforming the Canadian political system. The photo below, taken on May 9, 1919, is looking south on Bond Street from Dundas Street East. Obscured by trees, Mackenzie House is on the right-hand (west) side of the photo, six houses from the corner.

1919

c. 1955

RIGHT: Mackenzie's yellow-brick townhouse, built in the Greek Revival style, was originally part of a group of row houses, with houses attached to it on either side. After Mackenzie died in 1861, his family continued to live in the house and remained there until 1871, when they leased it to tenants. They sold it in 1877, and the home had various owners during the years ahead. The house was opened as an historic site in 1950, and in 1967 an addition was built on it that contained a reconstruction of an 1860s print shop and a gift shop. Today, the home has been furnished to reflect the lifestyle of the Mackenzie family. Viewing its cozy rooms with their gas ceiling-fixtures for lighting provides an intimate look into the lives of the family. It is reported to be one of the few documented haunted houses in Toronto. An historic site, it is fascinating to visit, its location only a few blocks from the Eaton Centre.

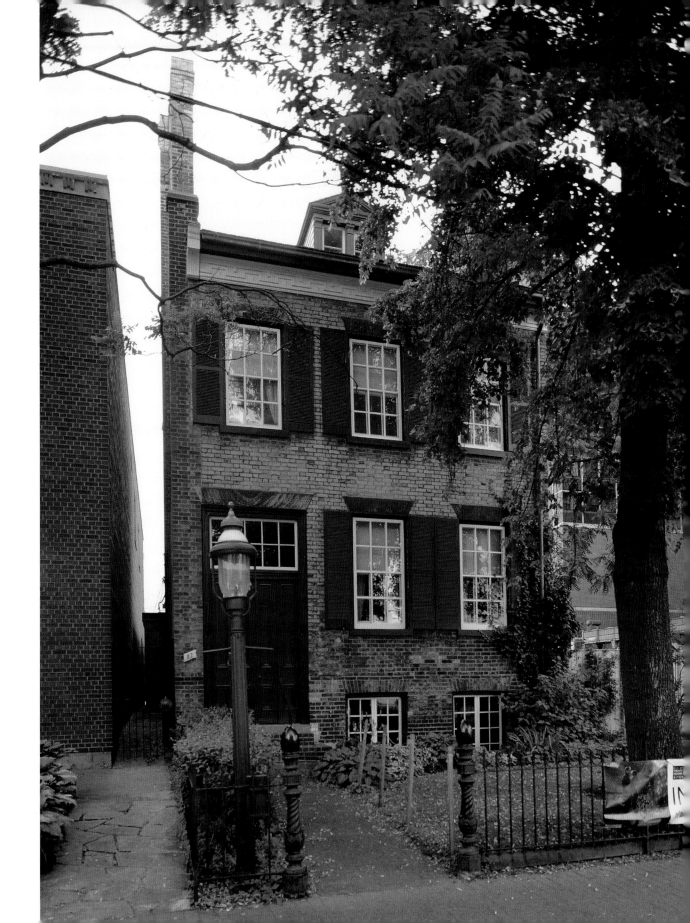

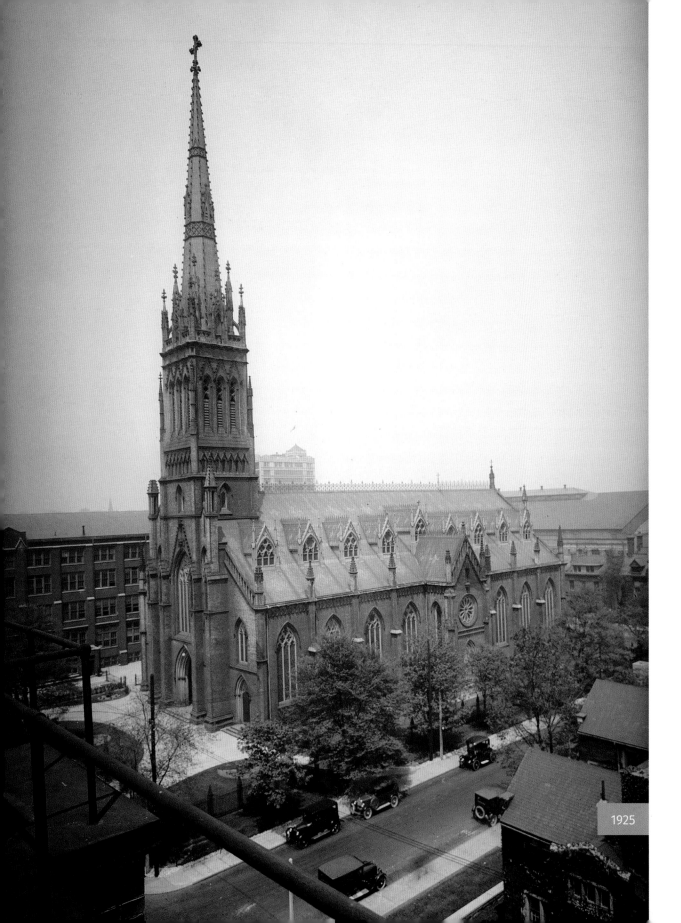

1925

ST. MICHAEL'S CATHEDRAL

The Cathedral Church of the Roman Catholic Archdiocese of Toronto

LEFT: Designed by William Thomas, the construction of St. Michael's Cathedral began in 1845 and was completed in 1848. The tower and spire, designed by the architectural firm of Gundry and Langley, were added in 1870. There is a mystery as to why they were selected for the commission, as Mr. Thomas remained active as an architect when the contract was awarded for the tower and had already created the plans for it. His architectural drawings can be viewed today in the collection of the Toronto Reference Library. The dormer windows in the roof were the work of Joseph Connolly and were added in 1890. Windows in a cathedral roof were not common features, as although they allowed extra light to enter the nave (as seen below), they interrupted the broad sweep of the roof.

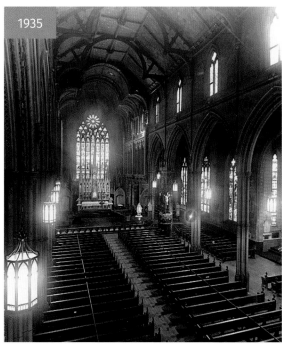

1935

RIGHT: Located on the northeast corner of Bond and Shuter Streets, St. Michael's is the Cathedral Church of the Roman Catholic Archdiocese of Toronto. The restoration of the spire of St. Michael's was completed in 2013, and it appears as magnificent today as it did when first built. The church is in the neo-Gothic style, possessing strong vertical architectural lines, numerous pinnacles, and a cross at the top of the tower. The inspiration for the church was derived from the Gothic cathedrals of 14th-century England. The stained-glass chancel window on the east side of the church was the work of Étienne Thévenot, and was installed in 1858. Bishop Michael Power was instrumental in purchasing the land for St. Michael's and raising the funds for its construction. He died before it was completed, his funeral held at St. Paul's on Queen Street East. However, he was buried in the crypt of the unfinished St. Michael's Cathedral.

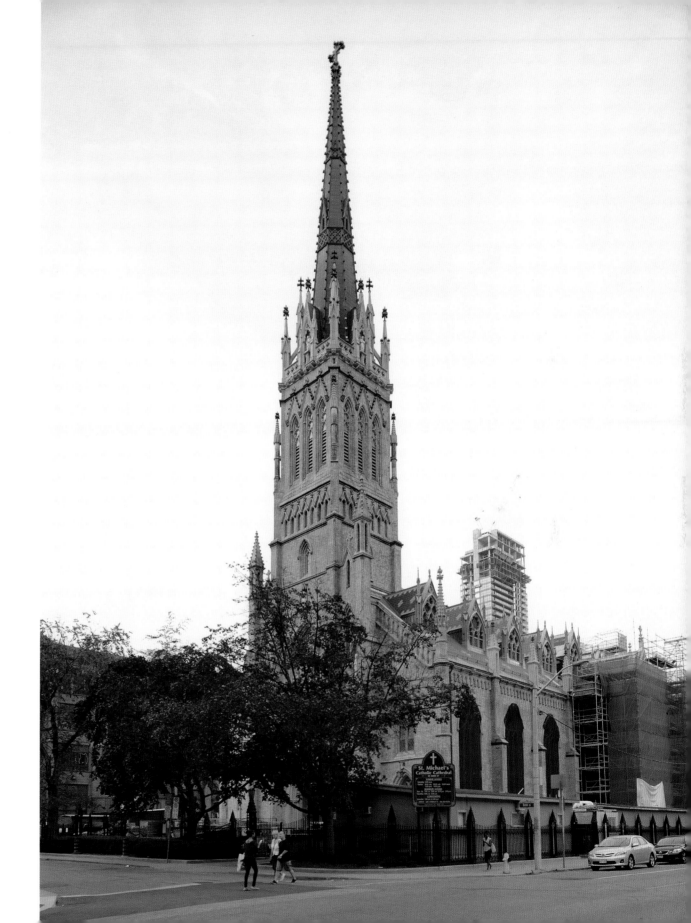

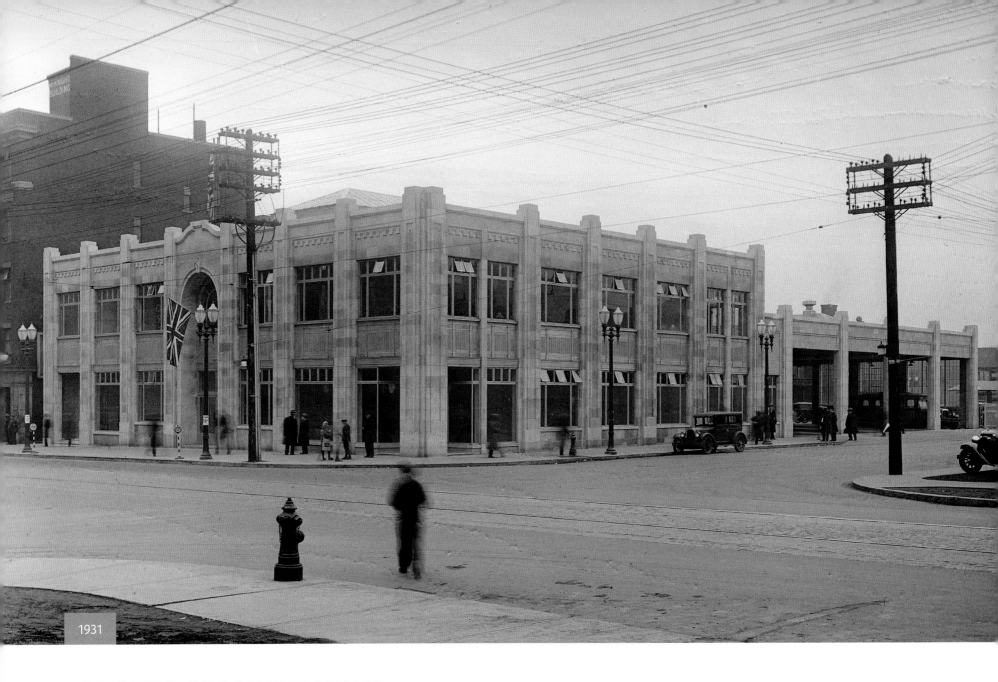

1931

TORONTO COACH TERMINAL

A beautifully preserved example of Toronto's Art Deco architecture

ABOVE: This photo captures the bus station at 610 Bay Street, on the southwest corner of Bay and Edward Streets, on the day it opened—December 19, 1931. The picture was taken from the east side of Bay Street, a short distance north of Dundas Street West. A Union Jack flag can be seen above the main entrance on Bay Street. Originally known as the Gray Coach Terminal, it was the central depot for the Gray Coach interurban bus service. The 1920s and 1930s were the golden decades of streetcar construction in

Toronto, with new lines opening every year. Travel beyond the city was also expanding, as Toronto's population had grown to 631,000. It was evident that a new central depot was required for busses to connect with towns throughout Ontario and in other provinces. The new terminal on Bay Street was officially opened by Premier George S. Henry. The terminal's elegant symmetrical facade, with its strong vertical lines, remains today an excellent example of Toronto's Art Deco buildings of the 1930s.

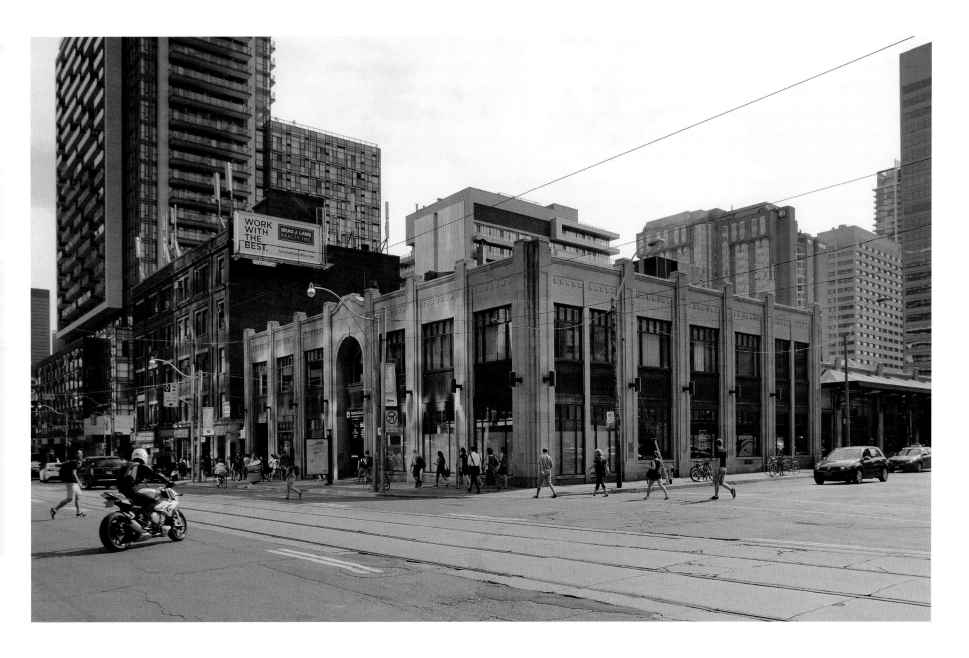

ABOVE: The bus terminal replaced an earlier open-air structure where passengers suffered from the whims of the weather. The new building was owned by Toronto Coach Terminal Incorporated, a subsidiary of Toronto Transit Commission. It was built to facilitate the needs of Gray Coach Lines, also owned by TTC. The platforms for the buses were on Edward Street, on the west side of the terminal. The platform areas were renovated in 1984 and the main terminal in 1990. The same year, TTC sold Gray Coach Lines, but maintained control of the terminal, since leasing the platforms was highly profitable. However, in 2012, TTC relinquished direct control and leased it to Coach Canada and Greyhound Canada, with Megabus also a major occupant. The bus station is connected to the underground PATH walkways by a tunnel under Bay Street, which provides access to many shops and restaurants. Today, the terminal handles over a million passengers a year.

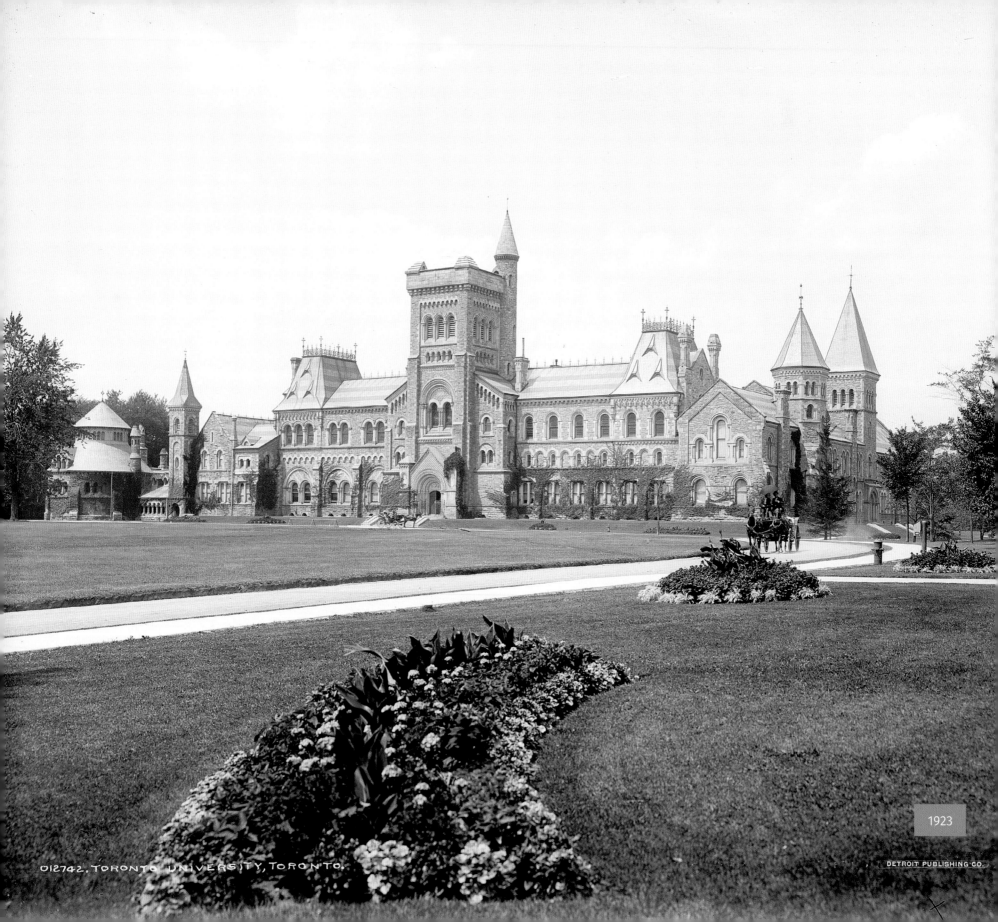

1923

012742. TORONTO UNIVERSITY, TORONTO. DETROIT PUBLISHING CO.

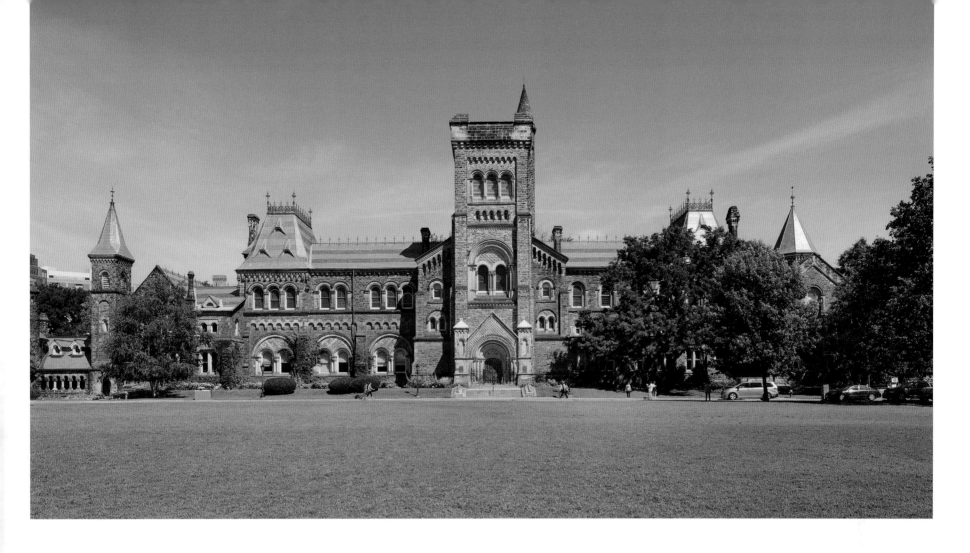

UNIVERSITY COLLEGE

Inspired by the buildings of Oxford and Cambridge universities

LEFT: Completed in 1859, University College was the first building constructed by the University of Toronto. The beginning of higher education in Upper Canada (Ontario) commenced in 1827 when a royal charter was granted by King George IV for the establishment of the University of King's College. In 1849, it changed its name to the University of Toronto, and in 1856 the King's College building was closed. Construction on a new structure commenced the same year. Named University College, it was on the grounds of the University of Toronto and officially opened on October 4, 1859. An impressive stone structure, it was designed by F. W. Cumberland and W. G. Storm in the neo-Romanesque style, inspired by the buildings of Britain's Oxford and Cambridge universities. When University College was built, it was to the northwest of the city, where cattle still grazed on the land to the north of it.

ABOVE: Shortly after University College opened, other colleges amalgamated with it. In 1852, Victoria College (Methodist) from Cobourg and St. Michael's College (Catholic) joined. Women were first admitted to the University of Toronto as students in 1884, and in the following year Knox College (Presbyterian) became part of the university. Trinity College (Anglican), which had formerly been located within the grounds of today's Trinity Bellwoods Park, was included in 1890. Emmanuel College (Methodist) became part of the university in 1925; the same year the United Church of Canada was formed and Emmanuel College entered as a United Church of Canada seminary. The Laidlaw Wing was added in 1964, enclosing the quadrangle on its north side. University College was declared a National Historic site in 1968, but in 1972 it was inspected and found to be in extremely poor condition. Because the building was threatened with demolition, the university's alumni raised the funds for its restoration. Today the building remains one of Toronto's architectural highlights.

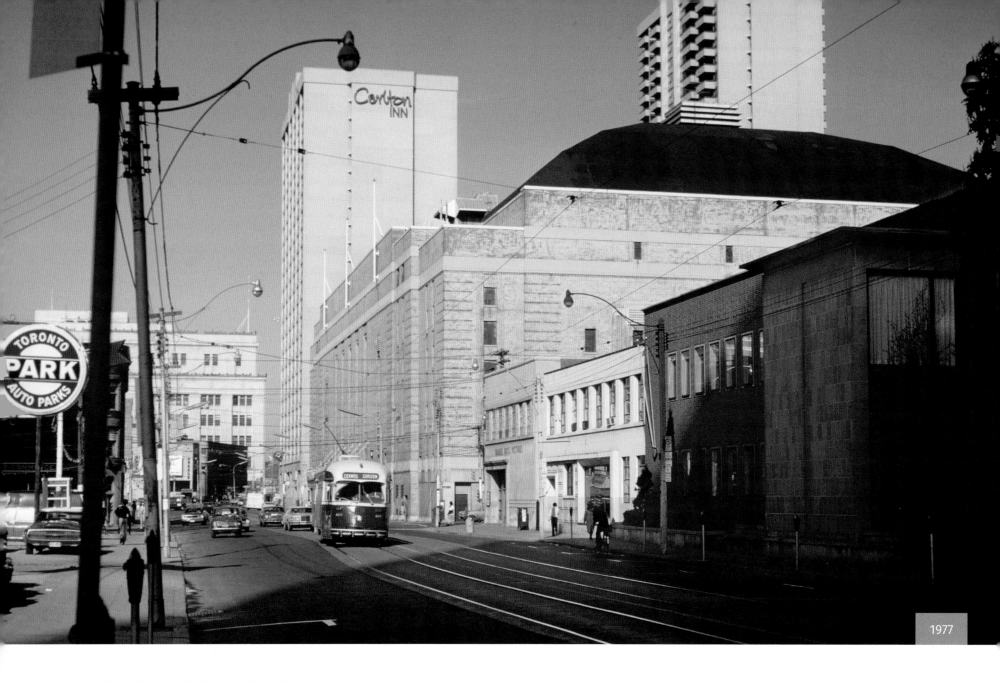

1977

MAPLE LEAF GARDENS

This National Historic Site is still a well-loved sports arena

ABOVE: This view from May 5, 1977, is looking west along Carlton Street. The 13,000-seat Maple Leaf Gardens at 60 Carlton Street was built at the beginning of the Great Depression of the 1930s, and was completed in just five months. Its architecture was a departure from previous decades, as it possessed an unadorned modernistic design with plain facades and straight uncluttered lines. Its interior was able to accommodate an ice rink, a basketball court, and also be converted into a concert venue. However, in some ways it reflected the austerity of the Great Depression, since in its interior there were exposed concrete walls and brickwork. The arena's massive arched ceiling contained steel trusses, supported by four concrete buttresses that required no other interior supports. This allowed unobstructed views from anywhere within the building. For many decades, Maple Leaf Gardens was the city's palace of hockey.

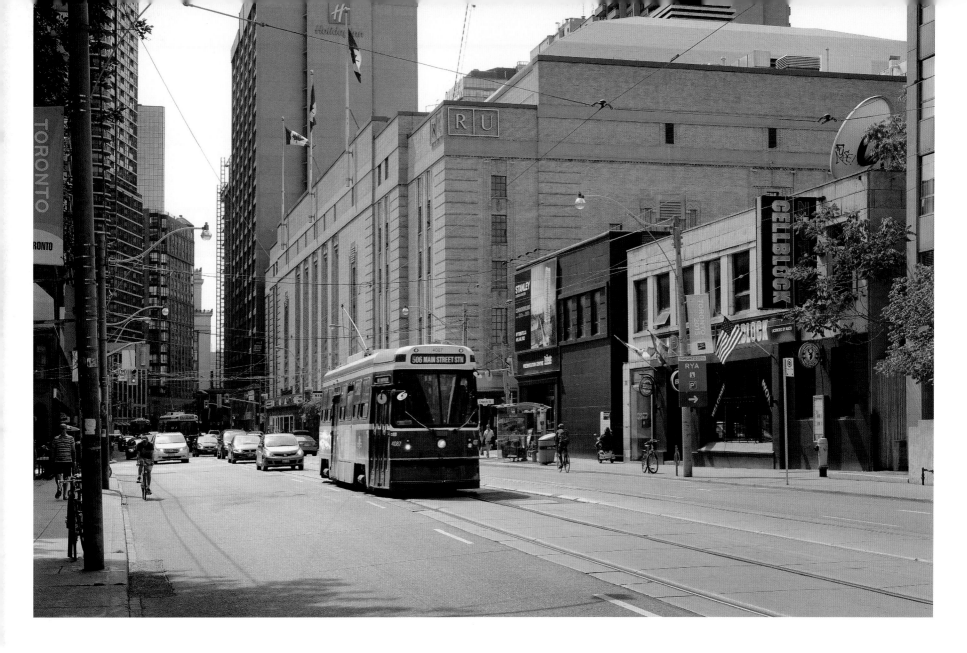

ABOVE AND LEFT: Despite the passing of many decades, the importance of "the Gardens" has never diminished in the eyes of Torontonians. After it opened in the autumn of 1931, it became the city's main venue for cultural, political, sports, and entertainment events. In the 1930s and 1940s, when the major circuses came to town, they performed in Maple Leaf Gardens. During the dismal years of World War II, rallies were held under its roof to raise morale and sell War Bonds. Religious denominations held mass services within its walls, and some of the greatest entertainers of the times performed in it. Rock concerts, wrestlers, and operas were showcased in the Gardens. When the Maple Leaf hockey franchise departed the building in 1999, it was vacant for several years. It was officially recognized as a National Historic Site in 2009 and has been renovated to house an enormous food emporium as well as a sports venue for Ryerson University.

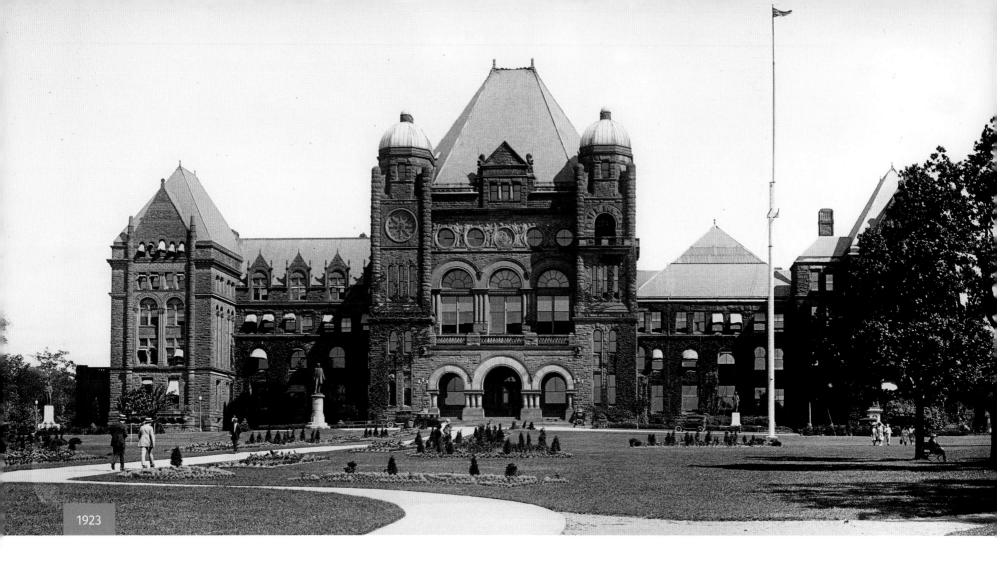

1923

ONTARIO LEGISLATIVE BUILDING
The seat of Ontario's provincial parliament since 1893

ABOVE AND RIGHT: Between 1880 and 1883, the Ontario legislature, then located on Front Street, authorized a design contest for new buildings. The lowest bid was $613,000, which they deemed too expensive, and so the project was postponed. In 1885, Richard Waite, an Englishman by birth, but living in Buffalo N.Y., was granted the contract. His price of $750,000 was accepted, which seems strange considering the previous bids. It is interesting to note that the eventual price was $1,227,963. Construction began in 1886, with Waite choosing a Richardsonian Romanesque style for the building, similar to Toronto's Old City Hall. It contained massive stone blocks, resembling an ancient fortress, with Roman arches and domed towers ornamented with carvings and intricate trim. The pink sandstone for the walls was quarried in the Credit River Valley, the large blocks transported by horse and cart to the grounds and carved to fit on-site. It was completed in 1892, and the first session of the legislature was held on April 4, 1893, with Premier Oliver Mowat officiating.

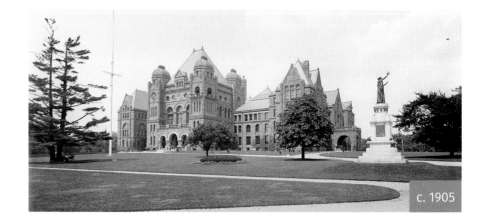

c. 1905

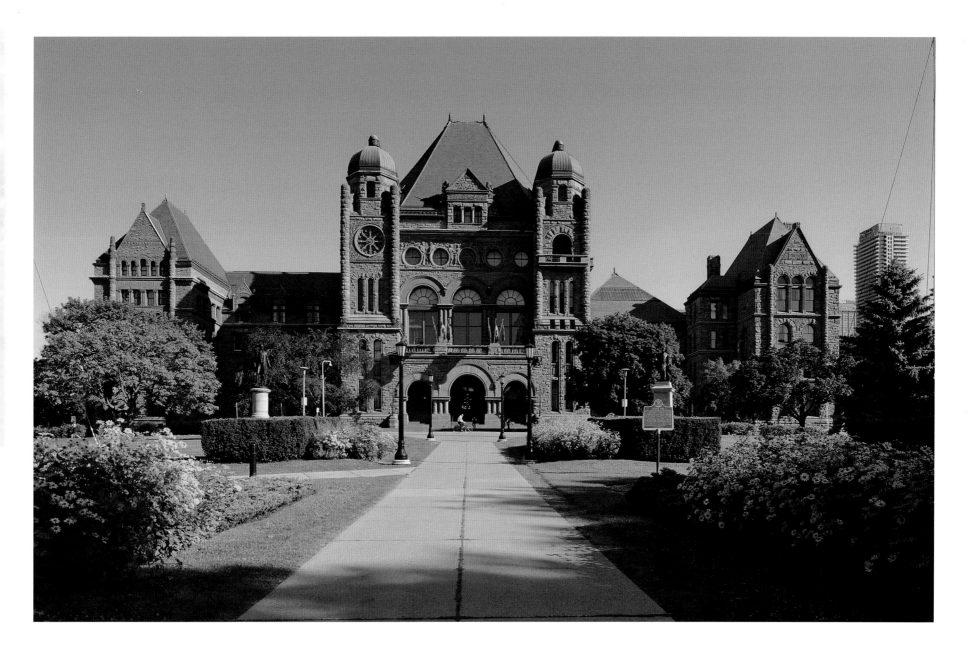

ABOVE: Still home to Ontario's provincial parliament, the Ontario Legislative Building is as impressive today as it was when first built. Its roof is of slate rock from Vermont and the domes on the towers are sheathed with copper. The interior includes oak panelling and floors, with cast iron columns. The building, which possesses a centre block, with wings on the east and west sides, was severely damaged by fire in 1909. E. J. Lennox, who was hired to handle the restoration, added two extra floors to the west wing to create more office space, and changed its hipped roof to a gabled roof. He also added a north wing to the building. Because the land where it is located was once a part of the city's Queen's Park, the Parliament Buildings of Ontario (as the Legislative Building is also known) are commonly referred to as "Queen's Park."

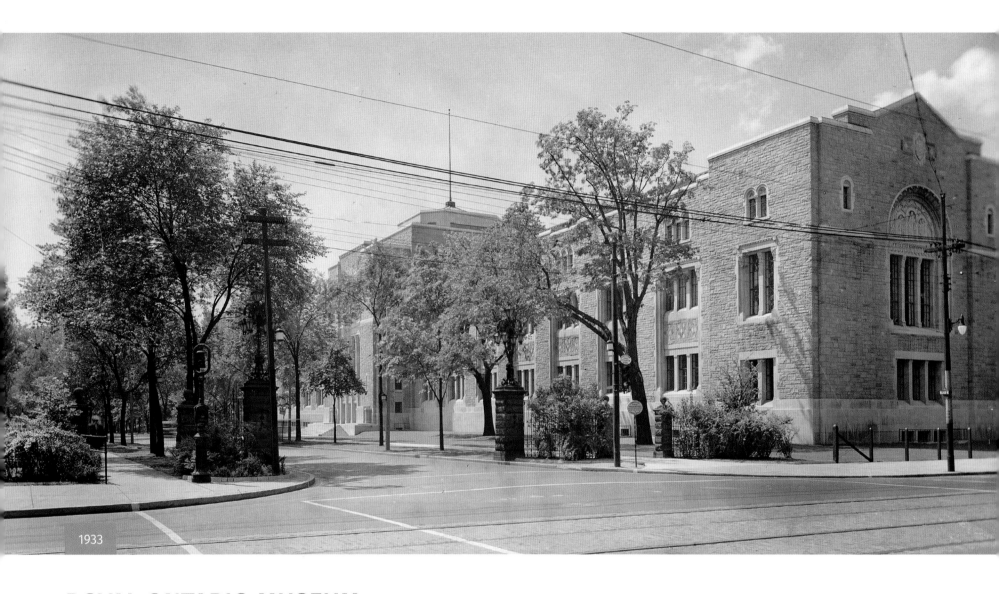

1933

ROYAL ONTARIO MUSEUM
Old and new collide with the addition of Daniel Libeskind's Crystal

ABOVE: This view of Queen's Park from Bloor Street shows the newly built first addition to the Royal Ontario Museum. The original building was behind it, to the west. In the early 20th century, as Toronto was growing rapidly, the need for a world-class museum was clearly evident. A small group of influential people sought funding from the Ontario Government, as well as from the University of Toronto. As a result of their efforts, the Ontario Legislature passed the ROM Act on April 16, 1912, which officially created the museum. The architects for the building were Darling and Pearson. The facade of the new museum faced Philosophers' Walk, a short distance west of the intersection of Bloor Street and Queen's Park. The main entrance was on the north side, facing Bloor Street. It was officially opened on March 19, 1914, by the Duke of Connaught, Canada's governor general. The east wing, shown above, was completed in 1933.

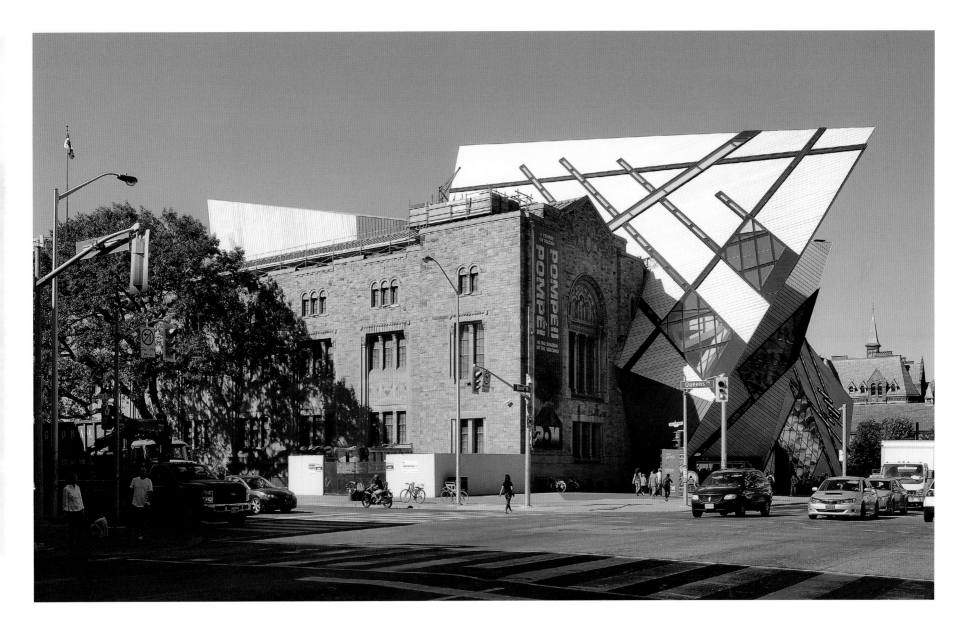

ABOVE: The Royal Ontario Museum has expanded greatly since its beginnings. When the east wing addition opened in 1933, the original section of the museum became its west wing. The combined structures created a U-shaped building that occupied the entire southwest corner of Bloor Street West and Queen's Park. The main entrance then shifted to the east side, on Queen's Park. The walls were of pale-yellow bricks and Ontario limestone. The architects were Chapman and Oxley, who chose the Beaux-Arts style, with detailed classical ornamentations. In 1967, the museum severed its connection with the University of Toronto and became a separate entity. The ROM, as most people refer to it, was renovated in 1984, at a cost of $55 million, and was officially opened by Queen Elizabeth II. The next major alteration to the museum occurred in 2007, when Daniel Libeskind's "Cystal" was built, at a cost of $320 million. This glass and steel addition is officially called the "Michael Lee-Chin Crystal" and is named after the Canadian billionaire banker who pledged $30 million to the museum. The entrance to this startling new addition is on Bloor Street.

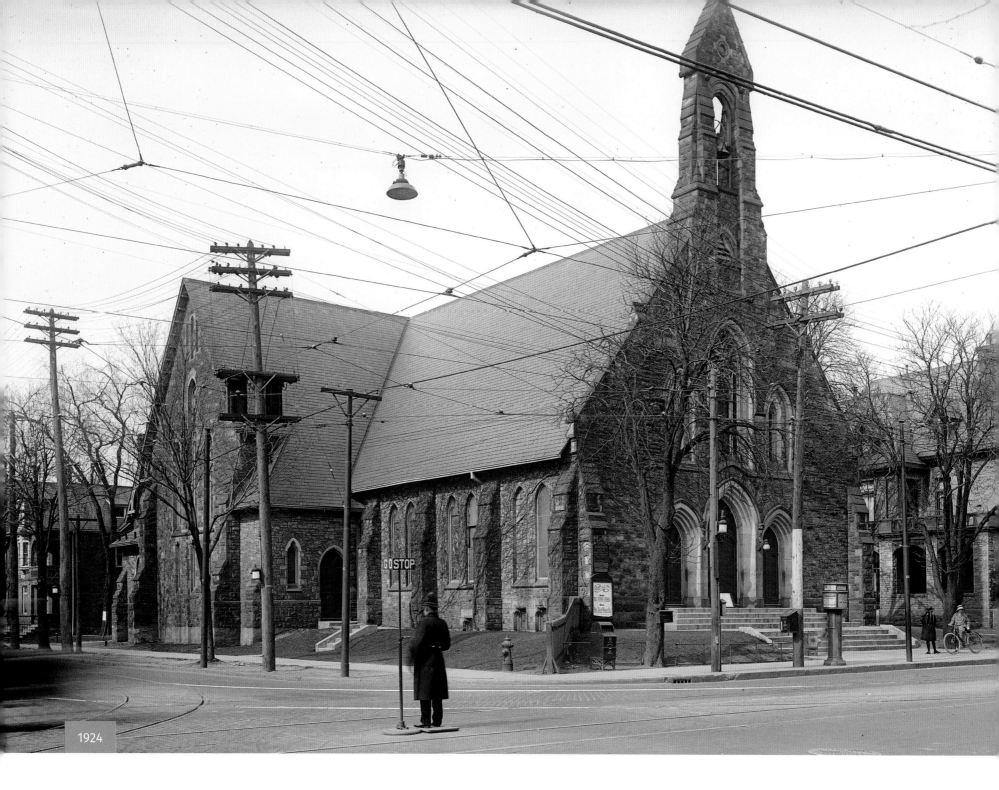

1924

CHURCH OF THE REDEEMER

An active church community in the heart of the city

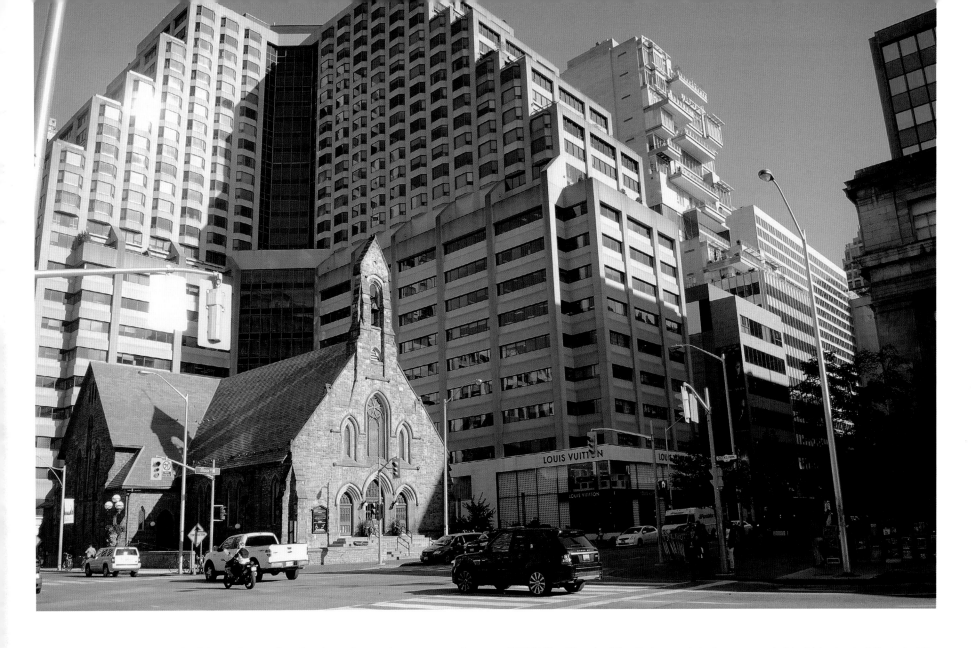

LEFT: This photo of the Church of the Redeemer (Anglican), on the northeast corner of Avenue Road and Bloor Street West, was taken on April 20, 1924. Constructed in 1878, the church was designed in the High Victorian Gothic style, its walls covered with rubble stone from the Credit Valley, near Georgetown. The term rubble stone implied that the stones were the rubble that remained after stones were cut in the quarry. They were irregular in shape and their sizes varied. However, though rough in texture and inexpensive, they created a pleasing effect when assembled on the church walls. Ohio sandstone was imported for the stone ornamentations and the trim around the windows. The nave originally held seating for 800 parishioners. Those who were able to afford to rent pews attended on Sunday mornings, while others worshipped on Sunday evenings, when the pews were free. This was the custom in many churches in the 19th century.

ABOVE: The Church of the Redeemer is today surrounded by high-rise buildings, but it remains an active church community in the heart of the city. Its interior has changed throughout the many decades as well, due to renovations and the memorial plaques added to its walls. The inside has white and red bricks, which are enhanced by the geometric patterns that were included. The support columns are of polished granite from the Bay of Fundy area. Extensive alterations occurred in the 1980s, when the parish hall on the north side of the church was sold. The church then lacked sufficient space for church offices and meetings. The problem was solved by raising a section of the floor at the south end of the nave to expand the basement level. Pews were removed from the raised section and replaced with chairs. Due to an ever-expanding congregation, more renovations were carried out in 1995, and then again in 2000–2001, to create more space and improve facilities.

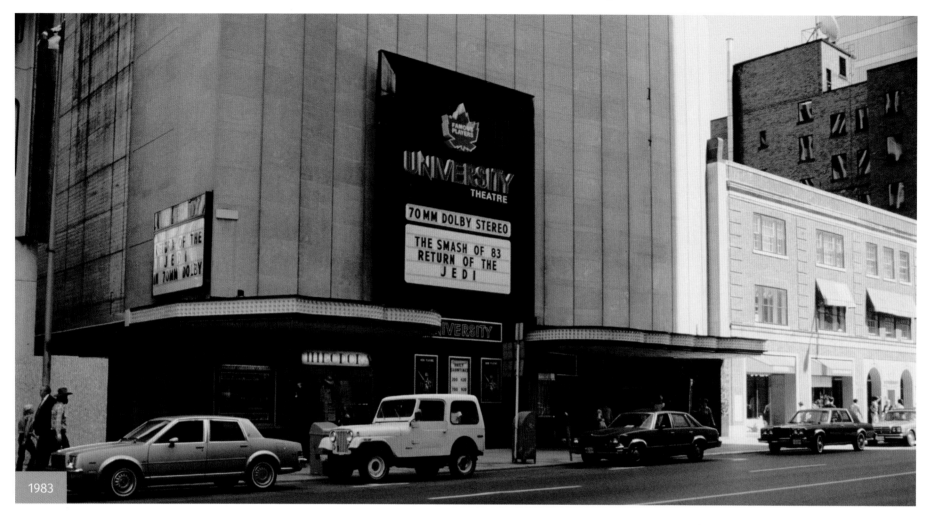

1983

UNIVERSITY THEATRE

Only the facade remains of this postwar movie palace

ABOVE: The University Theatre, which opened in 1949, was one of the greatest postwar theatres ever built in Canada. Owned by Famous Players, it was constructed to compete with Toronto's Odeon Carlton Theatre. Its architect was A. G. Facey, who designed a sleek modern facade with a two-storey lobby and an Art Moderne marquee that towered high into the sky. The original marquee can be seen in the photo on the right. The University was truly a movie palace in both size and design. Its auditorium, which contained approximately 1,350 seats, displayed modernistic vertical lines that seemed to exaggerate the ceiling's height. The theatre possessed Dolby sound and an enormously wide screen, ideal when featuring epic films. The movie featured on opening day was *Joan of Arc*, starring Ingrid Bergman. Many great movies had their Toronto premieres at the theatre: *Ben Hur* in 1959, starring Charlton Heston; *Cleopatra* in 1963, with Elizabeth Taylor and Richard Burton; and in 1965, *Doctor Zhivago*.

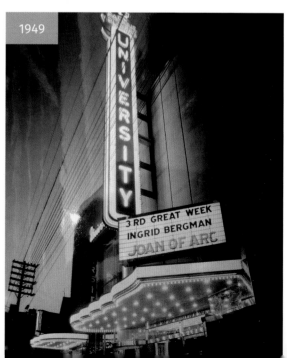

1949

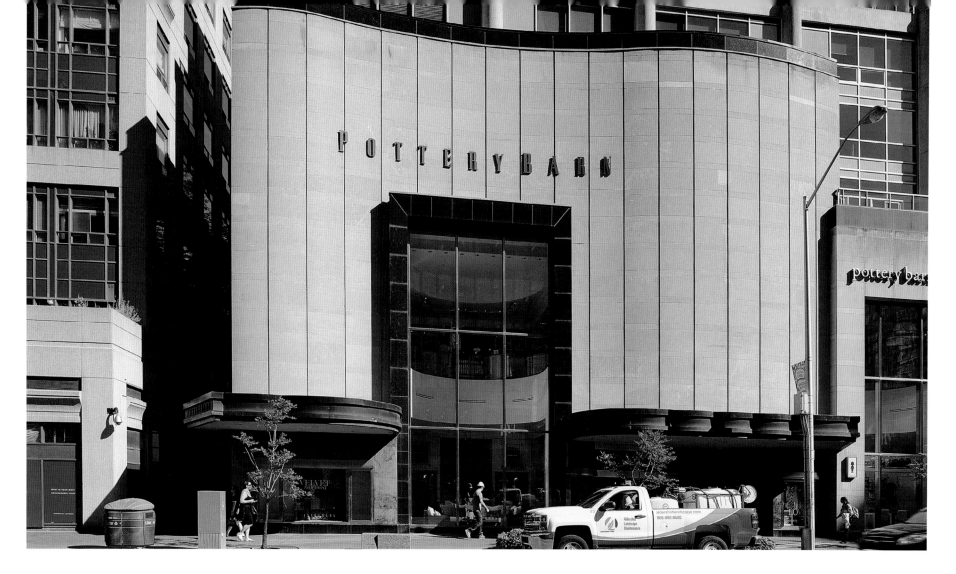

ABOVE AND RIGHT: The University remained one of Toronto's most popular theatres for many decades. However, with the advent of television, the economics of operating theatres changed. Due to the University's enormous size, as attendance dwindled it experienced financial difficulties. In the mid-1980s, it was realized that even if the theatre offered another film such as *Apocalypse Now*, which had been featured for 52 weeks at the theatre in 1979, it was not possible to operate it profitably. Eventually, it was offered for sale. The Toronto Historical Board attempted to have it designated a Heritage Building, but was not successful. When they locked its doors in 1986, a truly great movie venue was lost. The theatre was demolished, but its facade was retained and is today part of a condominium, with Pottery Barn, a home furnishings store, occupying the entrance. Its box office, which faces Bloor Street, is employed to display merchandise. This is all that remains to remind Torontonians of the existence of this great postwar theatre.

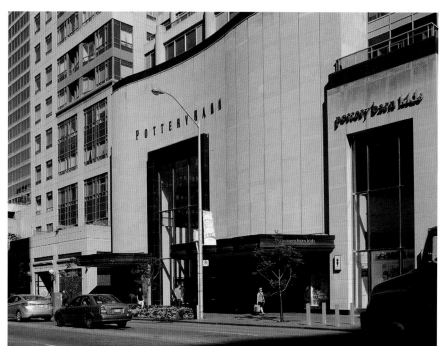

1913

OLD MILL
Once a derelict grist mill, now
a luxury Tudor-style hotel

LEFT: This photo, taken on July 31, 1913, shows the
ruins of a former grist mill beside the Humber River.
When the town of York (Toronto) was established, the
river was an important trade route, and by the 1830s
many mills were located along its banks. They became
obsolete when steam power was introduced, but the
valley remained popular as a recreational destination.
Shortly after the turn of the 20th century, Robert H.
Smith purchased 3,000 acres of land near the valley
to erect residential communities. On August 4, 1914,
he opened an English-style tea garden adjacent to
the ruins of the old mill shown here. Canada entered
World War I the same day the tea room opened, and
it soon became a popular gathering place for officers
and troops stationed in Toronto waiting to be shipped
overseas. Here, they could dance to the swinging
sounds of the greatest big-band orchestras of the
era. The photo below shows the Old Mill's dining room
in 1929.

1929

RIGHT: The tea garden beside the old mill at 21 Old Mill Road was expanded in the decades ahead, with a print room added in 1919. During the 1920s, people travelled from the city by boat to dine at the restaurant. In 1929, the Dance Hall and Garret Room were built, which facilitated dining as well as dancing, the additions constructed in the English Tudor Style. The Old Mill survived the Depression years due to the popularity of its traditional English teas. In 1956, the Humber Banquet Room was added for private parties. It was renovated in 1973 by William Hodgson, who expanded the facilities further. During this period, the ruins of the seven-storey 19th-century stone mill were restored and a wedding chapel constructed within it. In 1986, another wing and banquet room were built. After undergoing restoration, it was opened as the Old Mill Hotel in 2001 and in 2015 it was purchased by Adam de Luca of OTM Hospitality Inc.

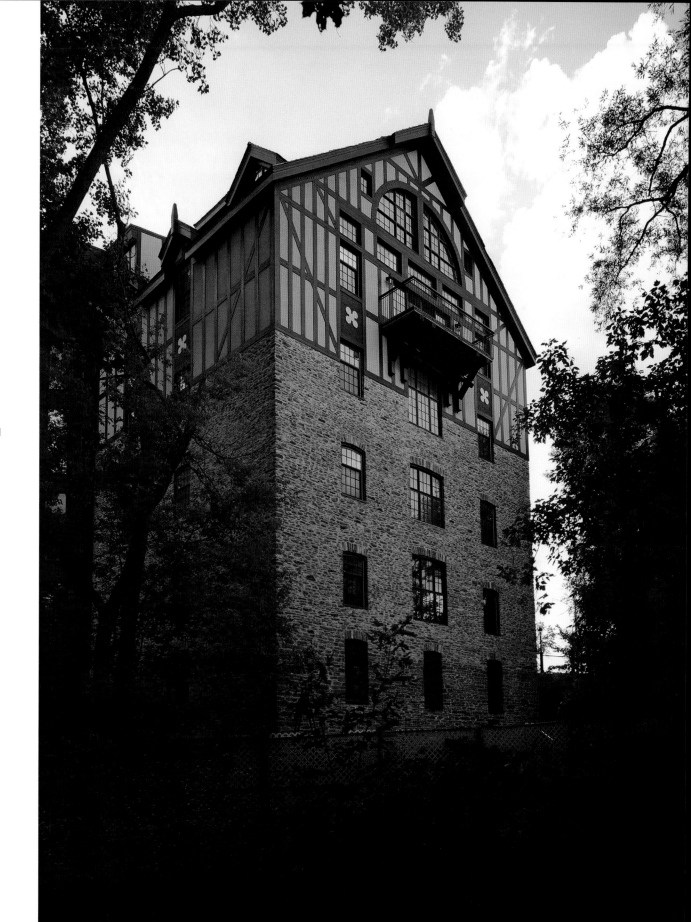

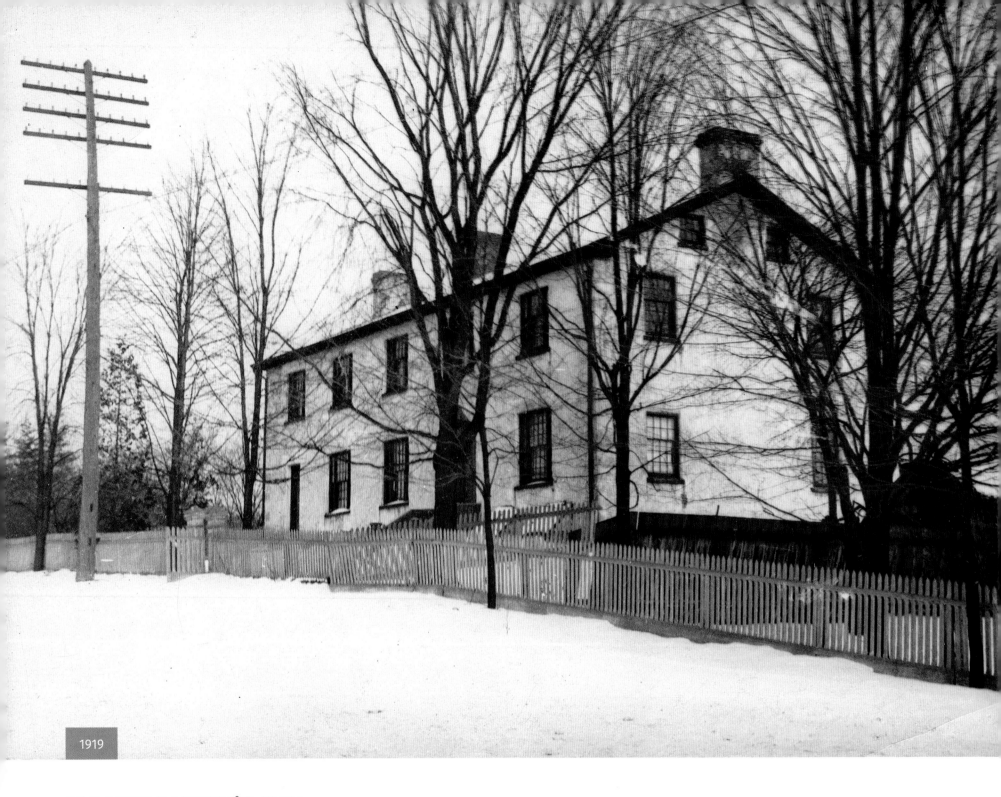

1919

MONTGOMERY'S INN

Now a museum that offers a glimpse into the inn's past

140

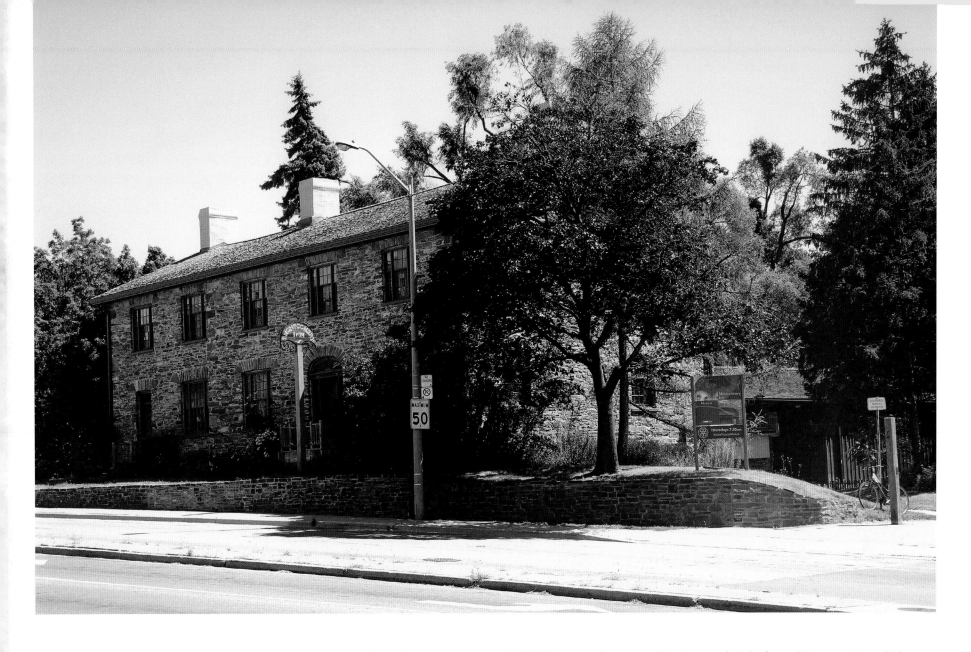

LEFT: Montgomery's Inn, seen here in a photo from January 12, 1919, is on the southeast corner of Islington Avenue and Dundas Street West. In the 1790s, after Yonge Street was built, Governor Simcoe ordered his soldiers to construct Dundas Street. In the 1830s, it became a stagecoach route, with inns constructed at various points to meet the needs of travellers. About the year 1830, Thomas Montgomery and his wife Margaret built an inn on the north boundary of their farm, in what is now the Islington neighbourhood of Etobicoke. It was constructed of local stone, most likely from the Humber River Valley. The facade of the building was Georgian, with an orderly symmetrical design, which was altered in 1838 when an extension was added. It remained an active inn until 1855, when Mrs. Montgomery died. After Thomas Montgomery died in 1877, his son William inherited the farm and inn, which he leased to tenant farmers.

ABOVE: The tenant farmers and Montgomery's heirs farmed the property until the 1940s. In 1946, the Presbyterian Church purchased the inn and renovated it to facilitate their needs, and in 1958 the first meeting of the Etobicoke Historical Society was held within its walls. Louis Mayzel bought the inn in 1962, and then sold it to the Etobicoke Historical Society for the same price he had paid. In 1965, management of the inn was taken over by the Etobicoke Historical Board. For several years its fate was undecided, but in 1975 they voted to maintain it as a museum. When the restoration commenced, many of the interior walls were missing and no blueprints had survived. Careful examination of the walls and floors allowed them to determine where the walls had once stood. The interior was furnished to reflect the period 1847–50, when the inn was in its heyday, and today the museum successfully recreates the impression that the Montgomerys remain in residence.

RUNNYMEDE LIBRARY
Designed in a style that reflects English, French, and Canadian Aboriginal traditions

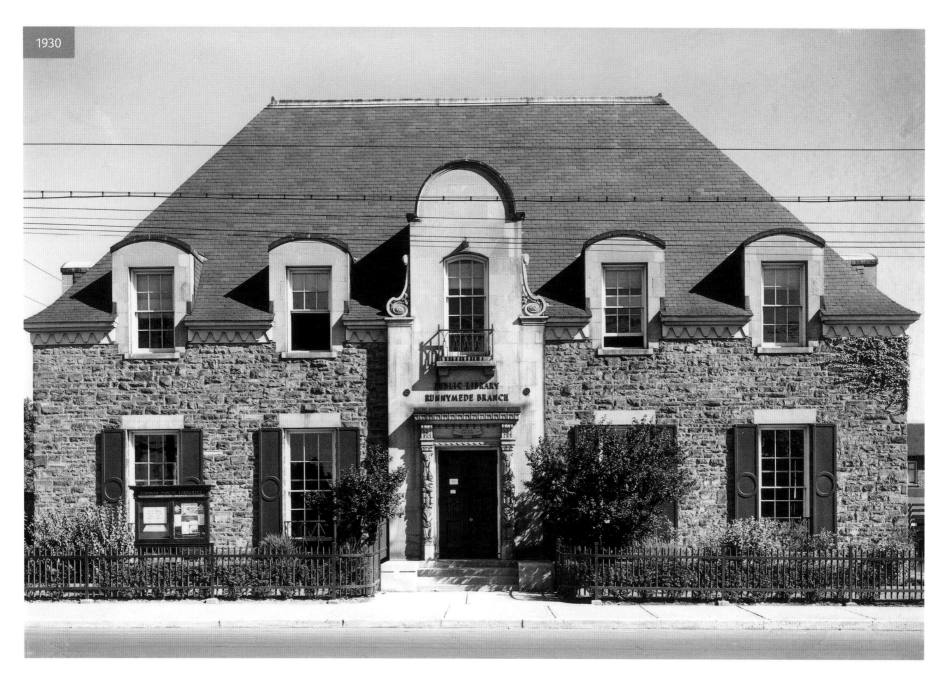

1930

LEFT: This photo of the Runnymede Library at 2178 Bloor Street, east of Runnymede Road, was taken just a year after the building opened. Its architect was John M. Lyle, who also designed Toronto's new Union Station, the Royal Alexandra Theatre, and the impressive headquarters of the Bank of Nova Scotia at King and Bay Streets. Lyle was born in Ireland in 1872, but spent his childhood in Hamilton, Ontario. He studied at Yale University and in Paris, but started his career in New York City. He returned to Canada in 1905 and lived in Toronto. Lyle greatly promoted Beaux-Arts Classicism and is often referred to as a "progressive traditionalist," as he combined the best of the traditional architectural styles. His designs employed motifs that reflected English, French, and Canadian Aboriginal traditions. The Runnymede Library is one of the best examples of a building that included these three traditions. It was inspired by Lyle's belief that the European architecture that dominated much of Canada did not reflect the nation's own unique culture.

BELOW: The Runnymede Public Library is one of the few libraries ever depicted on a Canadian postage stamp. The ornate stone structure is deserving of recognition, as it is architecturally among the most distinctive buildings owned by the Toronto Public Library. The walls of the two-storey structure are constructed of rough, highly textured stone from the Credit River Valley. The steep black-slate roof and gabled windows are reminiscent of French Canadian architecture, the four gables on the Bloor Street side breaking the roof line on the south side. The dressed-stone doorway facing Bloor Street has carved-stone totem poles with stylized ravens, bears and beavers—art from the Native Peoples of Canada's west coast. Since the library opened in 1929, it has been expanded to the north, but Lyle's original design has never been compromised. Today, the library is an important and integral part of the thriving Bloor West Village.

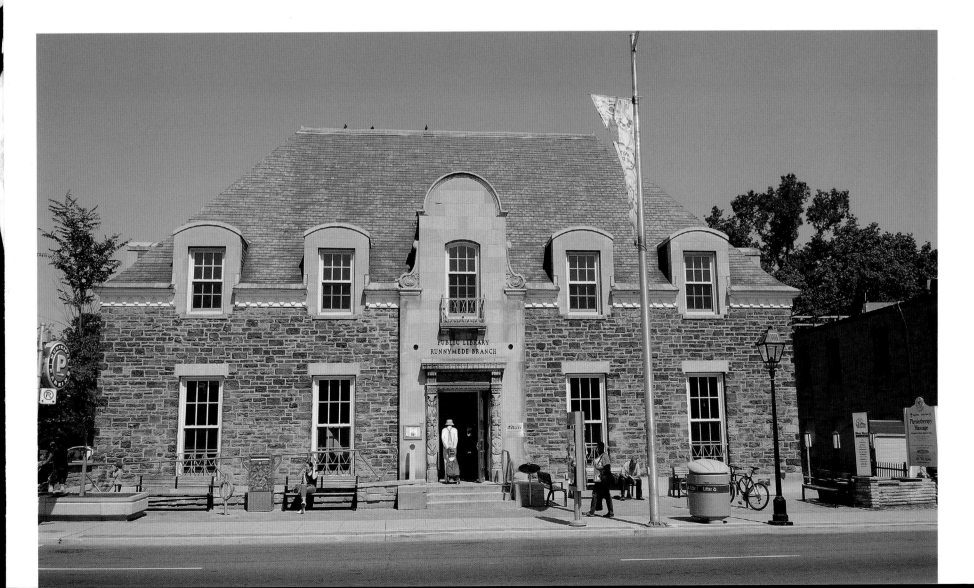

INDEX